13.99

D0347186

...NG CENTRES
...CENTRE CAMPUS
...ASTWOOD LANE
ROTHERHAM S65 1EG

on or before ... last date stamp...

WITHDRAWN

Rotherham College of Arts and Technology

R64047

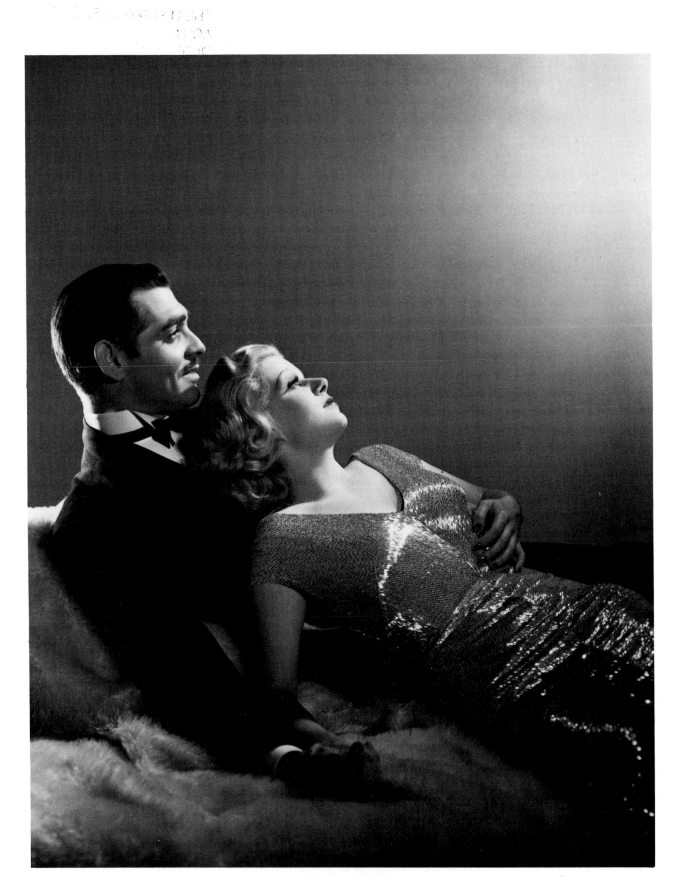

Clark Gable and Jean Harlow, 1937. Photo: Clarence
Sinclair Bull, for MGM. Gown by Adrian. Publicity shot
for *Saratoga*.

THE LEARNING CENTRES
ACC No. R64047
DATE 09/10/08
CLASS 779.92 kcb

HOLLYWOOD GLAMOR PORTRAITS

145 PHOTOS of STARS
1926-1949

EDITED BY JOHN KOBAL

Dover Publications, Inc., New York

Copyright © 1976 by John Kobal.
All rights reserved under Pan American and International Copyright Conventions.

Hollywood Glamor Portraits is a new work, first published by Dover Publications, Inc., in 1976.

International Standard Book Number: 0-486-23352-9
Library of Congress Catalog Card Number: 76–19671

Manufactured in the United States of America
Dover Publications, Inc.
31 East 2nd Street, Mineola, N.Y. 11501

INTRODUCTION

The stills photographers were a peculiar breed. In an industry that was based from the first upon the phenomenon of motion, they wanted to take still photographs. They came from everywhere to Hollywood, where some began as illustrators, some as actors, directors, painters, etchers. Many could have become cameramen—some did (like Bill Walling, Jr.) but gave it up to return to the thing they loved best, taking still photographs. In their heyday, they were known as just about the most independent breed of men in the motion-picture business (as their strike in 1932 proved) . . . and their work reflects it. In what was the film capital of the world they had nothing to do with making movies, but everything to do with the selling of the dream that movies meant. They were the ones who created "want see."

The work of these men—George Hurrell, Ernest A. Bachrach, Robert Coburn, William Walling, Eugene Robert Richee, Clarence Sinclair Bull, Ruth Harriet Louise (one of the few women in this masculine preserve), Gaston Longet, Otto Dyar, George Hommel, Russell Ball, Ted Allen, Laszlo Willinger, Roman Freulich, Ray Jones, Irving Lippman, A. L. "Whitey" Schafer, and all the many others—is portraiture, but of a particular kind. They were not mirroring life but illusion; their subjects were not humans, but gods—of love, of allure, of luxury, perfection incarnate from the golden age of Hollywood glamor.

Don't look for or expect to find the faces of real people. These beings have no warts; their lines, if any, are not the wrinkles of age, or of myopia—they are the furrows of experience such as mere mortals rarely have. They have neither scars nor imperfections of any kind. They don't even possess pores in their skin through which to breathe. After all, gods are immortal. Their skin, like marble, like alabaster, has a translucent sheen in which, as in a mirror, one can see reflected the fantasies of the beholder. The ideal only remains. When they made good in pictures, they didn't just change, they shed that coarse cocoon and emerged translucent, transformed.

The people who walked into the portrait galleries walked out again the same, unchanged. But they left a residue behind them, a residue not really their own but one which existed because of them, extracted by the photographers, captured by the cameras. It crystallized as an objet d'art—Art Deco lines, Mount Rushmore dimensions—waved hair spilling over beds of white animal furs, glazed lips parting seductively, Vaselined lids lowered languidly, arms alluringly akimbo or entwined in hair, nonchalantly helping to expose breasts—creatures of light, of marble, of glass. This was the American dream on paper. These images are not subtle; they are, like icons, made to be adored; they are to be coveted, to be collected like works of art.

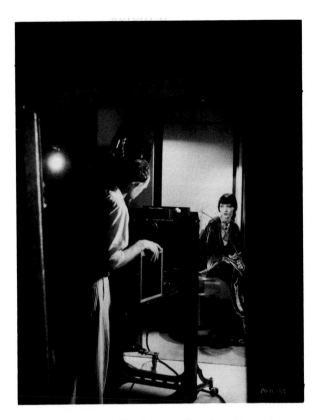

(A) Paramount stills photographer Otto Dyar photographing Anna May Wong, 1930. Publicity shot for *Daughter of the Dragon*.

The Hollywood stills photographers were, on the whole, among the least admired or appreciated of their fraternity. Few of them ever even became as well known as free-lance photographers working for fashion magazines. By necessity, their reputations were overshadowed by those of their subjects and by the sheer flood of material that had to be churned out. Yet, at their best, they had few peers and some, like George Hurrell, Ernest Bachrach and Robert Coburn, originated styles and ideas in glamor photography whose influence, though unsung, can be seen today, having inspired many a current photographer. Francesco Scavullo remembers that as a young boy he would get his younger sister to pose on the floor with hair spilling out, trying to photograph her in the manner of Hurrell.

When the studios first began to establish their portrait galleries about 1920, their work was not much different from the sort of portraiture that might be seen in any small town, of pretty girls on their birthdays or graduation or wedding days. Soft focus was basic; only the

faces, and sometimes the background and the poses, altered. The latter may, in some cases, have been bizarre, but because of the subject —great exotics like Valentino, Mae Murray, Swanson and Negri—rarely because of the photographer. In the 20's the star dominated the photo, in the 30's the photos could make the star. By the end of the silent era new, more sensitive photographic lenses were coming onto the market, and new photographers, not ruled by studio publicity departments, were arriving in Hollywood.

One such was George Hurrell. He began as an artist living on Malibu Beach, but soon found he was making more money by photographing other painters than by painting. His photographs, with their startling use of light, were seen by Ramon Novarro, who hired this independent. In turn the portraits of Novarro were seen by Norma Shearer, who wished to escape typecasting as a sweet young thing and prove that she was capable of more sophisticated, sexier roles. Hurrell's portraits of a new alluring, sensual Shearer got her the parts for which she won an Oscar. For a time Hurrell took over MGM's portrait gallery.

At this period, Ernest A. Bachrach, working at RKO, began to create his dazzling geometric studies of the human face and form with Dolores Del Rio, Katharine Hepburn and Astaire and Rogers. Other photographers at other studios were not slow to pick up ideas and escape from the confines of static sittings and soft focus. They began to experiment with backgrounds, shapes, textures, lighting, and produced a unique genre which not only served a specific function, but—unlike many of the films of the period—survives as a form of art.

Great care went into the stills sessions; the lighting, the costume, the props and the makeup were all designed to contribute to the production of a quintessential look of personal style. The magic arose from the interaction between photographer and star, in a framework as intimate as possible. After the sitting the work went on. The large 8″ x 10″ negatives were sent to be retouched by skilled artisans whose job it was to eliminate excessive waist, hips, throat, shoulders—a process often so extensive that duplicate negatives had to be made, as the first was so scraped, stippled and scored away

that no further retouching could be done. Airbrushing was often employed to give the alabaster finish to close-ups, and a delicate tracery of fine working can often be seen on the original negatives, covering the whole facial area. In all, this was a highly specialized art which, like the use of the large negatives, no longer exists.

This album includes images of Greta Garbo, Marlene Dietrich, Joan Crawford, Clark Gable, Norma Shearer, Jean Harlow, Buster Keaton, Louise Brooks, Mae West, Claudette Colbert, Clara Bow and many other very great names. But some other prints have been chosen as well, to illustrate different aspects of the stills photographer's work. There is, for instance, a group of prints showing a fabricated environment suggesting personality and mood —Evelyn Brent amid tropical shrubbery, or Tallulah Bankhead "imprisoned" by a grid of shadow. There are fashion shots illustrating the work of Travis Banton, Adrian and other Hollywood costume designers. There is no space in this small survey for a group of on-set pictures, contrived to show the star at work, relaxing between takes or at the make-up table; but the pin-ups include a rare leg show from Mae West and beautiful images of Carole Lombard. All the photos in these pages were taken by the studio gallery photographers in the years between 1926 and 1949, the definitive, most luxurious period of Hollywood glamor.

The photographs, the glamor and all they embody, thrived in the years of the depression —not despite, but because of it. While they could not shake off that reality, they nudged it, and like carrots on sticks, kept people believing in and striving for a better life. Contemporary photographers were being commissioned by Roosevelt's Farm Security Administration to capture and broadcast the grim reality of the Dust Bowl or men on breadlines—poverty such as America has seldom known. As if answering the challenge, Hollywood evolved new gods of more unreachable splendor that outshone, outspent and outdid the old dreams of the old America. Actresses like Joan Crawford felt, and said, that it was her duty as a star and an American to spend as much money and live as glamorously as she possibly could. The casual photo reportage of the everyday lives of stars was a vogue that arose in the more democratic 50's

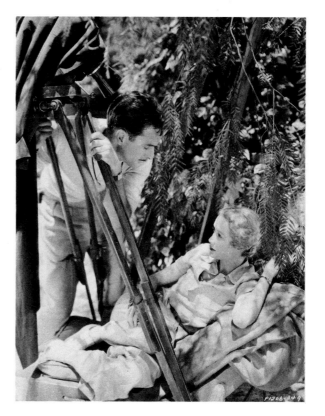

(B) Stills photographer Paul Hesse preparing a shot of Miriam Hopkins, 1934.

and 60's. Earlier fans did not wish to see the stars in the kitchen—nor would the luminaries have consented, except, perhaps, to look over the shoulder of the French chef. The public had no desire to see the stars "as they really were." They preferred the glamor and the luxury and the stories of how they dined at the Ritz and married royalty and employed butlers and maids.

The photographs and the stories were to be found in fan magazines. The stories were mostly infantile interpretations of studio publicity releases; the photographs, however, were lovingly printed in gravure, suitable for framing on a bedroom wall or pasting in an album. They kept the dreams alive between films, let the public examine more closely the cut of Garbo's new gown, provided fashion plates and beauty hints, and suggested that perhaps if you were lucky, this could happen to you too . . . isn't it the American way, where newspaper boys become presidents?

It is truly surprising, when one thinks of the flood of pictures of stars, starlets and supernumeraries that poured out of the studios every

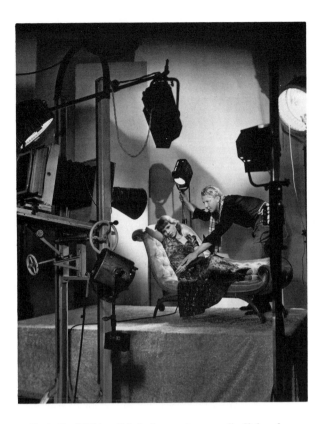

(C) A. L. "Whitey" Schafer setting up the lights for a portrait of Dolly Haas, 1937. Columbia.

day of the week for years, that the galleries of a major studio like Paramount had only two men in charge—Eugene Robert Richee in the No. 1 Gallery and William Walling in No. 2. (It was the same at the other studios.) The bulk of the Paramount portraits came from these two, who did almost everything for the sittings except hang the drapes. Walling estimated that he averaged about 65 portraits a day, six days a week, for the first three years. Sittings would be arranged for any time the stars had free between films; or after a day on the set they would appear at 6:00 at the gallery for portrait sessions that would continue until there were enough good shots.

The value of the stills photographers to their employers lay in their ability to make people want to see the star, by creating in a photograph the equivalent of the accumulative impact of the whole movie. It was the Harlow of Hurrell's photographs you sought in the films, and her close-up, when it came in the plot, took a lot of its lighting ideas from the Hurrell original. It was, as a matter of fact, quite common for a stills photographer of Hurrell's sta-

ture to be brought out to the set to assist in lighting the close-ups. There were few directors as knowledgeable or as consummately skilled in achieving the same results as the gallery photographer. Josef von Sternberg was, of course, the outstanding exception. No one ever understood the Dietrich face as he did, and the best portraits of her were those taken on the set by the publicity photographer on stand-by, employing Sternberg's lighting set-up and pose. But the exception proved the rule; most directors and cameramen would have been delighted to achieve on film the look of a Hurrell, Bull or Bachrach. Special film images, like the one in *The Spiral Staircase* when one sees on the screen a close-up of the eye of the murderer in whose pupil is reflected the victim-to-be, were also done in the gallery, this particular one by Ernest Bachrach.

Among the problems of the gallery photographers were how to deal with the stars whose image they were selling—how to liven up weary, bored or unwilling actors. Not all of them enjoyed being photographed as Crawford did. Hurrell said, "She believed in the star thing, and everything that went with it. She could make artificial poses seem so real, going on and on loving it. She'd set aside a whole day, changing into maybe twenty different gowns, hairdos, make-up, everything. I probably shot more stills of her than of anyone else. Let her stand stiff and aristocratic and she'd be off." Others, like Gary Cooper and Bing Crosby, were lethargic; John Barrymore and W. C. Fields positively loathed the process. The photographers had to deal with all of them.

Not only great stars, already formed, came to the galleries, but also aspiring actors and actresses who did not as yet have a public image which the studios could sell. Stills would serve as a cheap screen test, capturing them in every way, every mood, costume, setting until the face clicked. The studio heads would then decide on the basis of these photographs whether a screen test was worthwhile.

The gallery photographers answered to the publicity and advertising departments. Publicity wanted a basic head shot against a flat background that would reproduce well in the cheapest pulp magazines and in newspapers. Art studies were done for fan magazines. The ad-

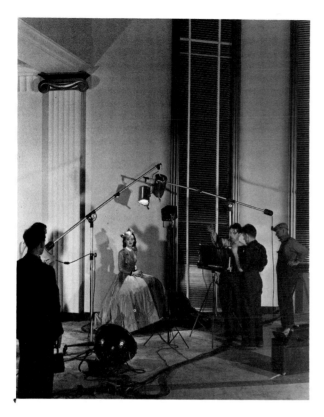

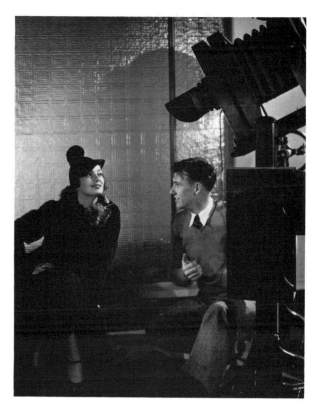

(D) Warner Bros. stills photographer George Hurrell (arm upraised) setting up a publicity shot of Bette Davis for *Juarez*, 1939 (photo by Schuyler Crail).

(E) Goldwyn's stills photographer Robert Coburn with Andrea Leeds, 1939.

vertising department needed images to use for poster work, fashion spreads and the like. Anything else was done to satisfy the star and the photographer. It is truly surprising that such demands produced even creditable results, let alone the consistent innovative artistry that these images exhibit.

Times have changed in Hollywood; the star image has faded, the studios are less dependent upon the public's adoration of their actors. The portrait work has changed as well. Hurrell mourned the passing of the great days: "Now they photograph a girl out in the hayfields where we used to bring the hay to the girl."

How do they differ, these images, from the works of a Steichen or an Arnold Genthe or a Karsh? In Karsh's famous portraits of Winston Churchill and other statesmen, one sees illuminated that quality of the man or woman that sets them apart from the crowd; this quality is then expanded to fill the whole image. The Hollywood photographers had a different task. It was assumed that if you were or were about

to become a star, this generic quality, and this alone, was the image to be captured. As Bill Walling remarked, "What you have to attempt to do is make them look like they think they look, and as the public wants to see them. Now, that's not the real person." The portraits in this collection are all of stars, all different, but sharing the peculiar traits that had brought them into the limelight—the will to succeed, the desire for fame, for glory, for stardom—a belief in the star quality in themselves. There was also their own particular image, the way each one of these personalities interpreted his or her primary role—that of star. It made Harlow the definitive bedspread, Mae West a boundless settee, Robert Taylor love's young dream, Shearer a living, breathing Watteau. Without the intrinsic star quality, these carefully adulatory photographs would cloy, their validity would be lost, the sham of the dream revealed.

The era of great Hollywood portrait photography stands as more than an escapist route for the depression-weary (though perhaps the modern yen for times past arises from a similar

need): seen in the light of today's critical attitude towards photography, these pictures still work, both as images of dreams and as photographs of great merit. The pictures that form the basis of this book appeared in 1974 in an exhibit mounted by the author in London's Victoria and Albert Museum, where they met with startling critical enthusiasm. "Products of a minor but distinctive art of the motion picture studios . . . the pictures in the V & A reveal them succeeding triumphantly in their single aim —which was the aim of all Hollywood at that time—of realizing the impossible, romantic ideal of youth and beauty" (*The Times*). "The quality is impeccable, and in that respect the Hollywood photographers must be considered highly skilled artisans Looked at now, many of the images are supremely elegant and simple yet powerful pieces of design which do admirably the job they were designed for—to make of an already beautiful woman a creature of pure fantasy" (*Amateur Photographer*). "It is as much part of photography as some esoteric school or style is part of the history of painting. An art of illusion, certainly, *all* art is. But an art with an aim in view" (*The British Journal of Photography*).

For, as the show's organizer, Elizabeth Bailey, writing in the Museum's catalogue, concluded, "The aim is to present the stills photographers as creative artists in their own right and to show the quality and the evocative power of their work. Realism has dominated photography in all but a very few highly specialized fields. This exhibition serves as a reminder that it can be an art of illusion and that the power of photography is not diminished by the manipulation of the recorded image."

The last word on the subject should be that of the photographers—as George Hurrell said in a conversation we had: "There was such a dramatic quality in those days . . . we were all such romantics. The stars were really wonderful about stills . . . they'd cooperate. There wasn't any false pretense of 'dignity'—just a naturalness. They were electric, full of sexual qualities, alluring. Our world was a storybook —a romantic fantasy. We were talented. We were working. We were making money and assumed it would always be so. We didn't fret and worry about it like they do today. We were too busy being alive. We were the children of the gods."

STATEMENTS BY FIVE PHOTOGRAPHERS About Their Careers

ERIC CARPENTER (MGM)
I wasn't born with a camera in my hands. I got into the business out of necessity. Originally I was a plasterer. The money was good but work wasn't steady in the 30's, and my wife's mother didn't approve of me as a husband without better security. I went and got a job as an office boy at MGM in 1933. The chief of the studio's

police hired the office boys and my cousin, who was working there, told me, "Be sure you wear your best suit and your garters. There's nothing he hates more than sloppy socks." While I was working in the publicity department I'd started taking photographs for my own amusement, so when Howard Strickland asked me one day what I'd like to do and since I didn't have the

education to be a writer or publicist, I asked for a job in the photographic department. I became the assistant to Clarence S. Bull till I managed to get into the union. They accepted me on condition I stayed in the gallery and wouldn't become a unit photographer.

My first solo assignment, and this was a case of make or break, was to photograph Norma Shearer. If she approved I was in. Lucky for me she liked my photos. I went through a period of copying others. I learnt a lot by watching Hurrell and Bull, but my style was mostly the result of trial and error. I think the challenge in doing glamor photographs is harder today than it ever was. I had three electricians, hairdressers, costumers to help when it was a big star like Lana Turner. There'd even be a gal from the music department to play mood music when the star wanted it, and once they heard of one star doing it, they all wanted the same. I remember Lana wanted a full-length mirror alongside, and then they all wanted one. The only secret of good work was to get the star to have confidence in you so you could try and do something interesting. The stars were about the only ones who appreciated what you were trying to do. As far as the producers and executives were concerned, it was just publicity. They couldn't have cared less.

The problem in that sort of set-up was that all the pictures had to be shot with a light background, like glorified passport photos. The fight was always to get in some dark. Another irritation and restriction was that all the stills we took had to be sent to the Hays office, and at Metro, once you took the photos, they were out of your hands. You could give suggestions as to how you wanted them printed, but that was it. You were very limited by the studio's image of itself. The retouchers were the real artists in my opinion. They had about 22 of them working at MGM alone. They helped make the reality a dream.

Eventually I got fed up just taking portraits, and quit to go into the shipyard business with my brother, but after a couple of years I returned to the studio. They said, "But we can't give you a gallery, it will have to be unit work." Hell, that was OK with me. I'd been wanting to do unit publicity since I got there.

At last I had a chance to travel around the world. So it worked out very well.

CLARENCE S. BULL (MGM)

The Western artist Charlie Russell got me started on photography when I went to him hoping to learn how to paint. I bought my first Kodak back in 1912 with the money I made selling subscriptions to *The Saturday Evening Post*.

My first job was at the old Metro Studio, back in 1918, as an assistant cameraman. But in lulls between production I took still photos of the stars. These got me a job with Goldwyn as stills man.

In 1924 Metro merged with Goldwyn and I became the head of the still department. For over forty years I've photographed Hollywood's greatest stars. In portraits I have tried to capture a moment or mood unattainable with the motion-picture camera. I've also captured highlights in human experience that shall live with me as long as I can remember.

I never said "Hold it" or "Still, please." The face did that when it matched the inner mood. All I did was light that face and wait and watch, and when I saw the reflected mood I clicked the shutter. The most inspirational face I ever photographed belonged to Garbo.

BOB COBURN (RKO; UA; COLUMBIA)

I was taking pictures at ten on my father's ranch—from the saddle. In 1916, when I was sixteen, a company came to film *The Sunset Princess* on the ranch and all I did was get in the cameraman's hair from morning to night. The very next year, I was in Hollywood with Billy Beckay, learning.

We did everything, all sorts of trick photographs that were closely guarded secrets.

The main thing about my style was action. Even if it was a portrait, the feel of the picture had to have action in it. Those years in the 30's and 40's were the best . . . we were all learning at the same time; it was a real challenge. And we worked . . . I'd work all day in the lab and sleep on a cot. There were so many firsts—the first color pictures, the first color lab and the first sound pictures.

Glamor was the key—we were always trying to outglamor the others. It was a contest to see who could provide the most glamor . . . those beautiful pictures of beautiful women. We sat in from beginning to end on a movie. Our business was to sell that mystique . . . that appeal.

We were painting pictures with lights, not gimmicks, and a good photographer had to be just as good in the lab. The serious photographers became popular because they didn't mess up scenes, they just got their job done.

There's no reason to use most of the pictures they take today—that glamor is gone. There is no more fashion, no more glamor. How can you make that impact with snaps taken on the set?

BILL WALLING (PARAMOUNT; UNIVERSAL)

Very little is understood about what's really required to be a good portrait photographer in a theatrical set-up. Unless you have the capacity to form an opinion of those strangers who walk into your studio as to how they'll look best, you'll end up photographing them at a disadvantage. Not the real person, but what they should look like and how the public wants to see them—you only catch that flick of expression at the right moment with a squeeze of the shutter.

Glamor is simply what you'd expect to see in a beautiful woman—mesmerizing—the kind you can never approach in real life but can dream of on the screen. If you really looked at some of those dreamboats, you'd notice they have fannies on them you could drive railroad spikes with. We gave them that Aphrodite figure you think you saw on the screen.

Pictures would be nothing without the skill and excellence of the retouchers. It is such an important skill—you could do a complete reconstruction on somebody that way.

Of course, a big star isn't hard to make look good. There never was an outstanding portrait photographer who made a reputation on ugly people. I made my reputation photographing beautiful women, and they made my reputation.

LASZLO WILLINGER (MGM)

I started as a writer. I started illustrating my stories because I found out they'd sell faster. Then I discovered I could get more for my pictures than for my writing, and that was it!

One thing I always kept in mind was that regardless of your subject, whether it's a movie star or a box of matches, the photograph has a purpose . . . and that's to sell. I never lose sight of that. There are an awful lot of photographers who get too fascinated with themselves and do pictures solely to please themselves. That's a nice exercise, but I couldn't afford it.

I had no technique to speak of. The basic thing was to create that poster effect. The photograph has to stand on its own—without caption. If you have to explain it, it's not good. This is something I can verbalize today, but in those days I didn't know what I was about—I just felt it instinctively.

I never tried to consciously imitate something else—like painting. I grew up with painting and sculpture, but I never looked to them for influences on my work. I was only interested in the end result—the final photograph. Shooting the pictures was only half the work, the rest you do with the enlarger if you know how. Everyone kept telling me, "Don't waste all that time on them because nobody knows the difference."

I know the difference.

ALPHABETICAL LIST OF STARS

The book is arranged in the following large chronological divisions: the 1920s (pages 1–18), 1930–1935 (pages 19–82), 1936–1939 (pags 83–110) and the 1940s (pages 111–114). The letters A through E refer to the pictures in the Introduction.

PHOTOGRAPHIC
CREDITS

The letters A through E refer to the pictures in the Introduction. An asterisk indicates that the photographer is shown in the picture.

Alexander, Kenneth: 22, 55.

Apeda: 1.

Bachrach, Ernest A.: 49, 53, 58, 68, 69, 77–79, 104, 126, 127, 133, 139.

Beaton, Cecil: 19.

Bull, Clarence Sinclair: *frontispiece*, 38, 59, 72–76, 81, 82, 103, 128.

Carpenter, Eric: 92, 93, 118, 124, 141.

Coburn, Robert: E*, 83, 88, 95, 105.

Crail, Schuyler: D.

Cronenwerth: 136.

Duncan, Preston: 22.

Dyar, Otto: A*, 40-42, 48, 50, 60.

English, Don: 11, 20, 34, 36, 37.

Engstead, John: 102.

Fraker, Bud: 143.

Fryer, Elmer: 52.

Hesse, Paul: B*.

Hesser, Edwin Bower: 8, 15.

Hommel, George: 9, 17, 18, 51, 120.

Hurrell, George: D*, 23–31, 39, 54, 62–67, 70, 71, 84, 99, 111, 122, 123.

Jones, Ray: 80, 107, 144.

Keyes, Nelson Biddly: 14.

Kornman, Gene: 100, 125.

Lacy, Madison: 132.

Lippman, Irving: 44-46.

Louise, Ruth Harriet: 2, 6, 7, 13.

Rahmn, K. O.: 21.

Richee, Eugene Robert: 3-5, 10, 12, 16, 32, 33, 35, 43, 47, 56, 57, 61, 87, 91, 97, 106, 108, 114, 129-131.

Schafer, A. L. ("Whitey"): C*, 89, 119, 137, 138, 140, 142.

Six, Bert: 86.

Walling, William: 90.

Welbourne, Scotty: 116, 117.

Willinger, Laszlo: 85, 98, 101, 109, 110, 112, 113, 121.

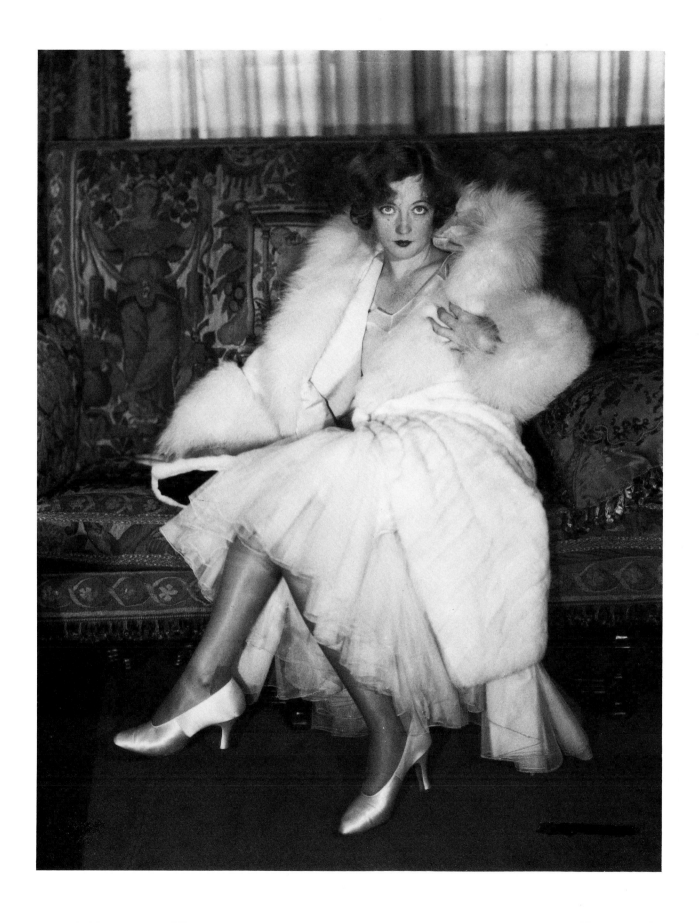

Marion Davies, 1928. Photo: Apeda, New York.

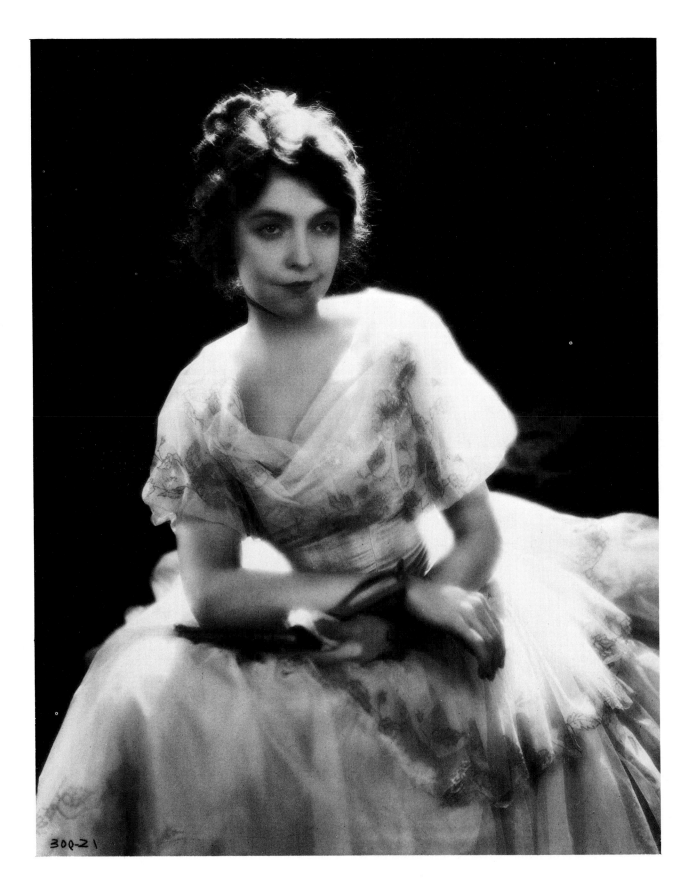

Lillian Gish, 1927. Photo: Ruth Harriet Louise, for MGM.
Costume by André-ani. Publicity shot for *The Wind*.

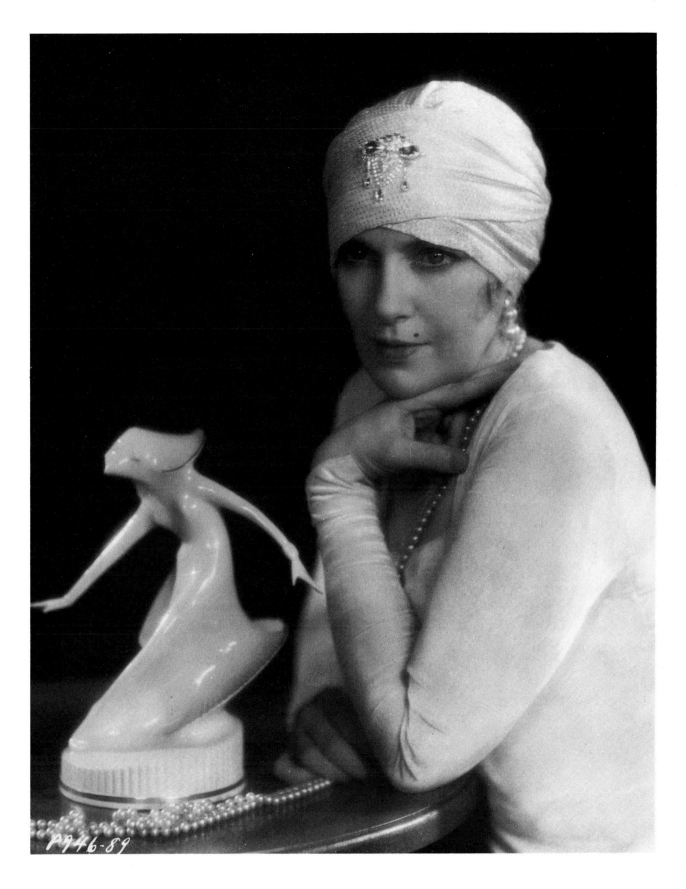

Olga Baclanova, 1927. Photo: Eugene Robert Richee, for
Paramount. Costume by Howard Greer.

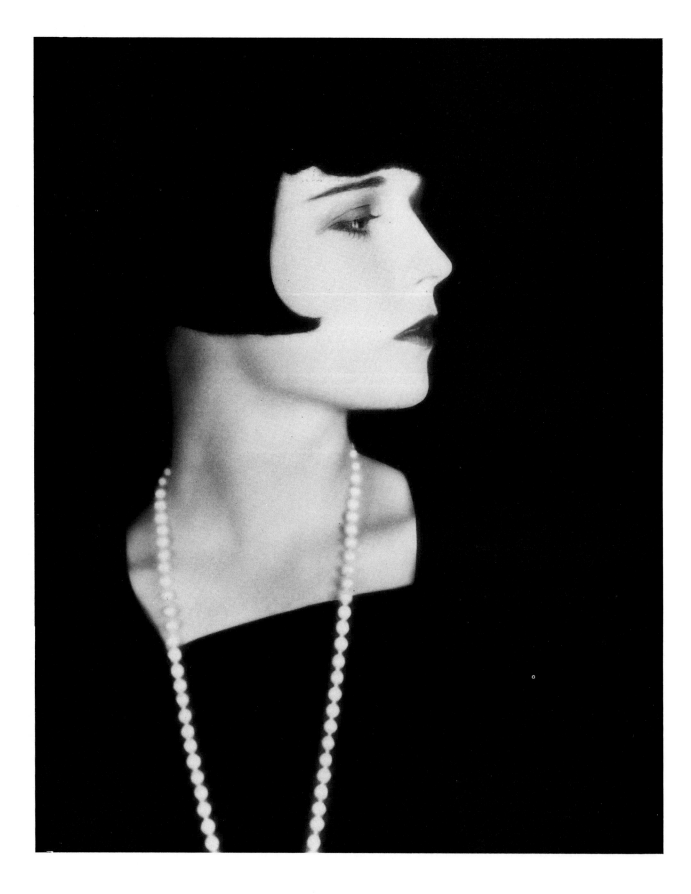

Louise Brooks, 1928. Photo: Eugene Robert Richee, for Paramount.

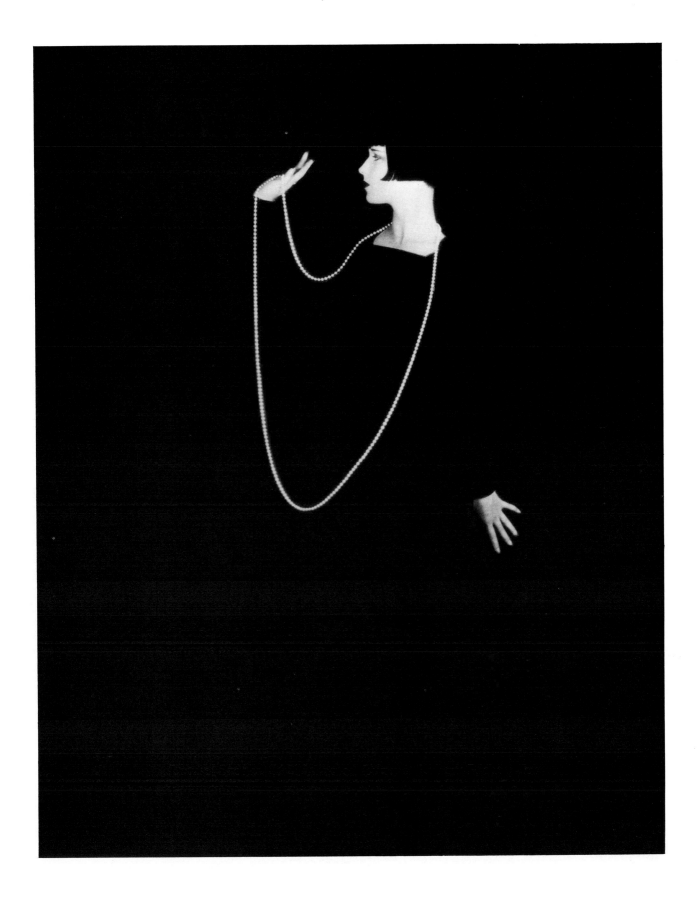

Louise Brooks, 1928. Photo: Eugene Robert Richee, for
Paramount.

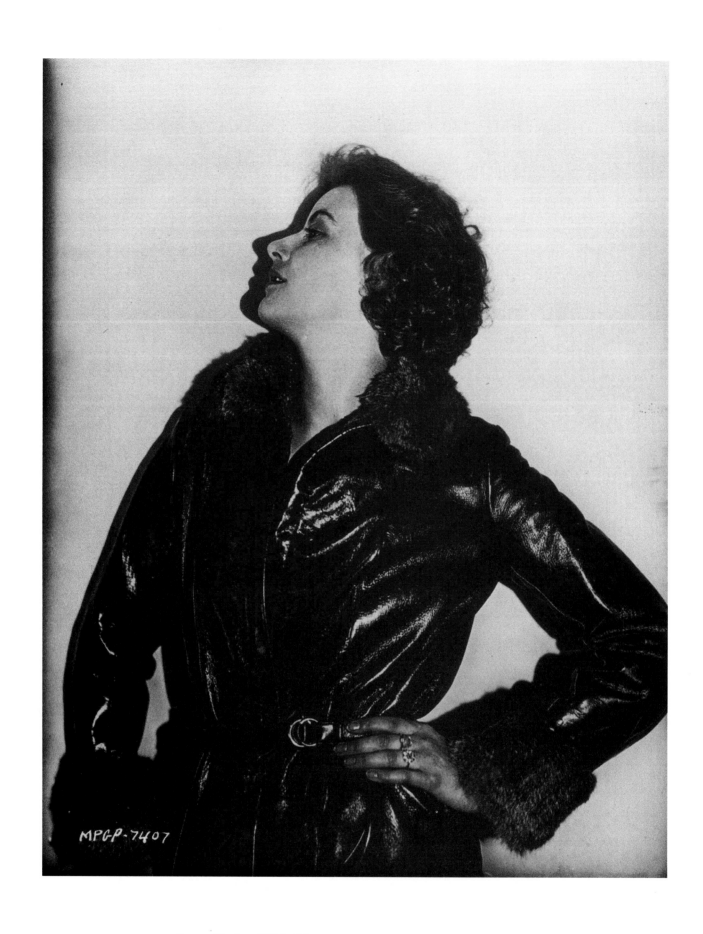

Greta Garbo, 1925. Photo: Ruth Harriet Louise, for MGM.

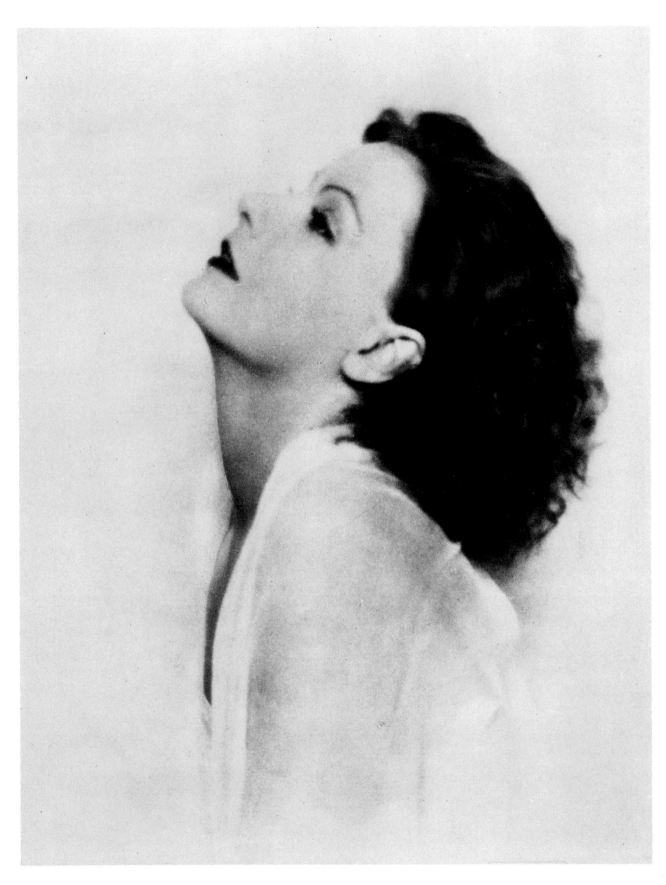

Greta Garbo, 1928. Photo: Ruth Harriet Louise, for MGM.
Publicity shot for *The Single Standard*.

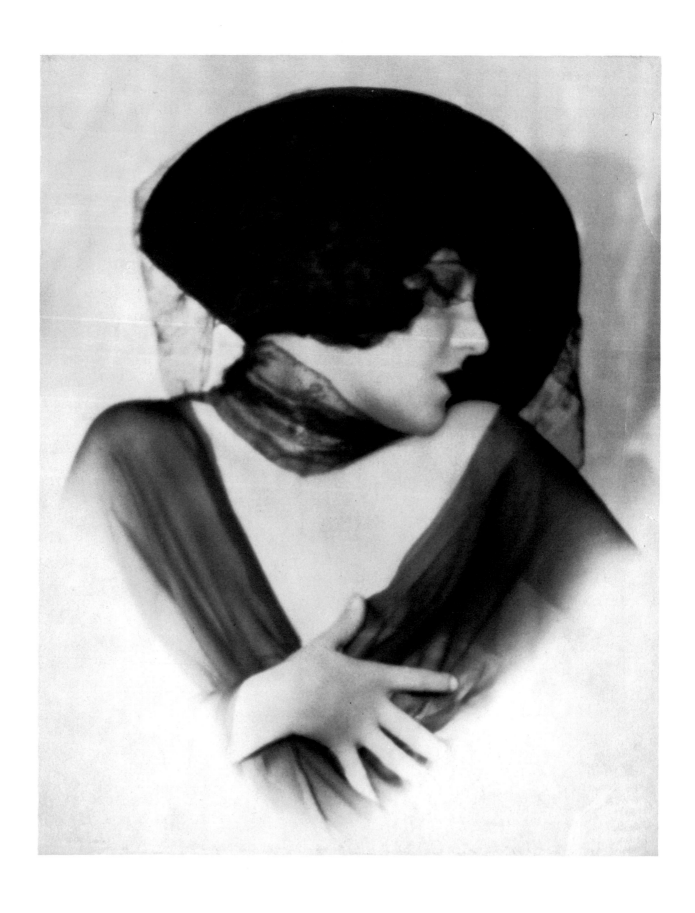

Gloria Swanson, 1924. Photo: Edwin Bower Hesser.

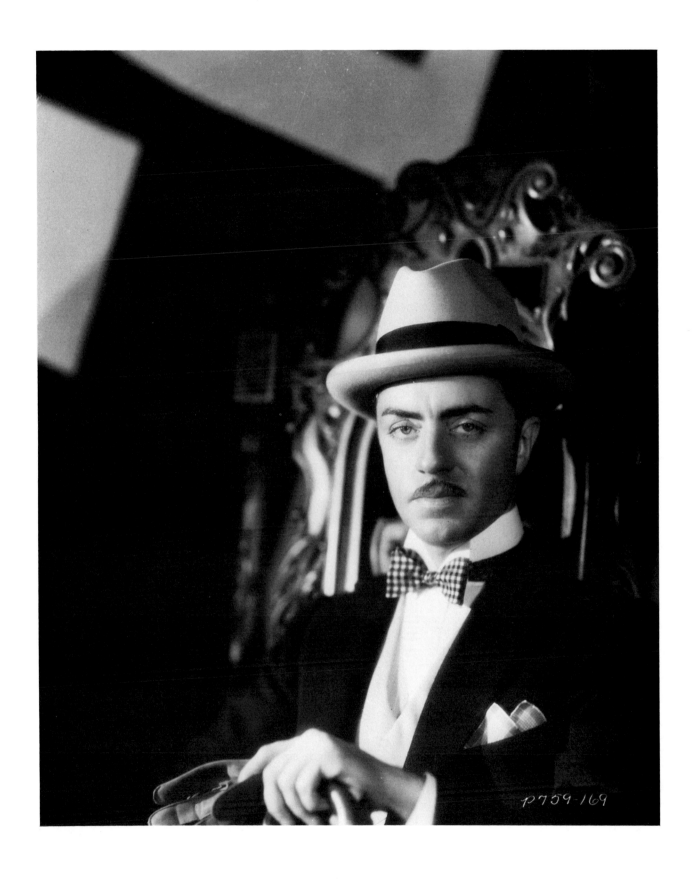

William Powell, 1929. Photo: George Hommel, for
Paramount.

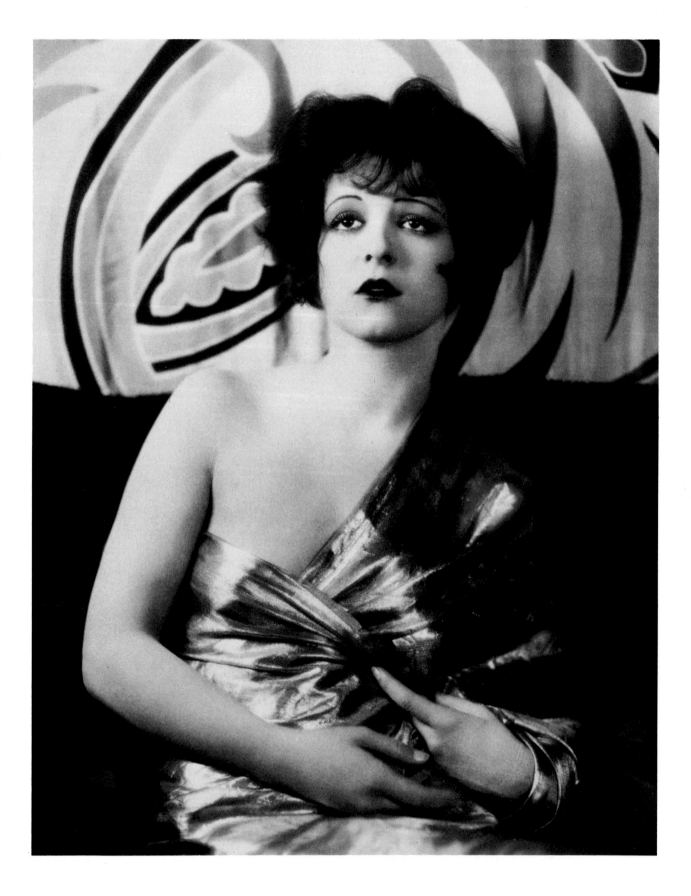

Clara Bow, 1926. Photo: Eugene Robert Richee, for
Paramount.

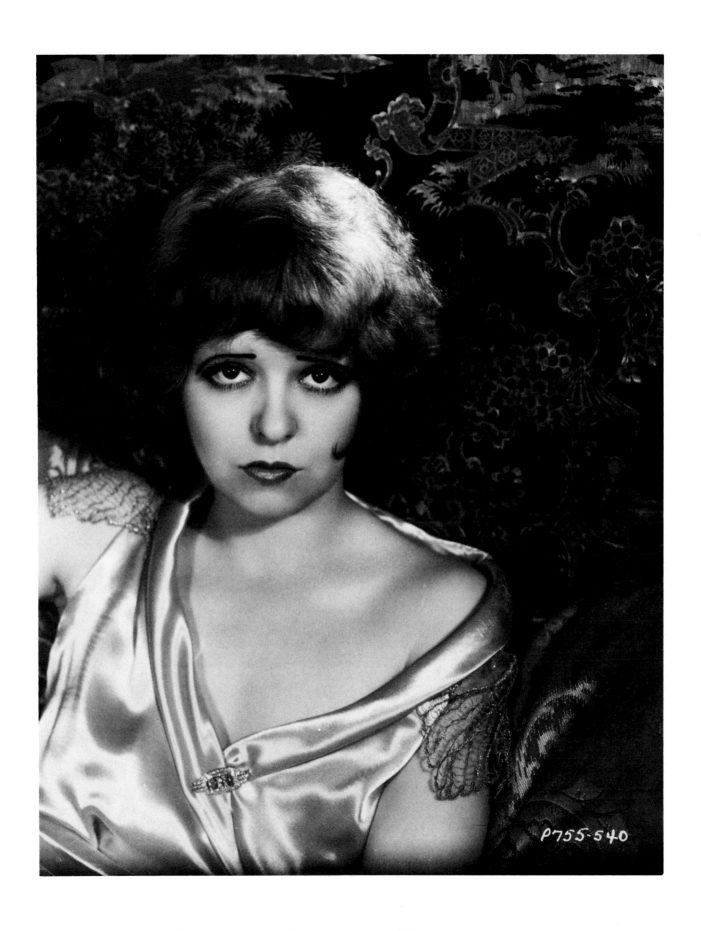

Clara Bow, 1928. Photo: Don English, for Paramount.

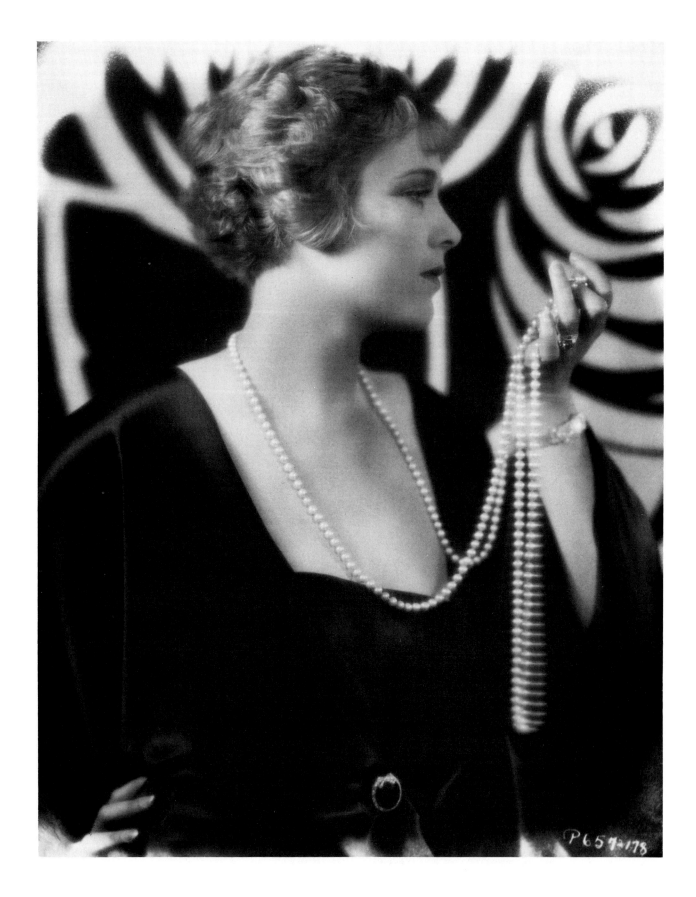

Esther Ralston, 1928. Photo: Eugene Robert Richee, for
Paramount.

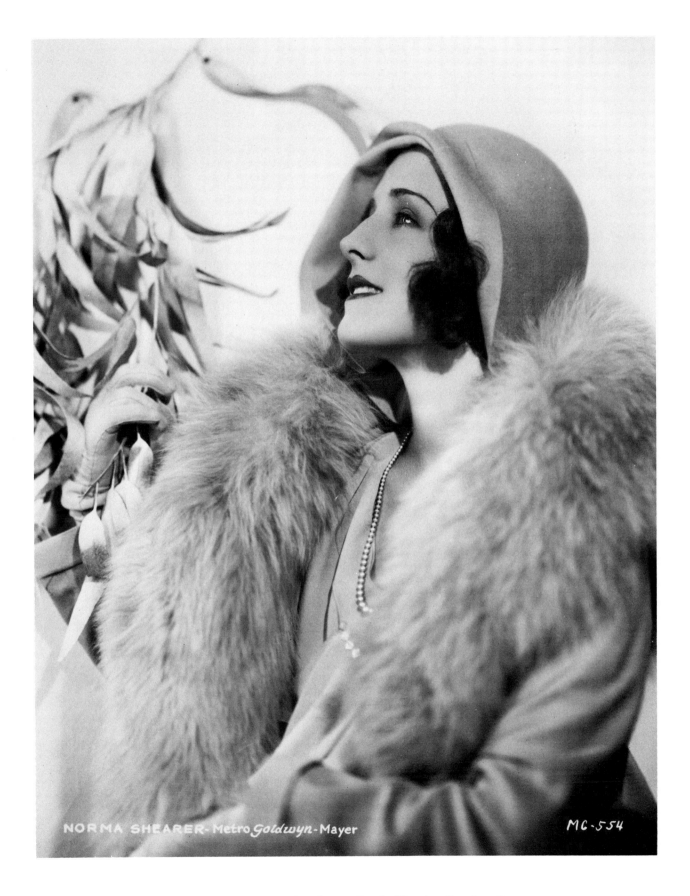

Norma Shearer, 1929. Photo: Ruth Harriet Louise, for
MGM.

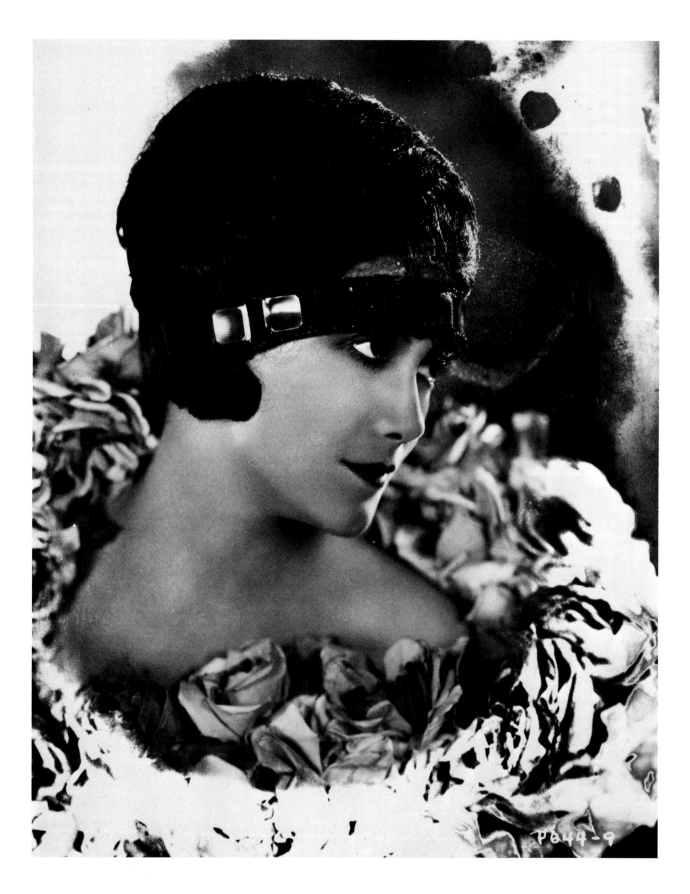

Jetta Goudal, 1924. Photo: Nelson Biddly Keyes, for
Paramount.

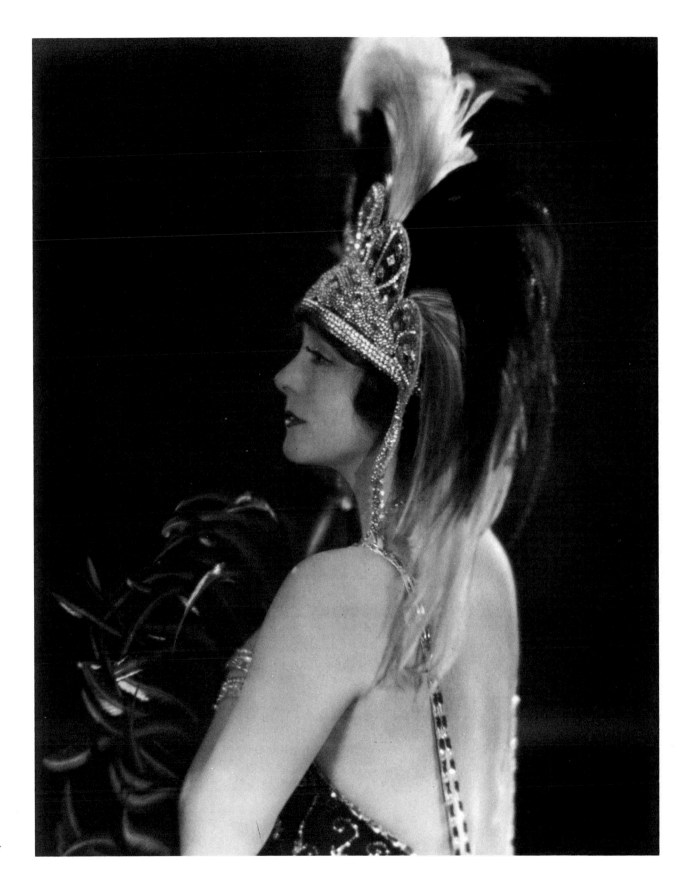

Irene Rich, 1926. Photo: Edwin Bower Hesser, for Warner
Bros. Publicity shot for *My Official Wife*.

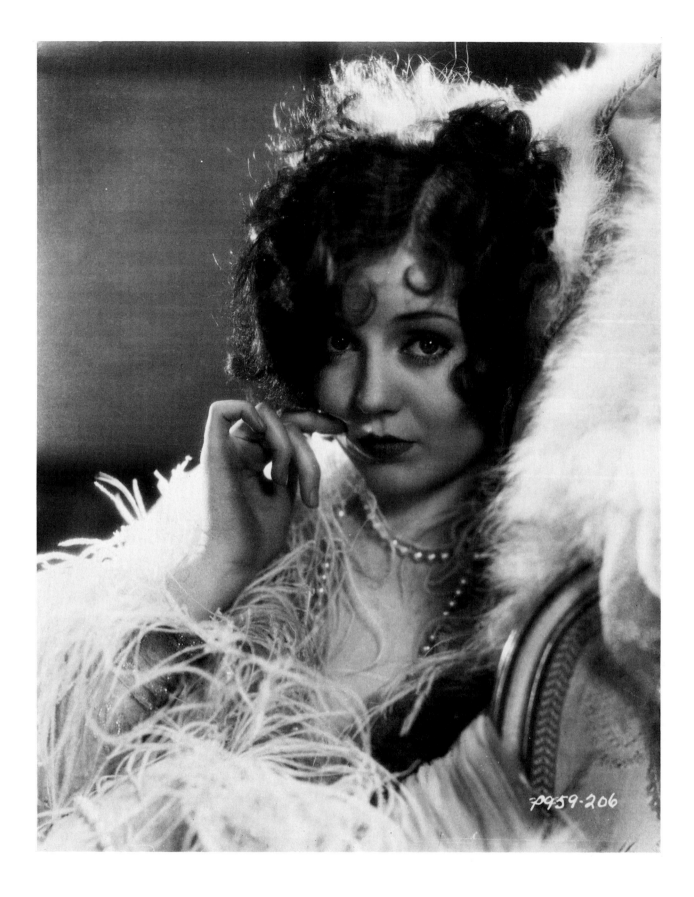

Nancy Carroll, 1929. Photo: Eugene Robert Richee, for
Paramount. Publicity shot for *Shopworn Angel*.

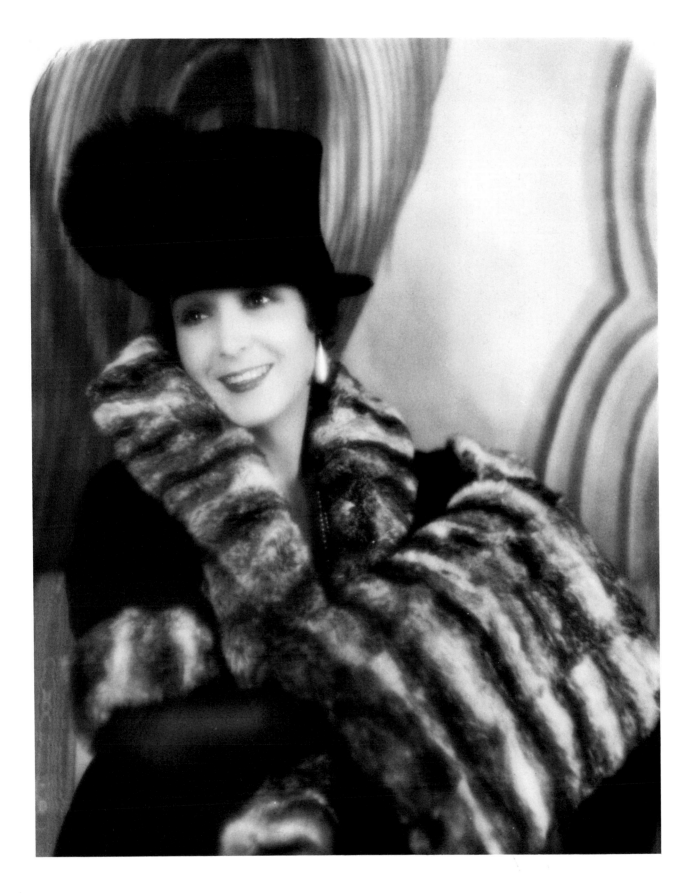

Florence Vidor, 1928. Photo: George Hommel, for
Paramount. Costume by Ali Hubert for *The Patriot*.

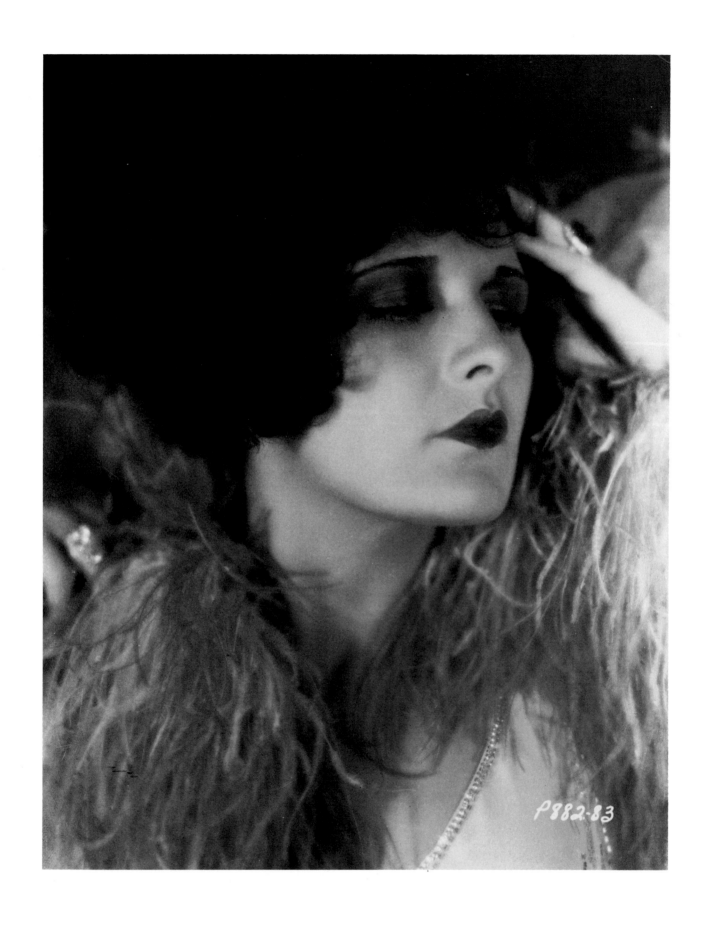

Evelyn Brent, 1929. Photo: George Hommel, for Paramount.

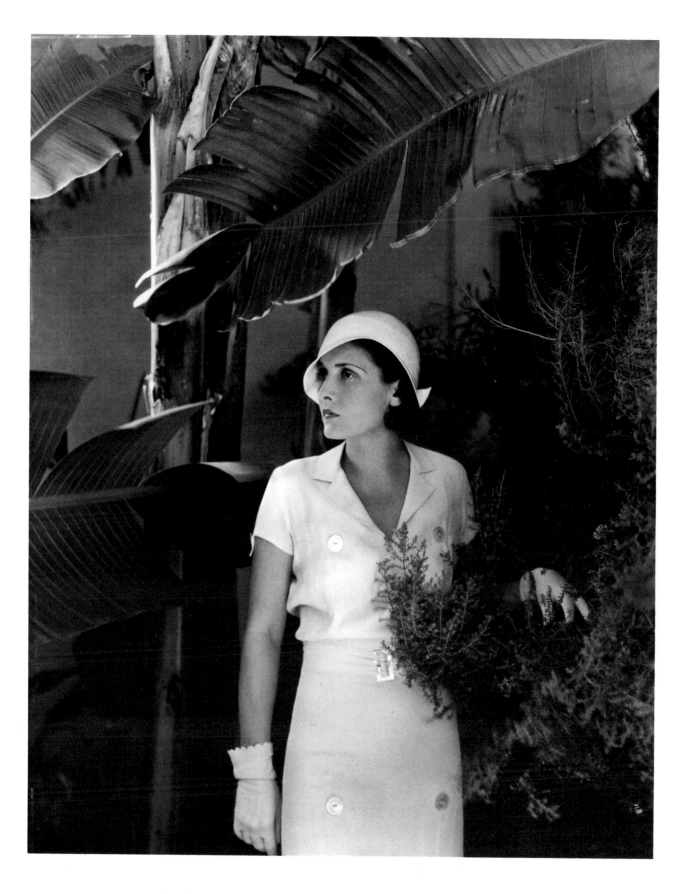

Evelyn Brent, 1930. Photo: Cecil Beaton. Costume by
Howard Greer.

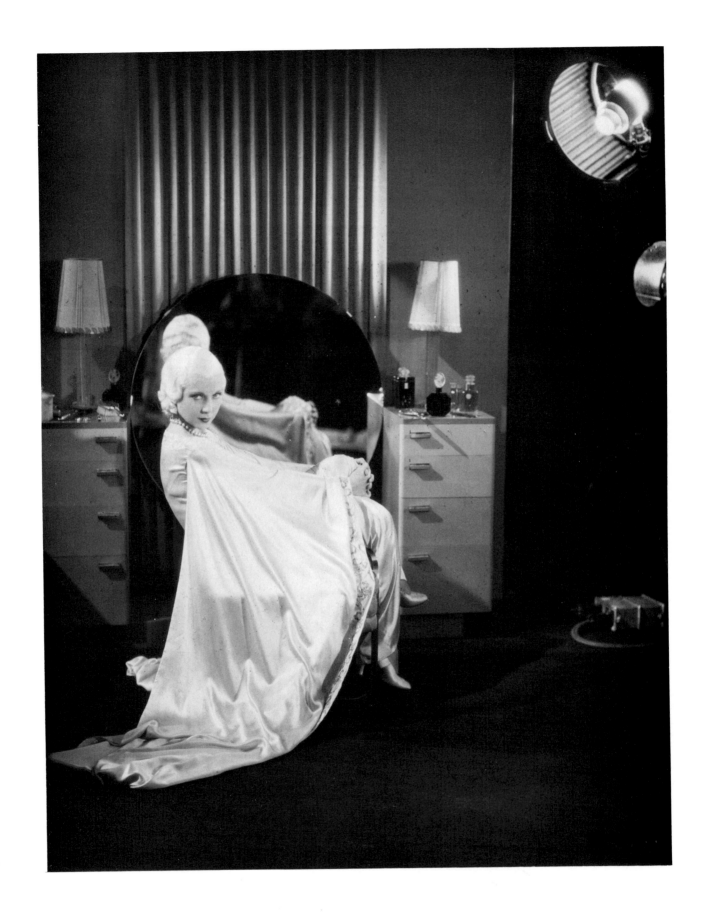

Lilyan Tashman, 1931. Photo: Don English, for Paramount.

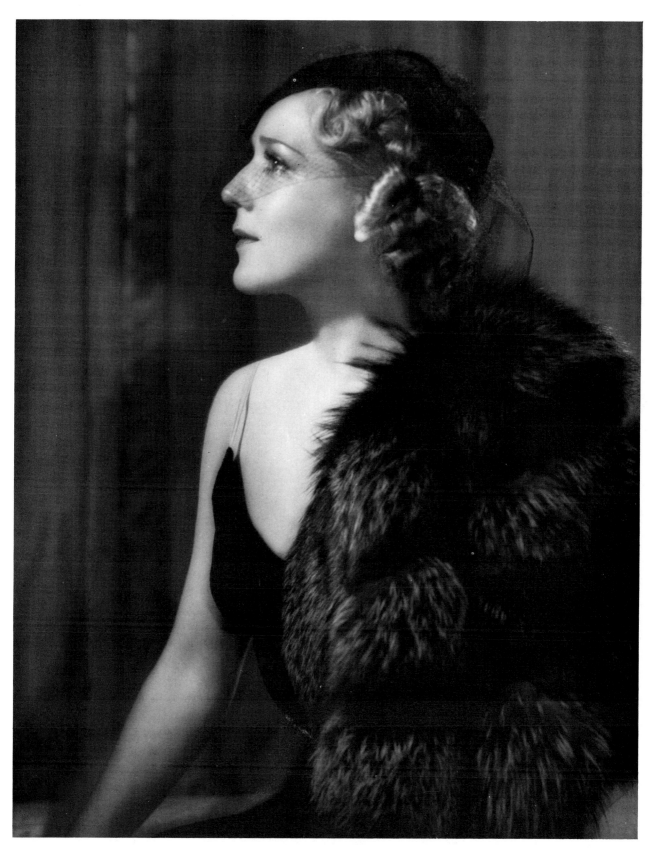

Mary Pickford, 1931. Photo: K. O. Rahmn, for her
productions at United Artists (to reveal sophisticated
hostess image).

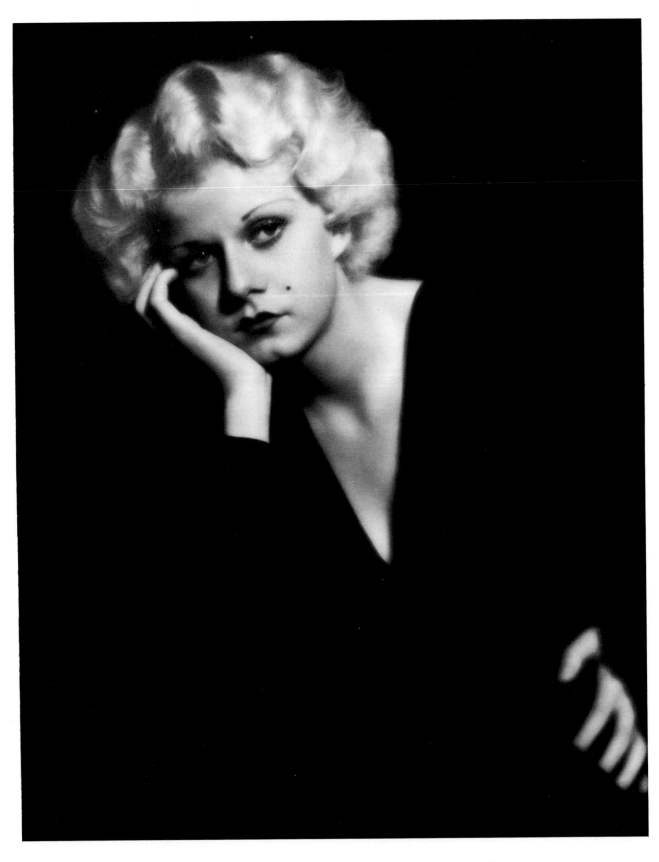

Jean Harlow, 1931. Photo: Preston Duncan or Kenneth
Alexander, for Columbia. Publicity shot for
Platinum Blonde.

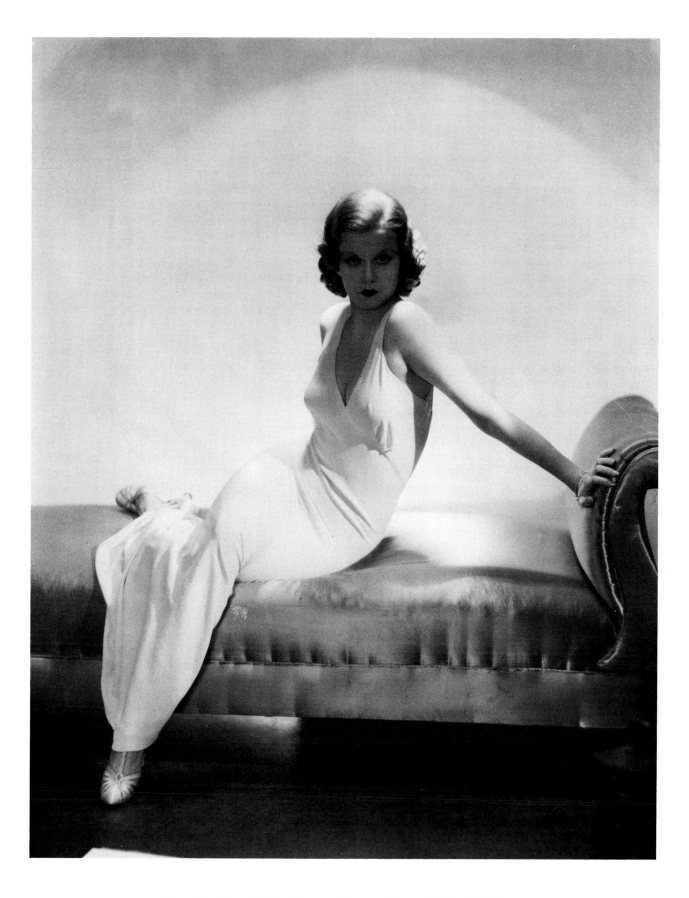

Jean Harlow, 1932. Photo: George Hurrell, for MGM.
Costume by Adrian. Publicity shot for *Red-Headed Woman*.

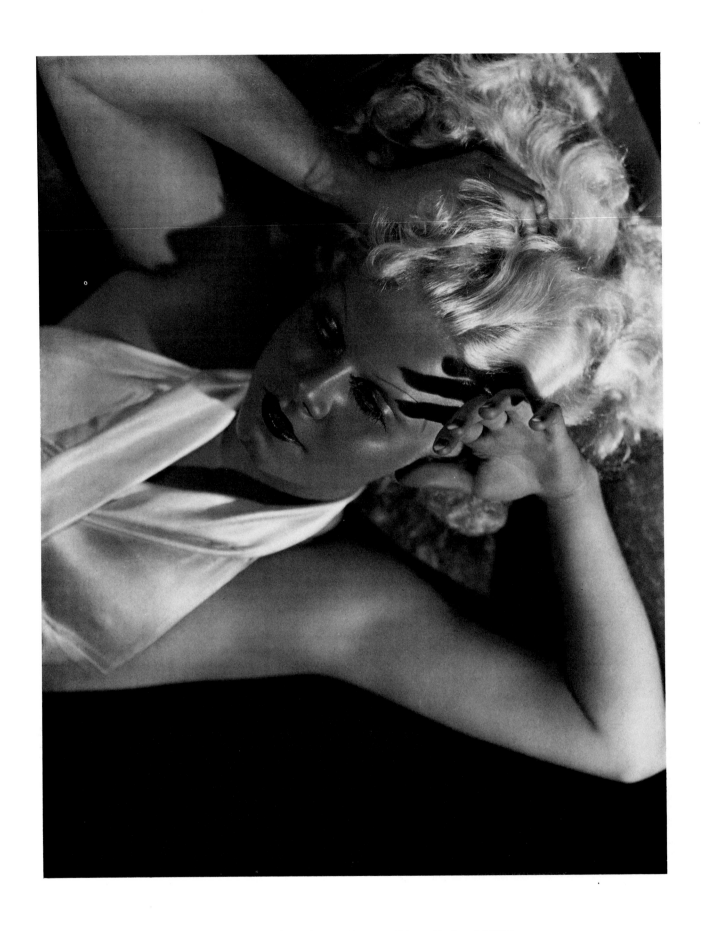

Jean Harlow, 1932. Photo: George Hurrell, for MGM.

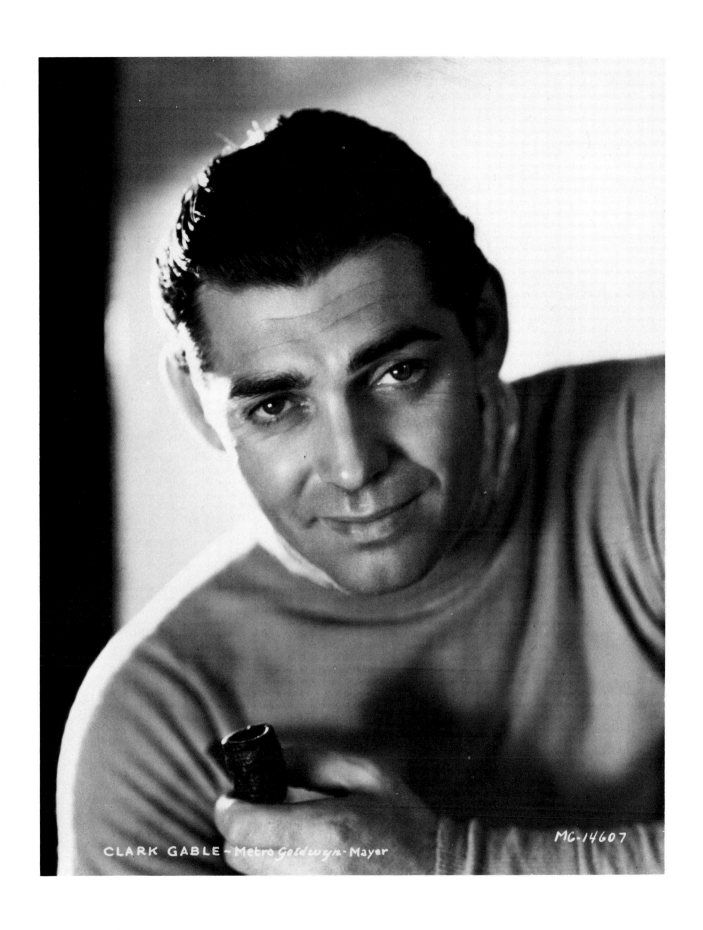

Clark Gable, 1931. Photo: George Hurrell, for MGM.

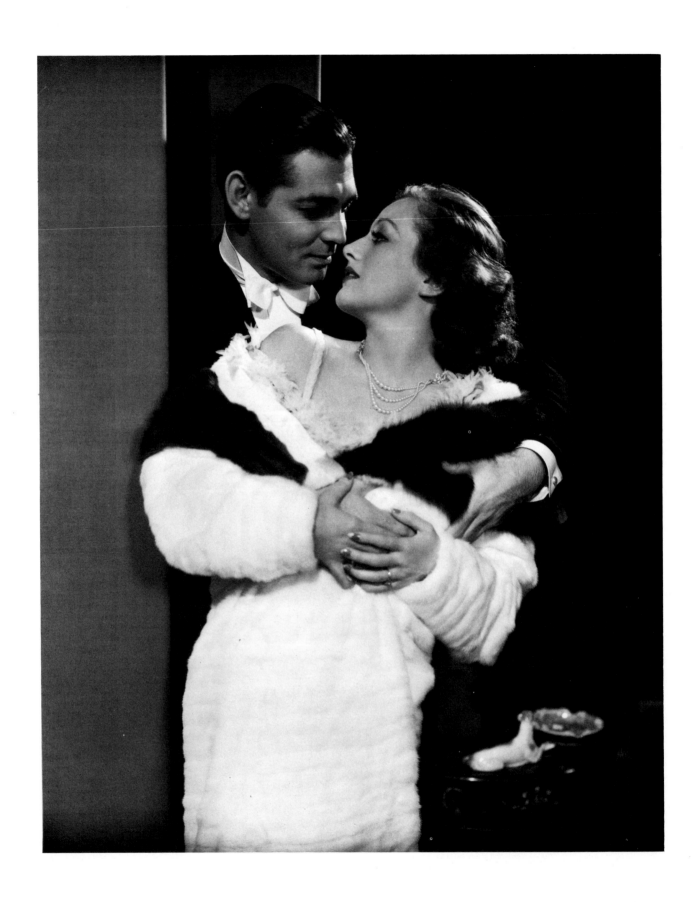

Clark Gable and Joan Crawford, 1931. Photo: George
Hurrell, for MGM. Publicity shot for *Possessed*.

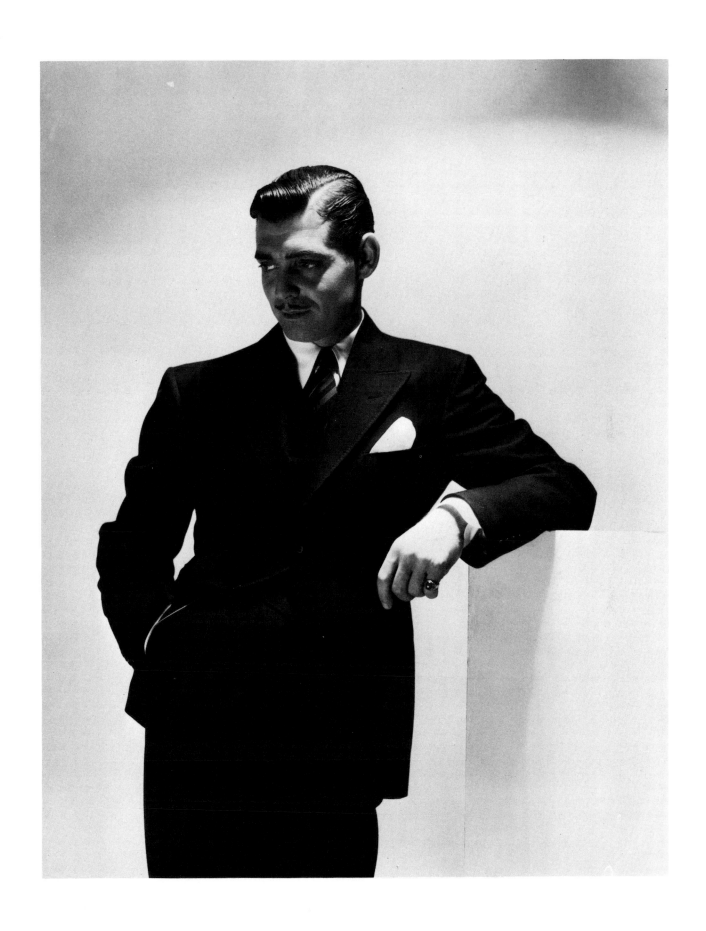

Clark Gable, 1933. Photo: George Hurrell, for MGM.

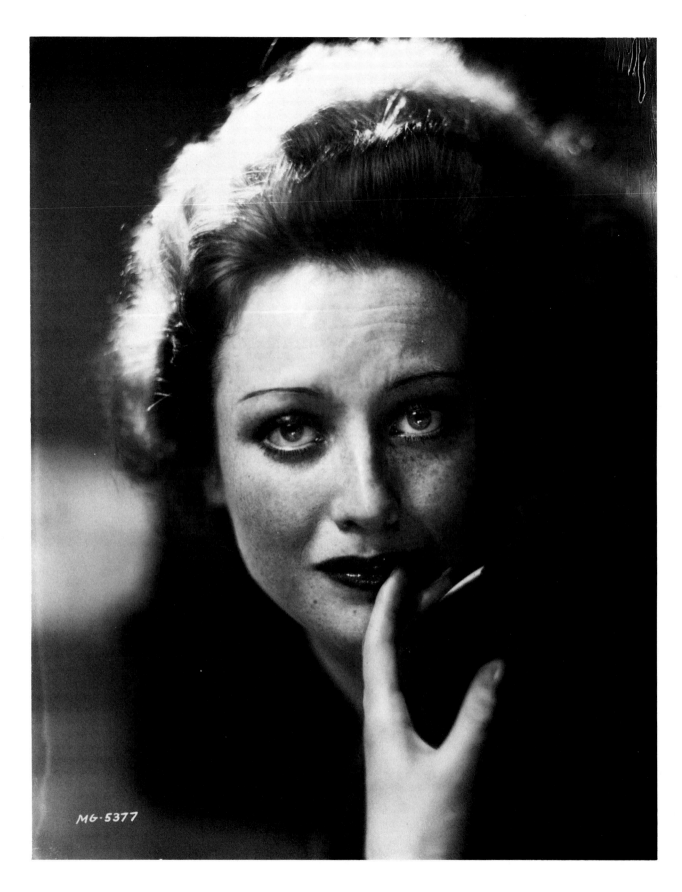

Joan Crawford, 1930. Photo: George Hurrell, for MGM.
Publicity shot for *Paid*.

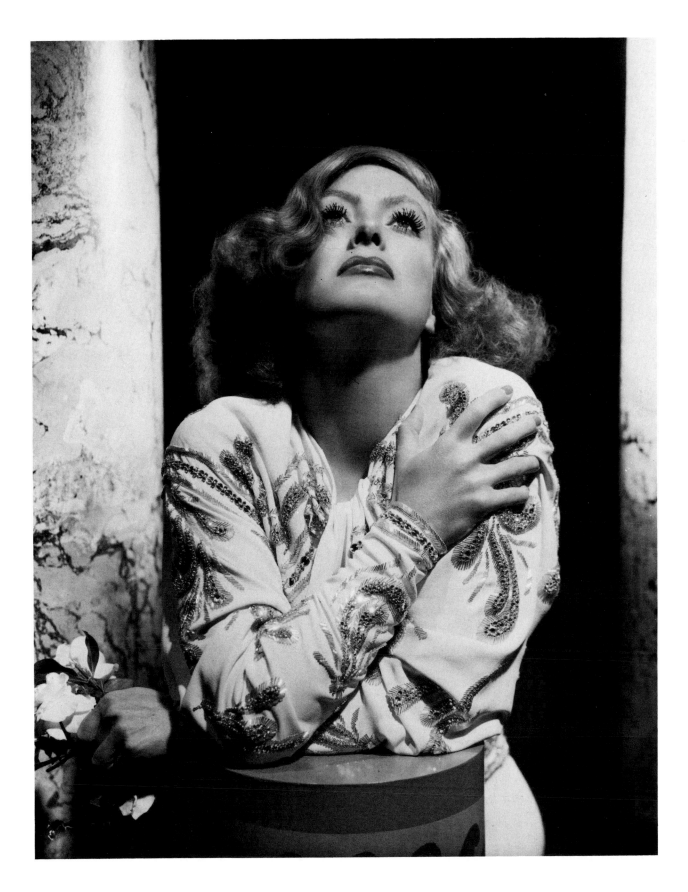

Joan Crawford, 1933. Photo: George Hurrell, for MGM.
Costume by Adrian.

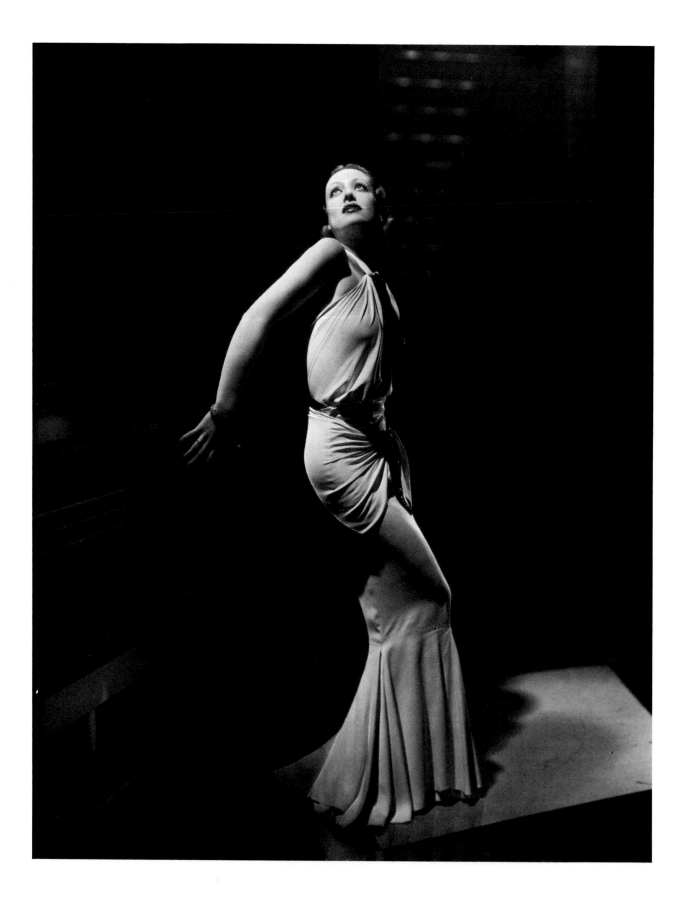

Joan Crawford, 1932. Photo: George Hurrell, for MGM.
Costume by Adrian. Publicity shot for *Letty Lynton*.

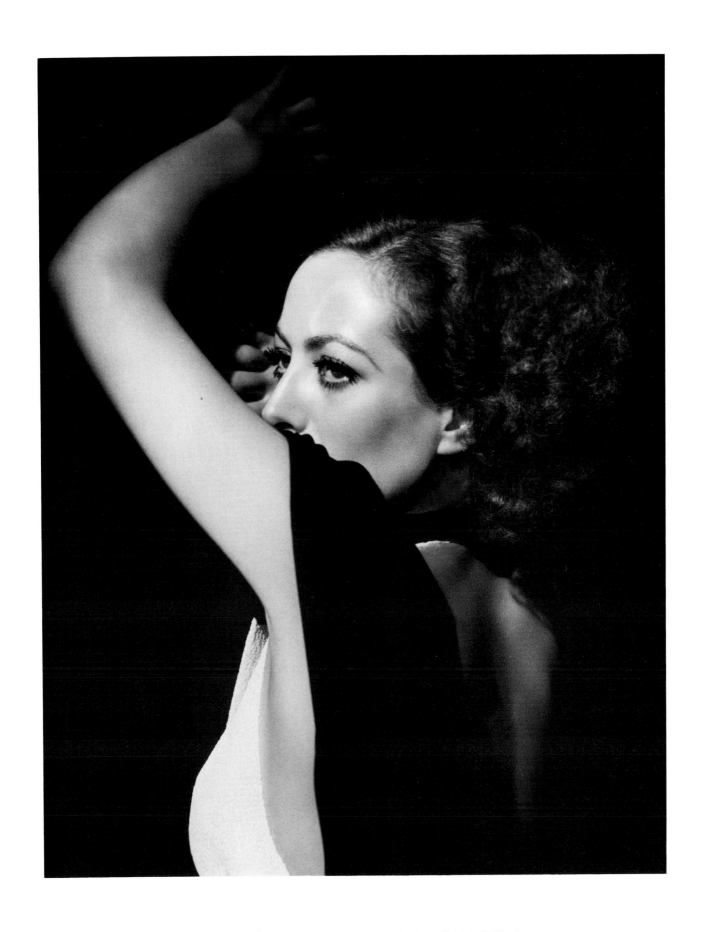

Joan Crawford, 1933. Photo: George Hurrell, for MGM.

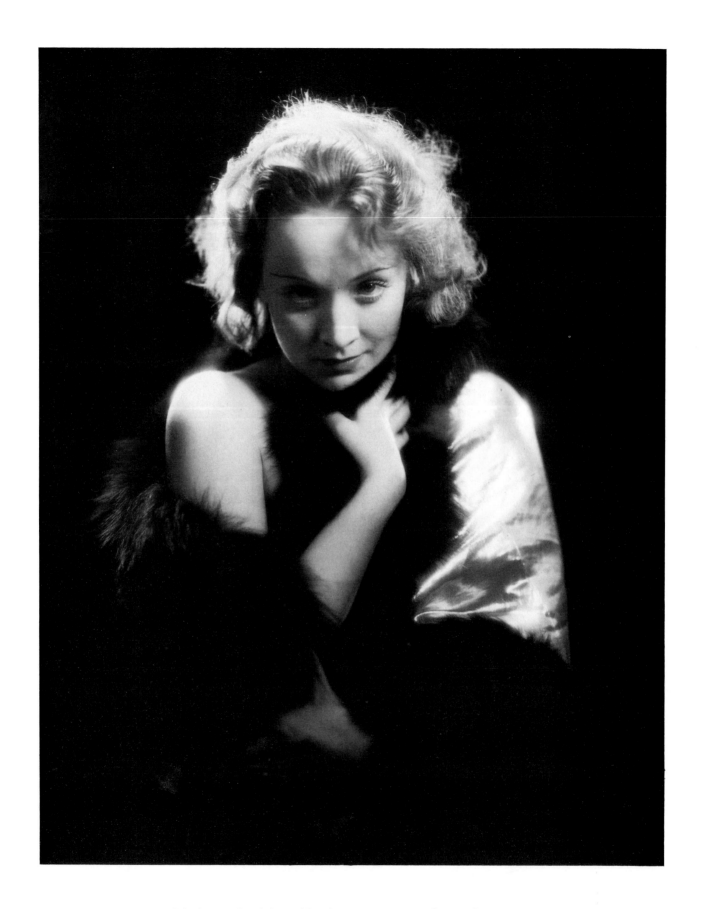

Marlene Dietrich, 1930. Photo: Eugene Robert Richee, for
Paramount.

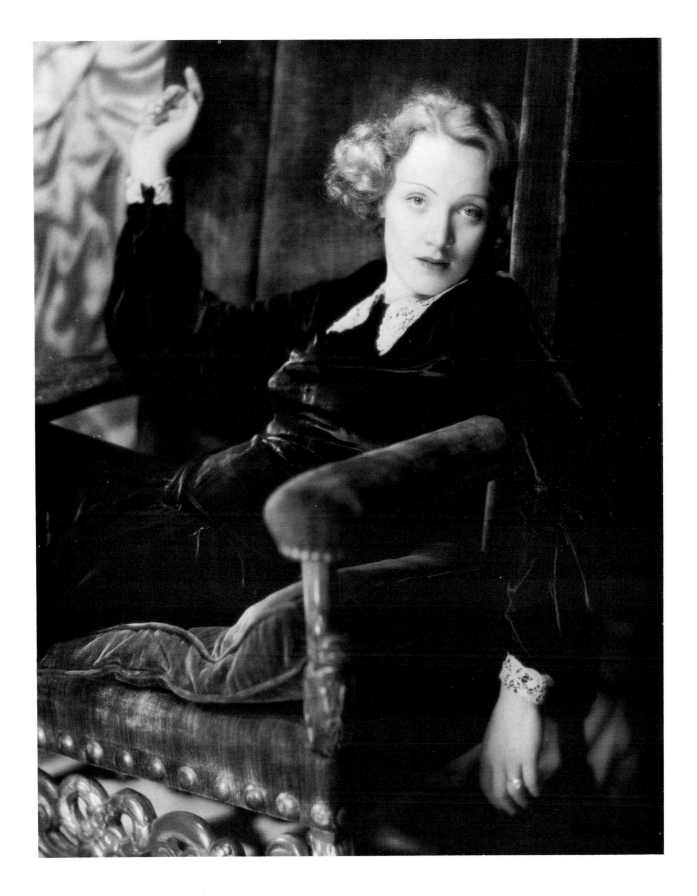

Marlene Dietrich, 1930. Photo: Eugene Robert Richee, for
Paramount.

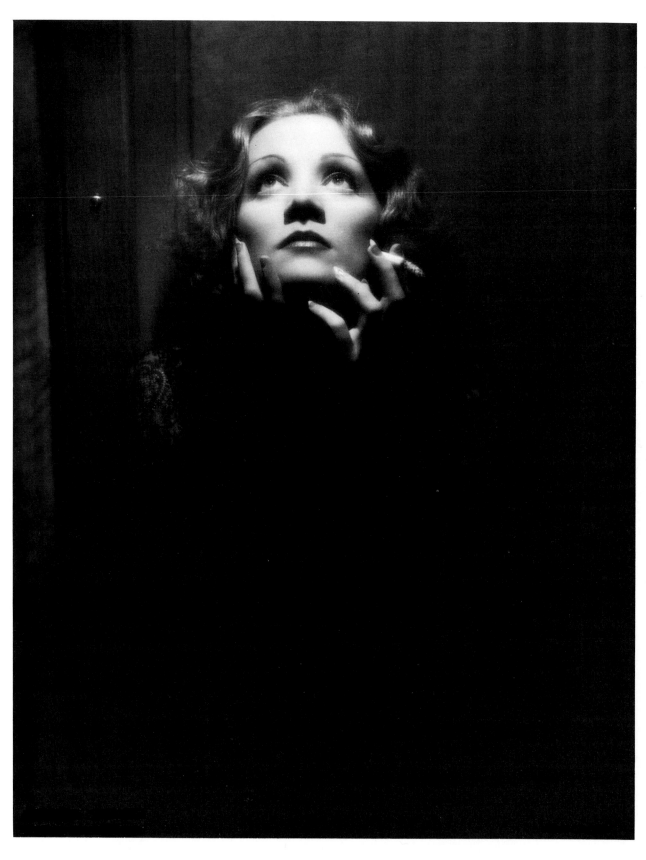

Marlene Dietrich, 1932. Photo: Don English, for Paramount.
Lighting: Josef von Sternberg. Costume by Travis Banton.
Publicity shot on the set of *Shanghai Express*.

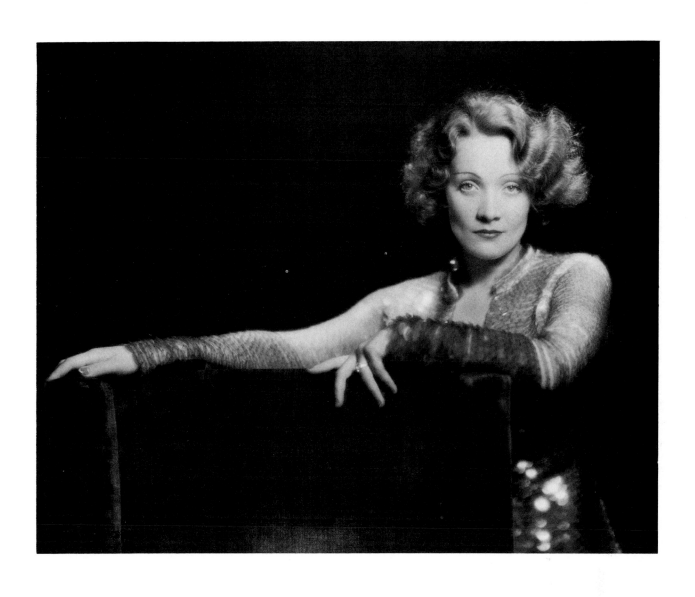

Marlene Dietrich, 1931. Photo: Eugene Robert Richee, for Paramount. Costume by Travis Banton. Publicity shot for *Dishonored*.

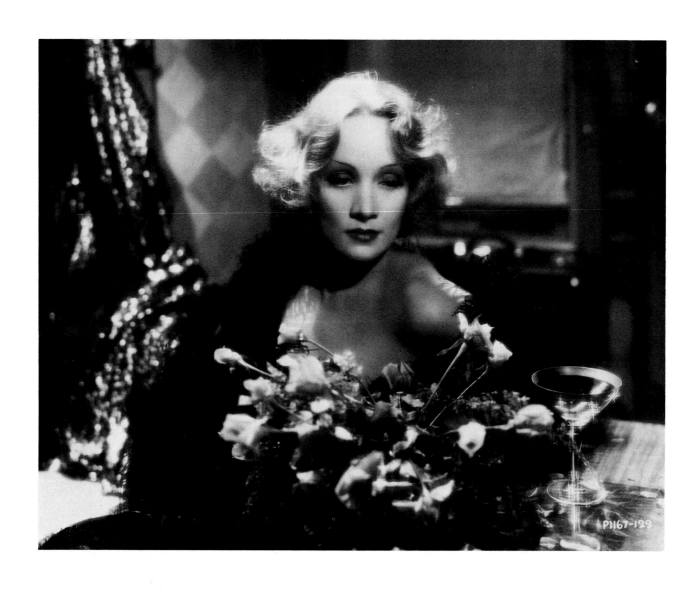

Marlene Dietrich, 1932. Photo: Don English, for Paramount.
Lighting and set-up: Josef von Sternberg. Costume by
Travis Banton. Publicity shot for *Shanghai Express*.

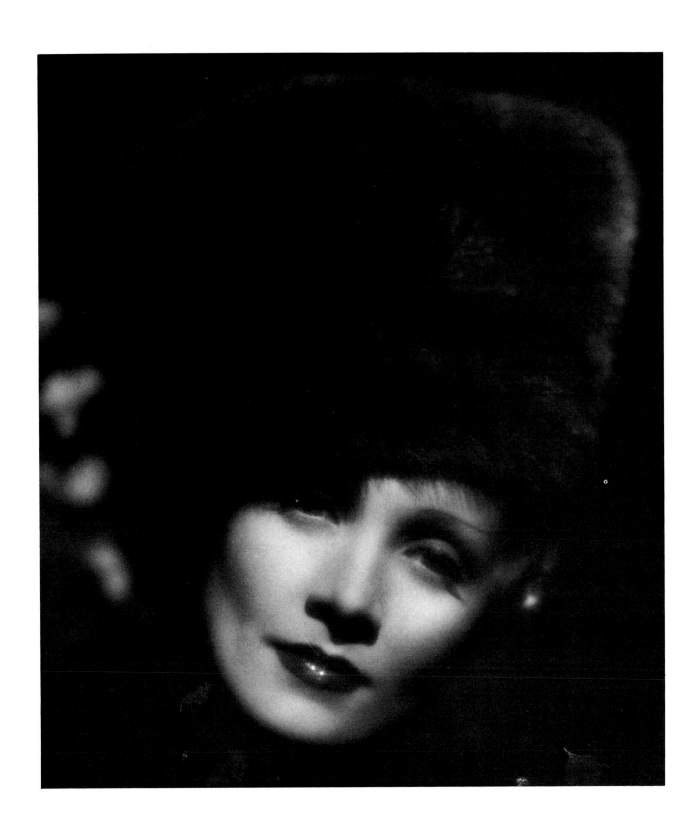

Marlene Dietrich, 1934. Photo: Don English, for Paramount.
Publicity shot for *The Scarlet Empress*.

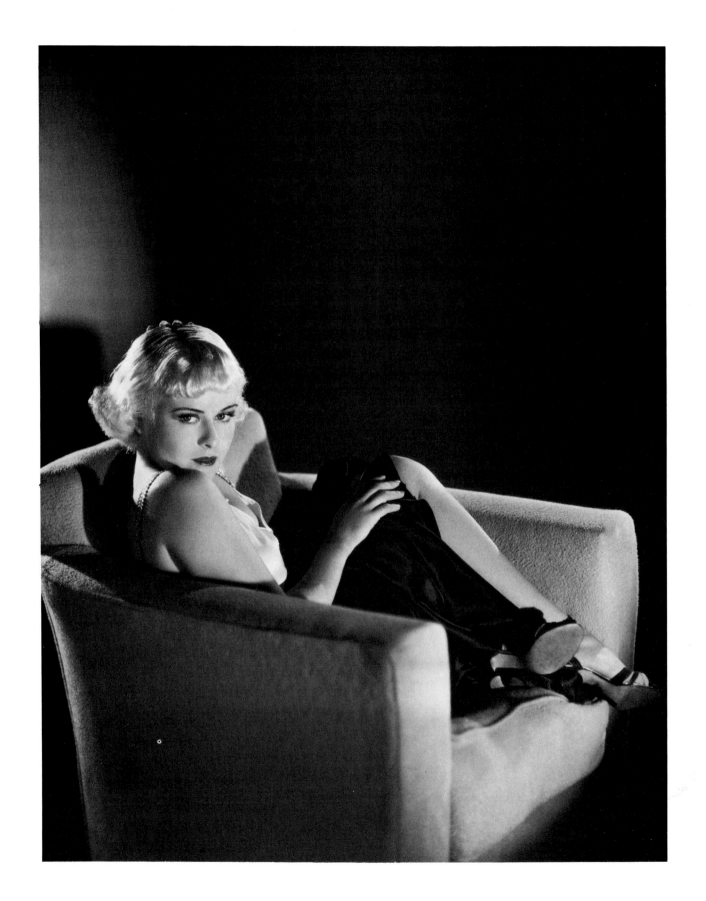

Paulette Goddard, an unlikely blonde, 1932. Photo:
Clarence Sinclair Bull, for MGM.

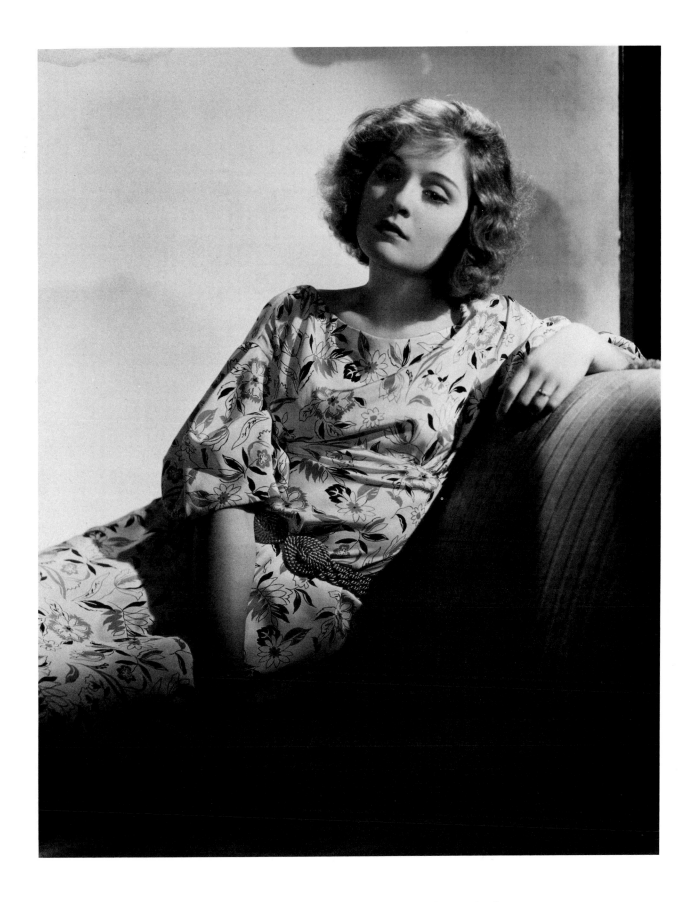

Anna Sten, 1934. Photo: George Hurrell, for United
Artists (Goldwyn). Costume by Omar Kiam.

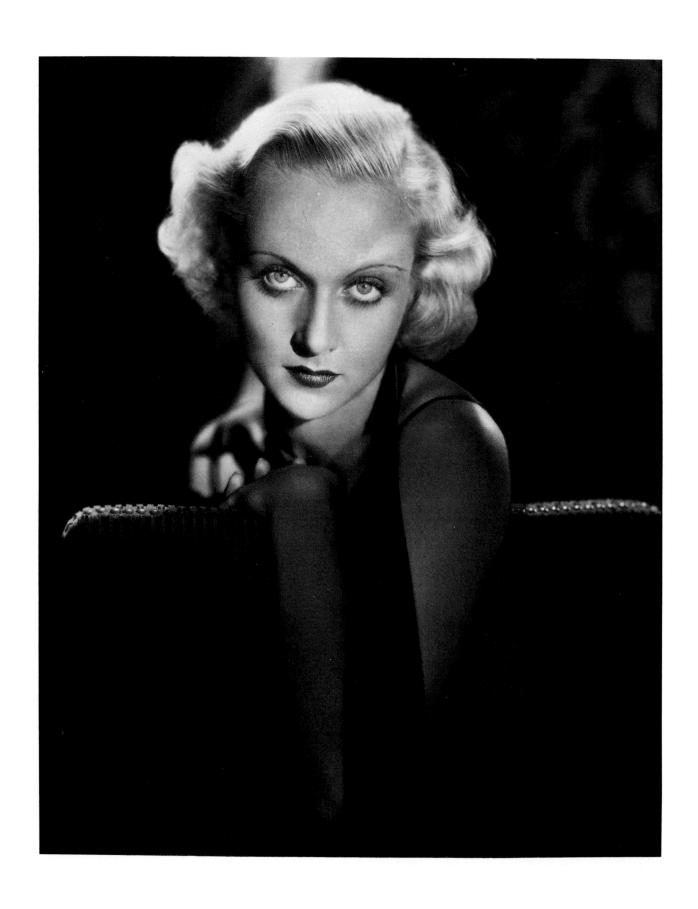

Carole Lombard, 1932. Photo: Otto Dyar, for Paramount.

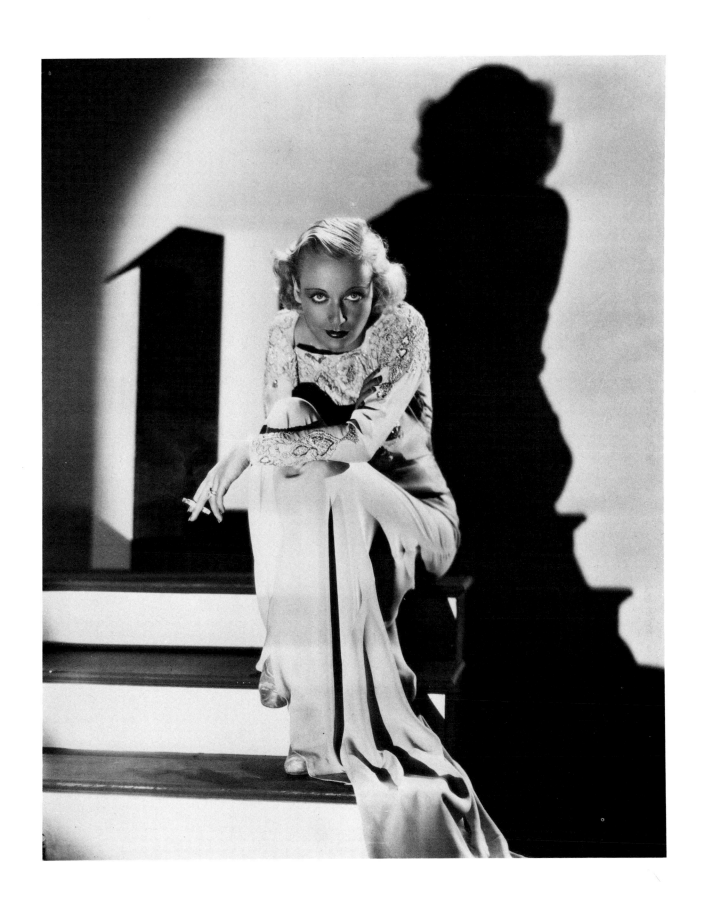

Carole Lombard, 1932. Photo: Otto Dyar, for Paramount.

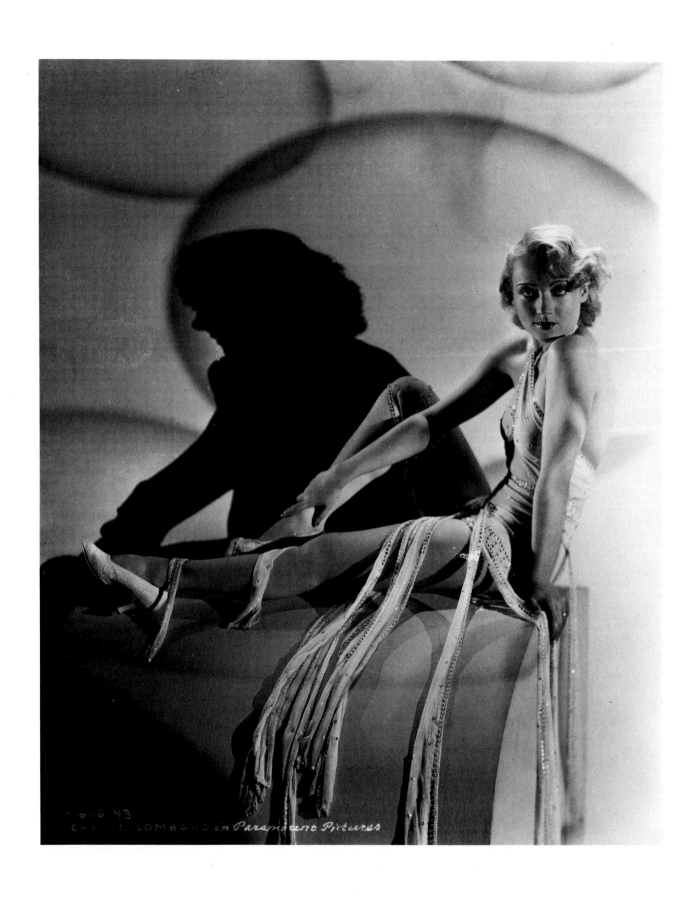

Carole Lombard, 1931. Photo: Otto Dyar, for Paramount.

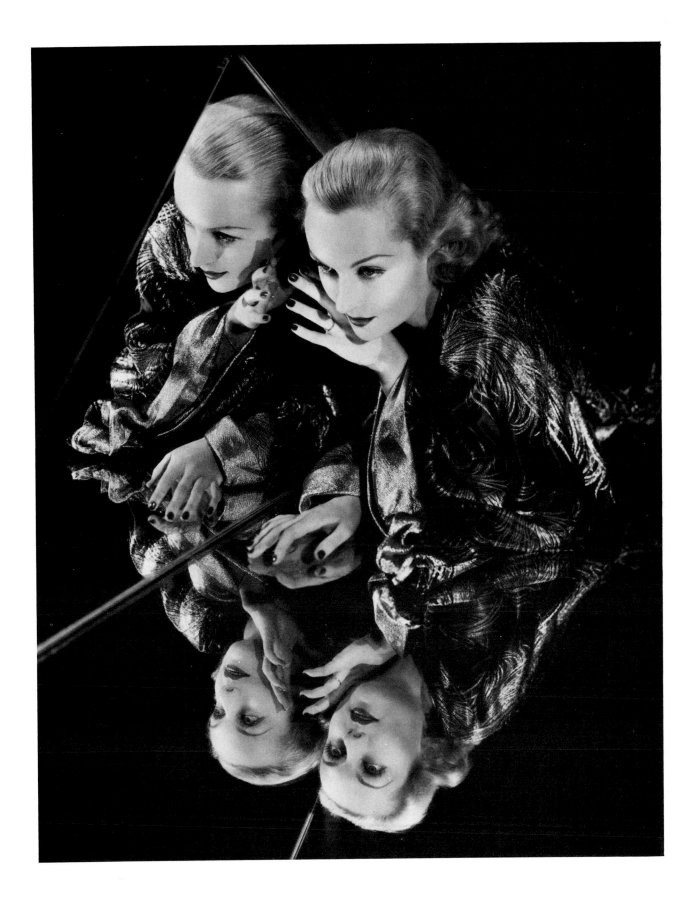

Carole Lombard, 1935. Photo: Eugene Robert Richee,
for Paramount. Wardrobe by Travis Banton.

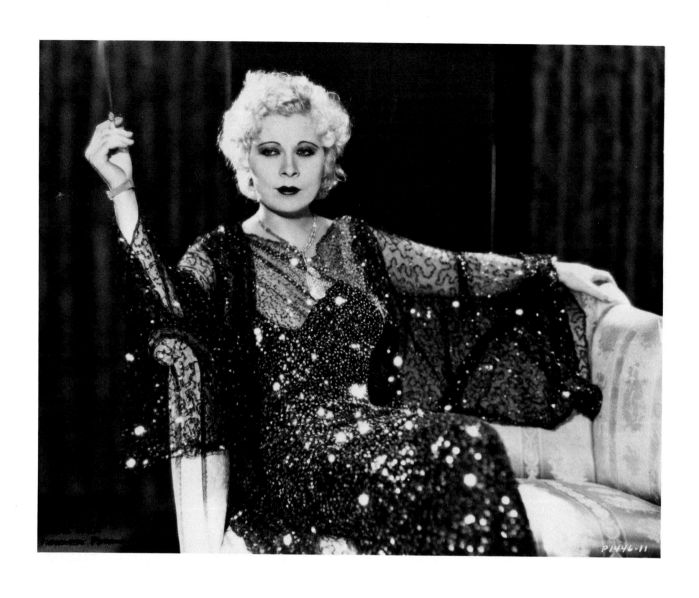

Mae West, 1932. Photo: Irving Lippman, for Paramount.
Publicity shot for *Night after Night*.

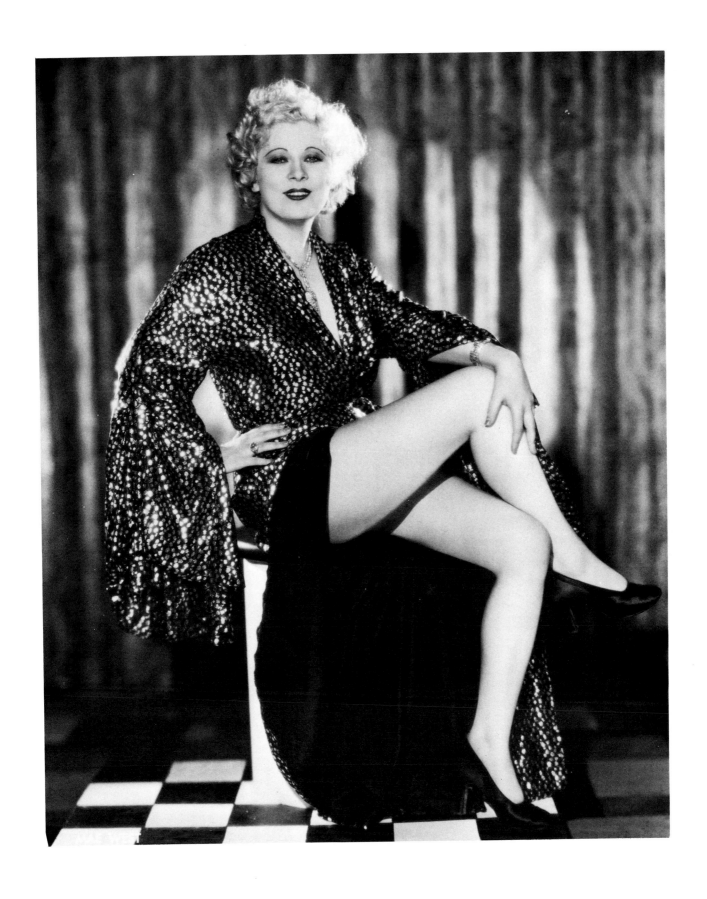

Mae West, 1932. Photo: Irving Lippman, for Paramount.
Leg art for her film debut in *Night After Night*.

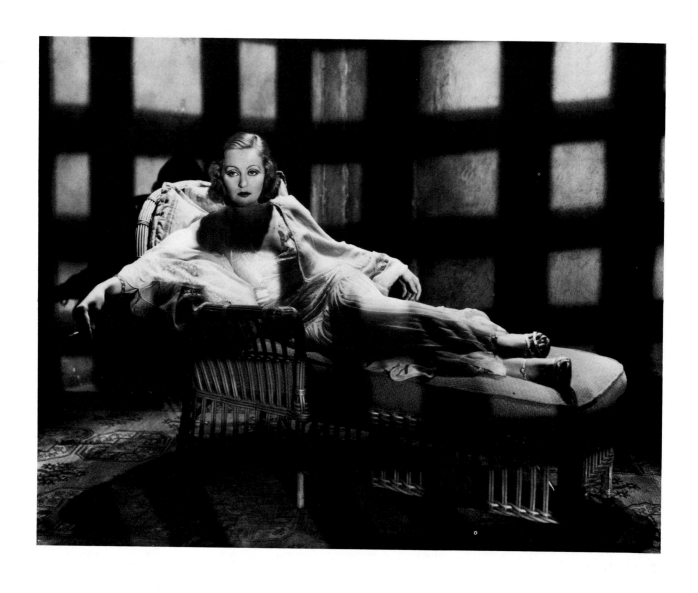

Tallulah Bankhead, 1932. Photo: Irving Lippman, for
Paramount. Costume by Travis Banton. Publicity shot for
Thunder Below.

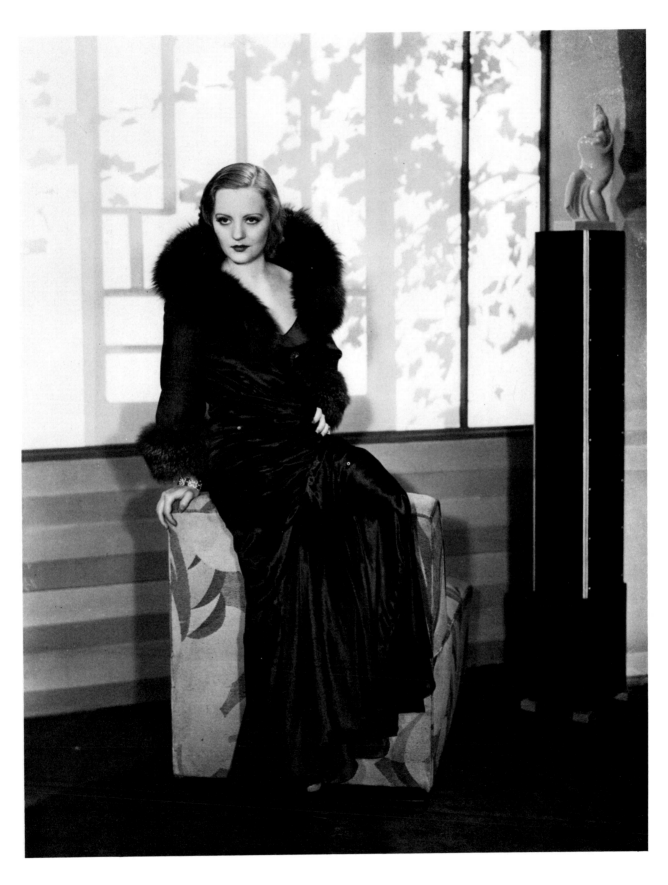

Tallulah Bankhead, 1931. Photo: Eugene Robert Richee, for Paramount. Costume by Travis Banton.

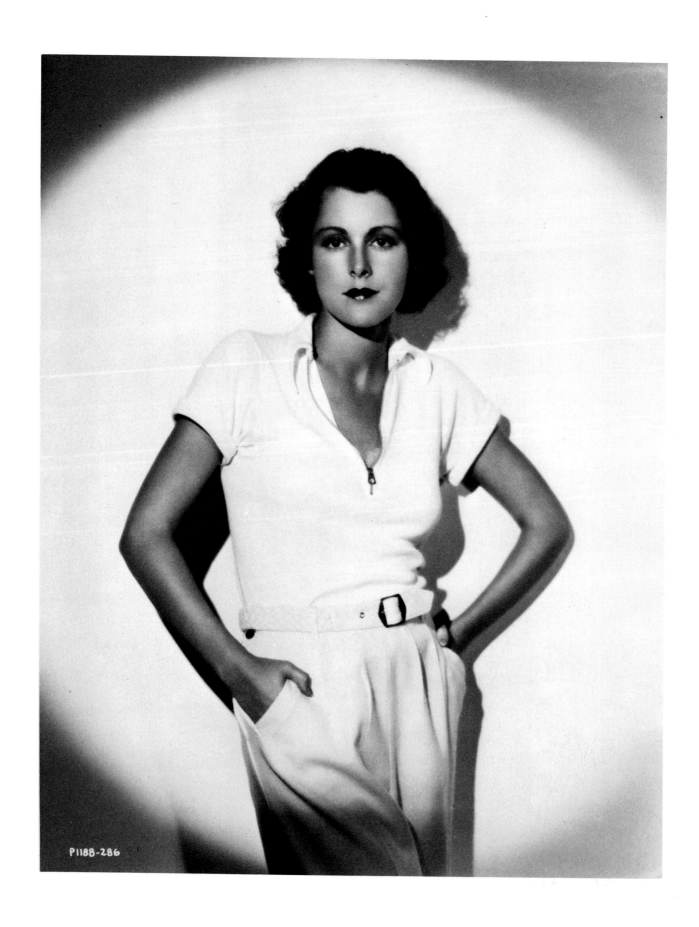

Frances Dee, 1932. Photo: Otto Dyar, for Paramount.

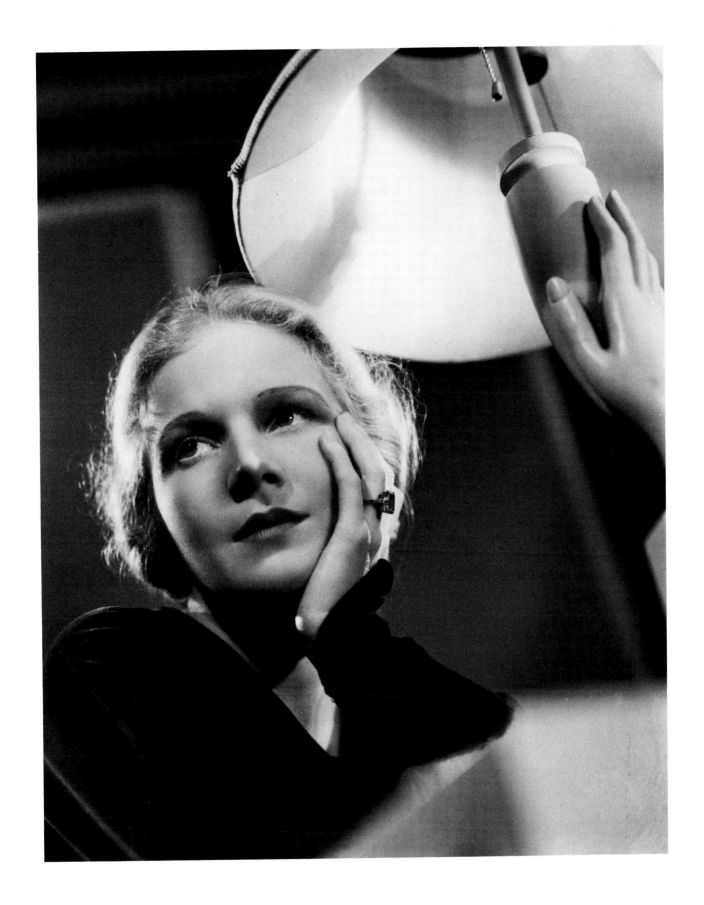

Ann Harding, 1933. Photo: Ernest A. Bachrach, for
RKO-Radio.

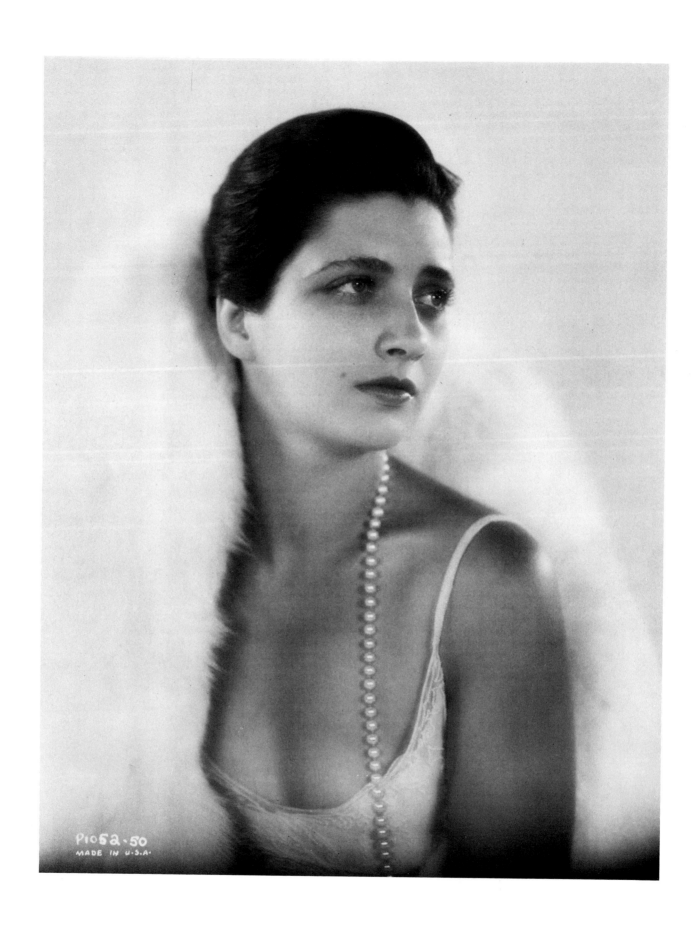

Kay Francis, 1930. Photo: Otto Dyar, for Paramount.

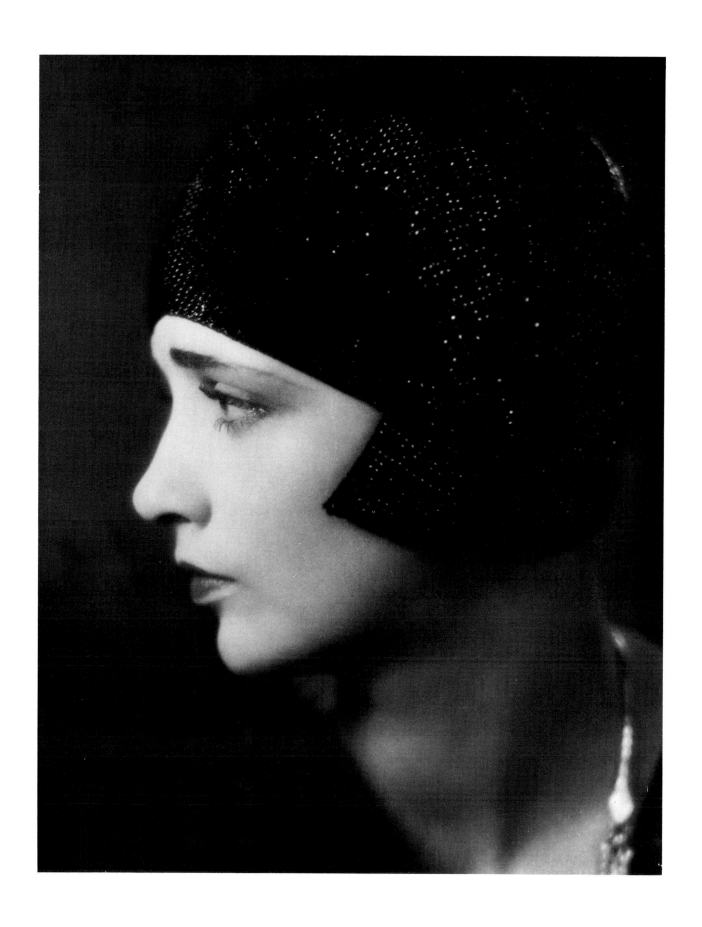

Kay Francis, 1930. Photo: George Hommel, for Paramount.

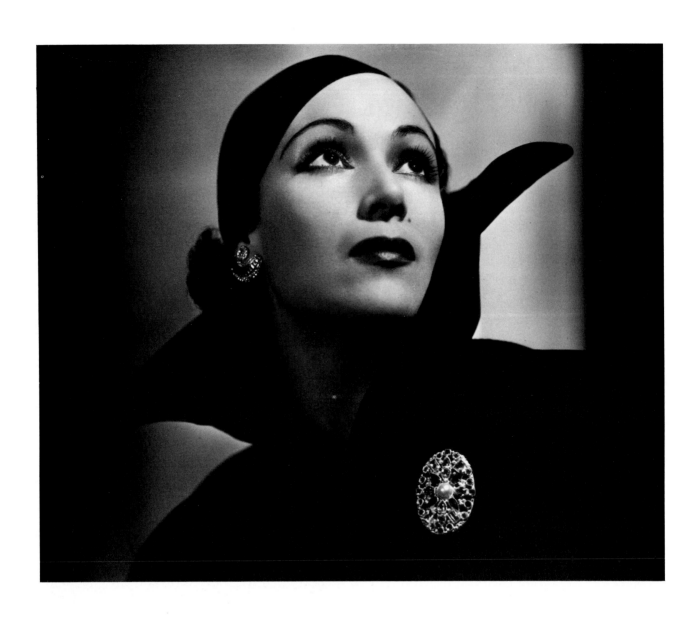

Dolores Del Rio, 1935. Photo: Elmer Fryer, for Warner Bros.

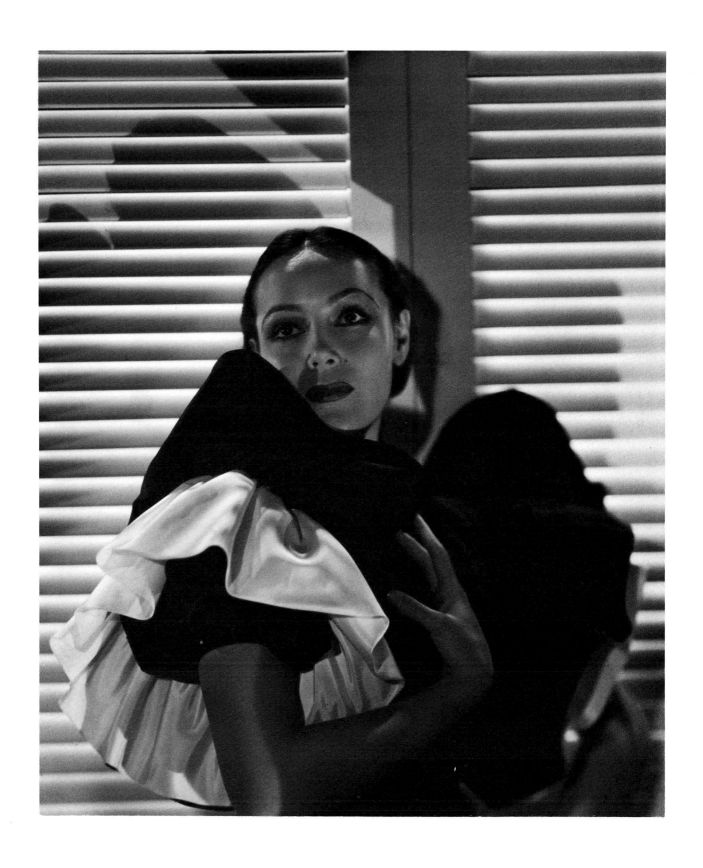

Dolores Del Rio, 1933. Photo: Ernest A. Bachrach, for
RKO-Radio.

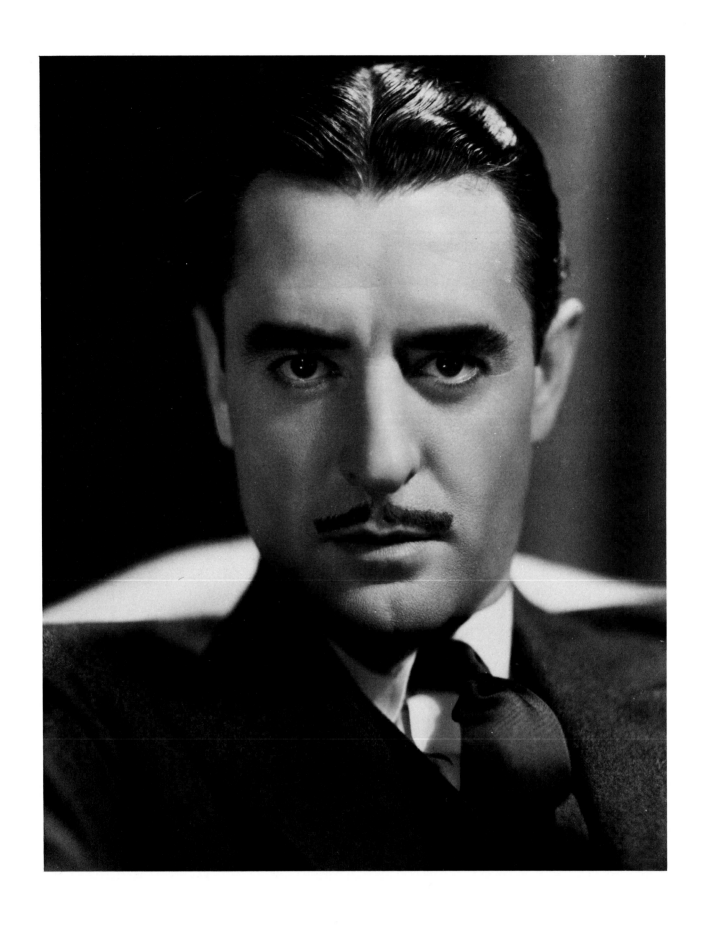

John Gilbert, 1932. Photo: George Hurrell, for MGM.

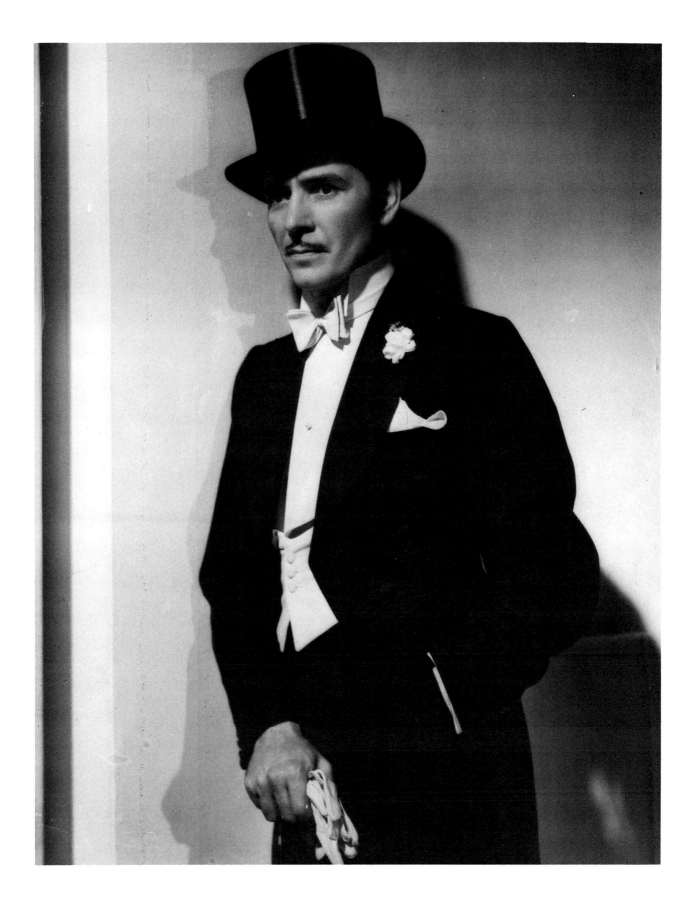

Ronald Colman, 1930. Photo: Kenneth Alexander, for
United Artists (Goldwyn). Publicity shot for *Raffles*.

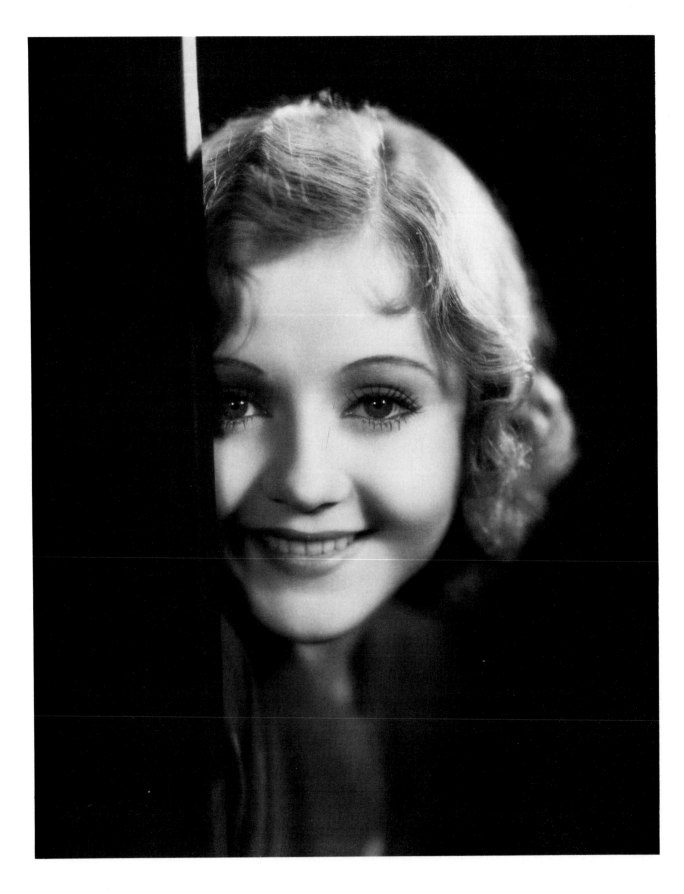

Nancy Carroll, 1930. Photo: Eugene Robert Richee, for
Paramount.

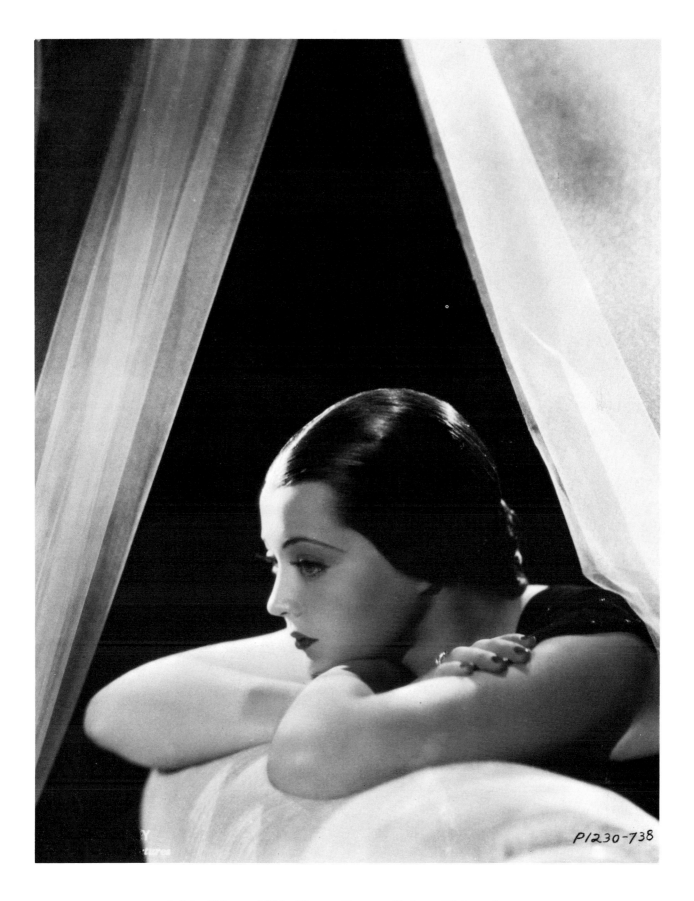

Sylvia Sidney, 1935. Photo: Eugene Robert Richee, for Paramount.

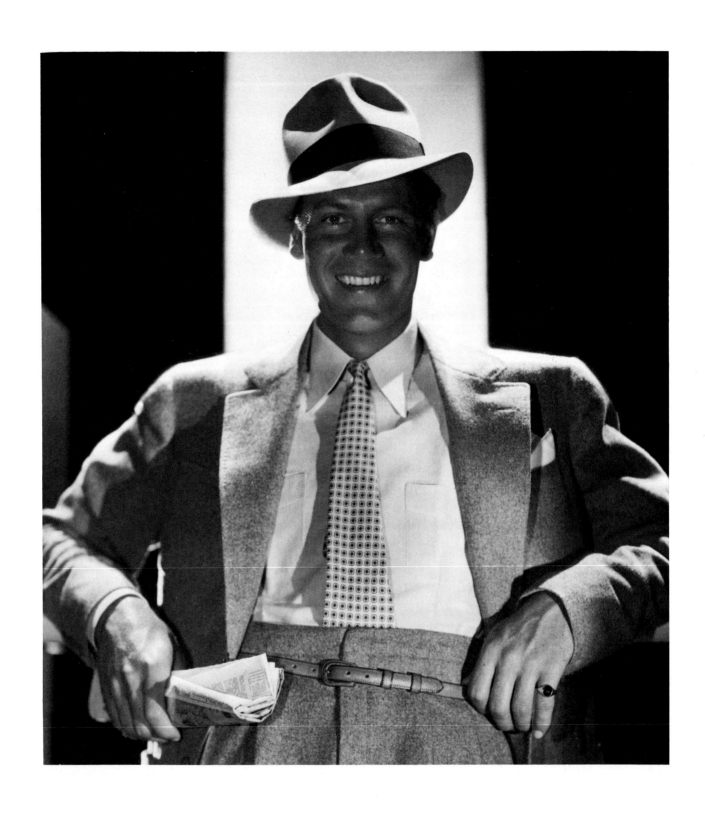

Joel McCrea, 1933. Photo: Ernest A. Bachrach, for
RKO-Radio.

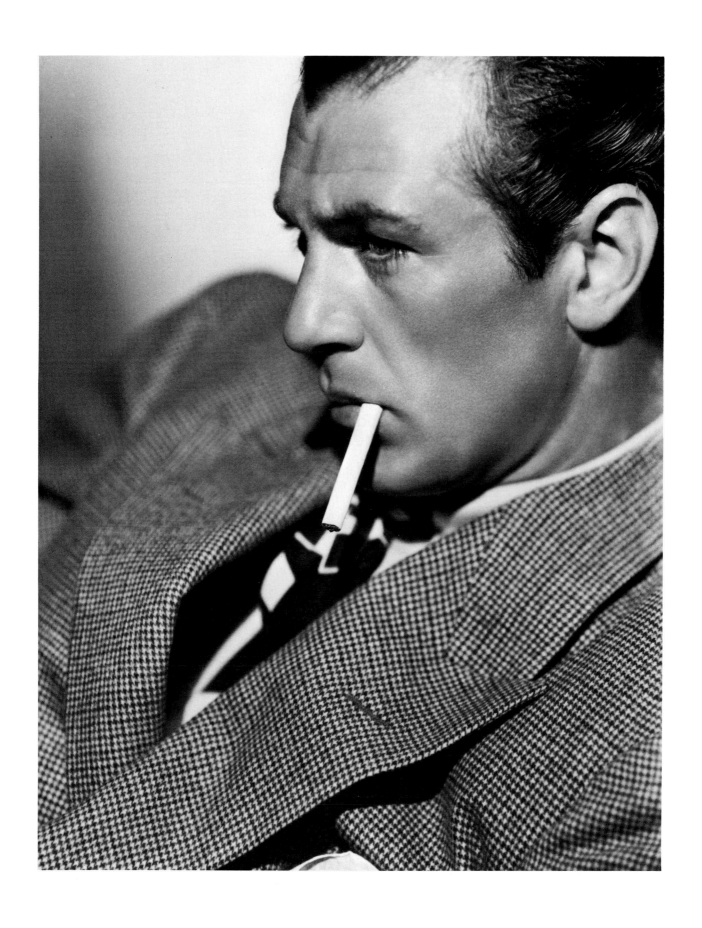

Gary Cooper, 1934. Photo: Clarence Sinclair Bull, for MGM.

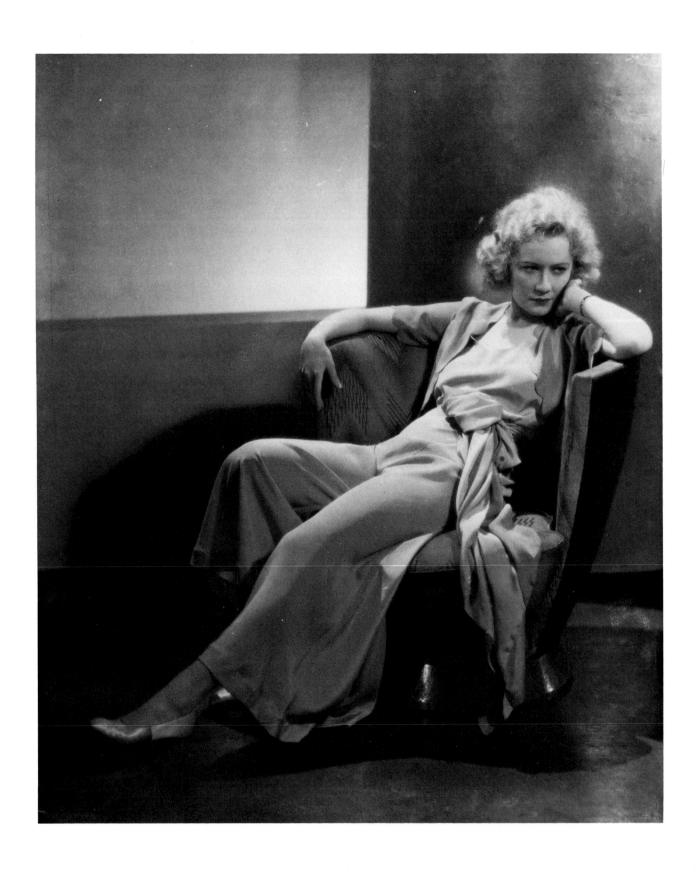

Miriam Hopkins, 1931. Photo: Otto Dyar, for Paramount.

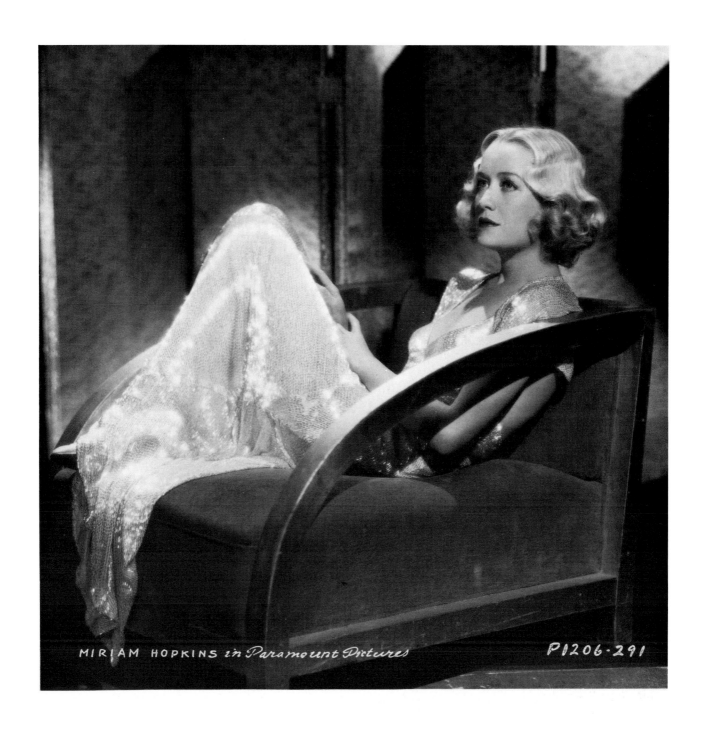

Miriam Hopkins, 1933. Photo: Eugene Robert Richee,
for Paramount. Costume by Travis Banton. Publicity shot
for *Design for Living*.

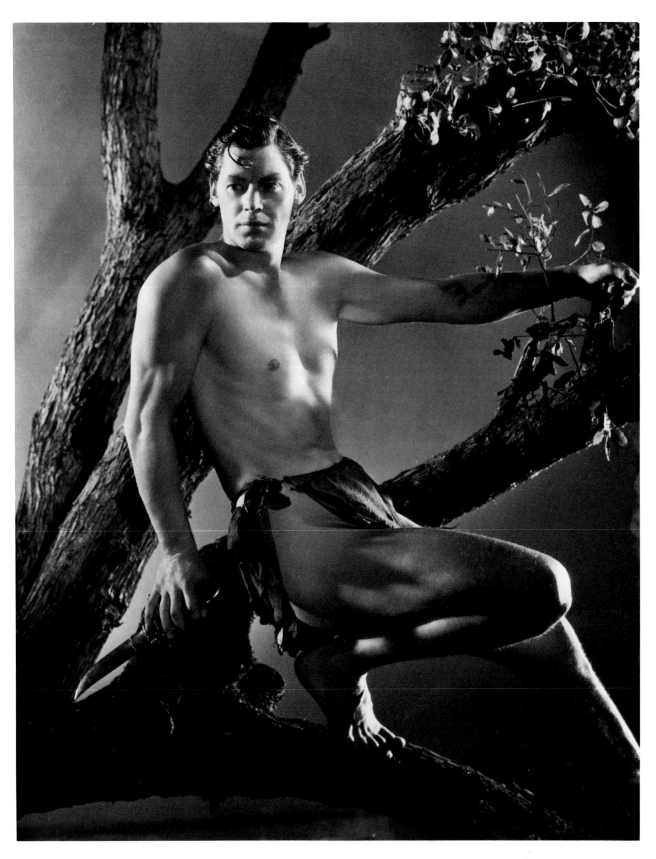

Johnny Weissmuller (as Tarzan), 1933. Photo: George Hurrell, for MGM. Costume by Adrian. Set by Cedric Gibbons.

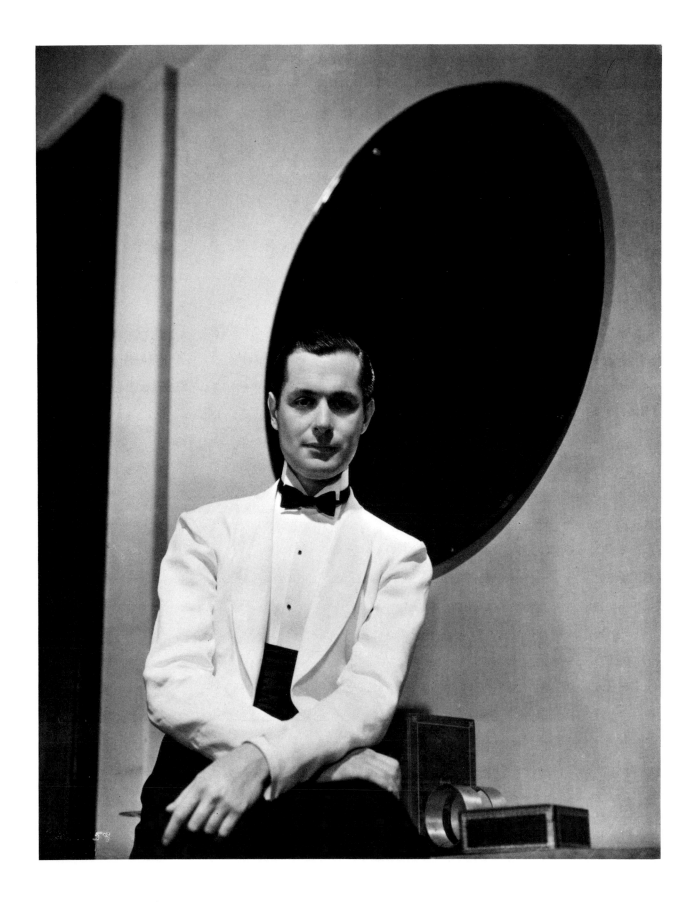

Robert Montgomery, 1932. Photo: George Hurrell, for
MGM.

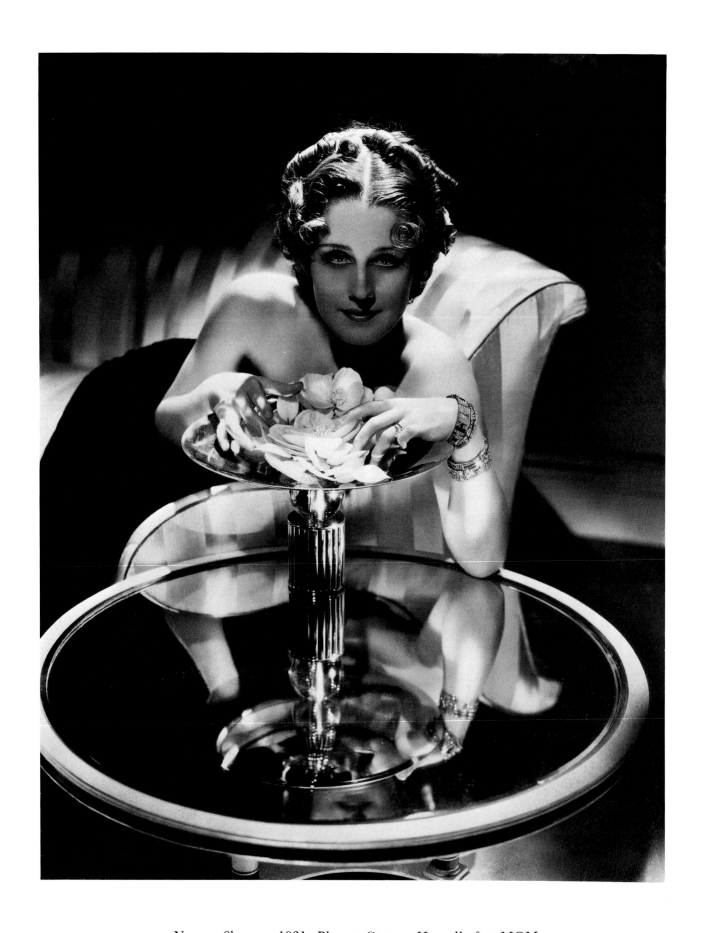

Norma Shearer, 1931. Photo: George Hurrell, for MGM.

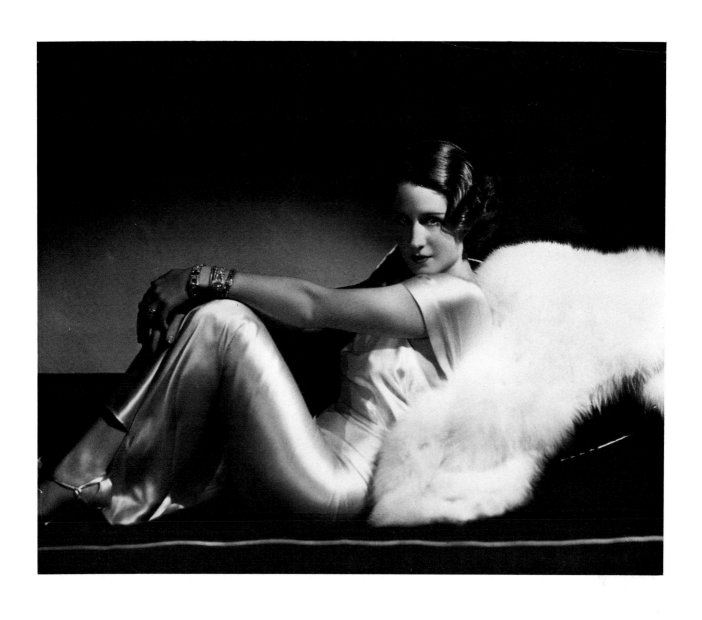

Norma Shearer, 1932. Photo: George Hurrell, for MGM.

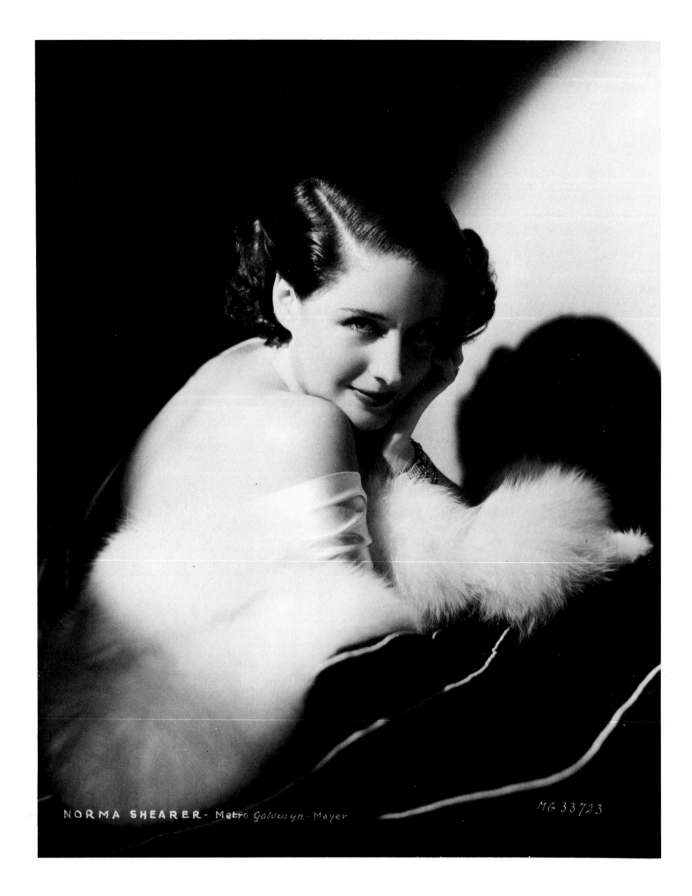

Norma Shearer, 1932. Photo: George Hurrell, for MGM.
Costume by Adrian.

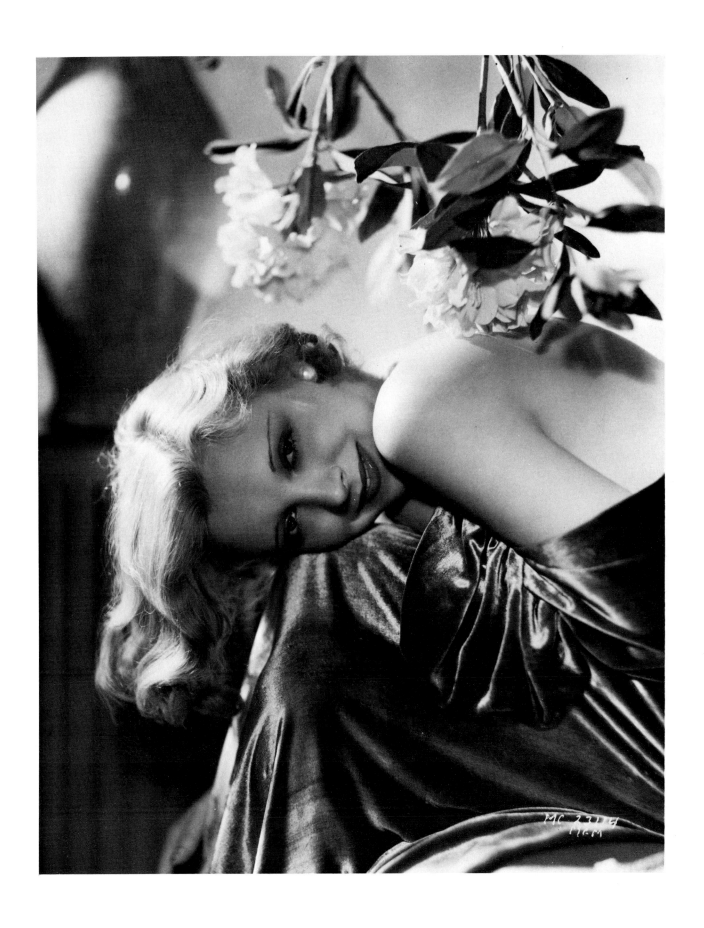

Virginia Bruce, 1930. Photo: George Hurrell, for MGM.

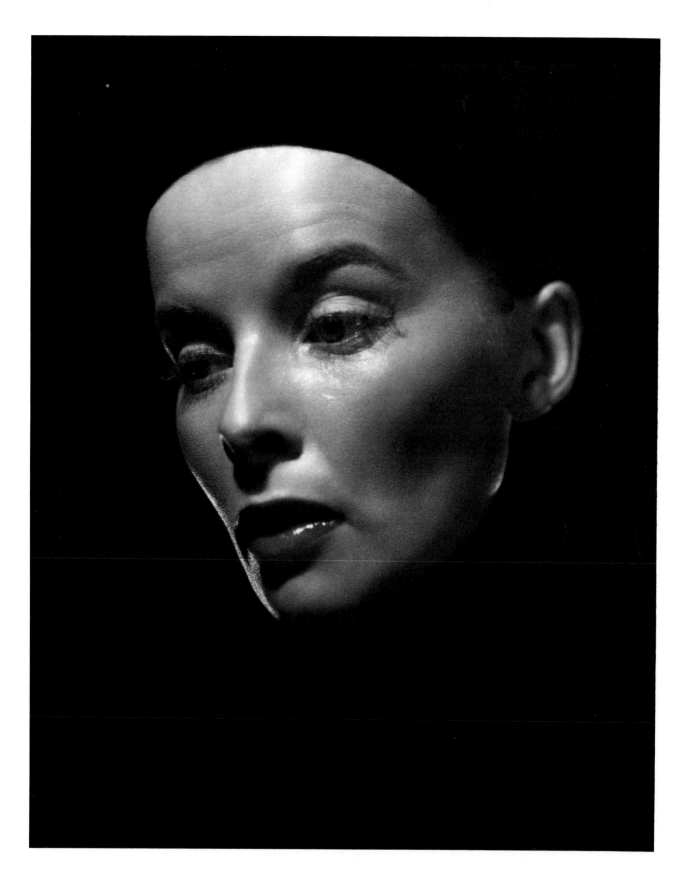

Katharine Hepburn, 1935. Photo: Ernest A. Bachrach, for
RKO-Radio.

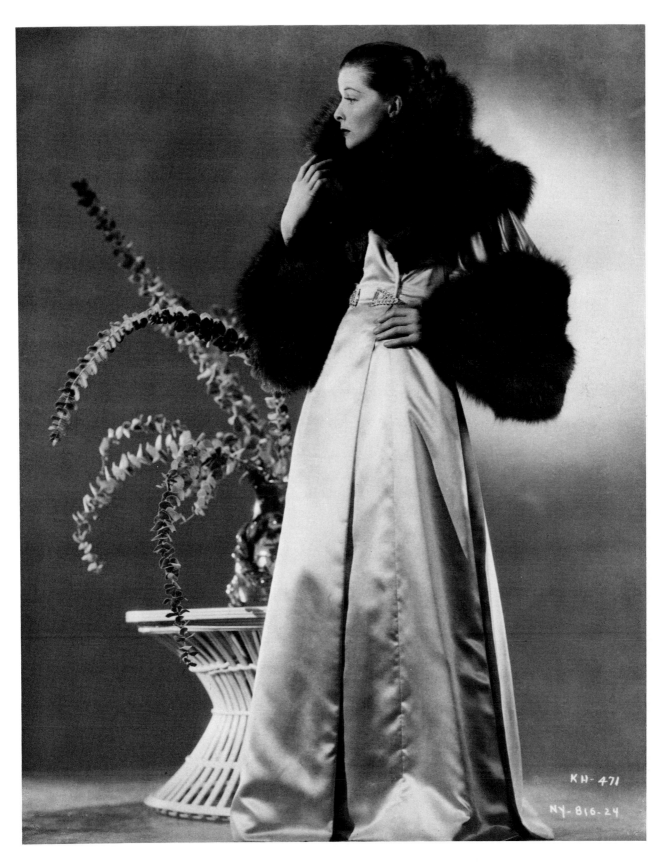

Katharine Hepburn, 1935. Photo: Ernest A. Bachrach, for
RKO-Radio. Costume by Bernard Newman. Publicity
shot for *Break of Hearts*.

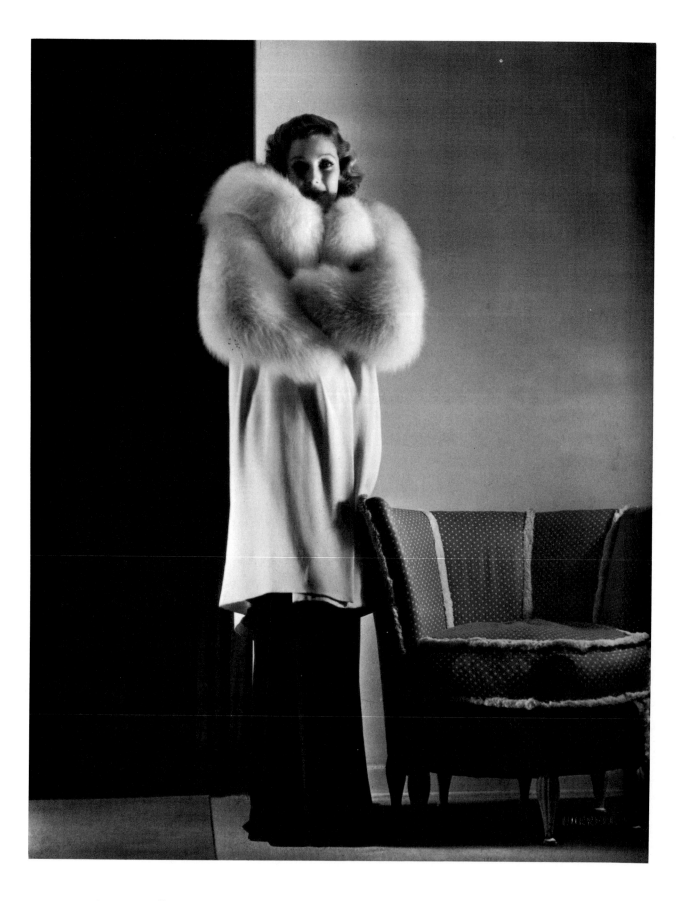

Loretta Young, 1934. Photo: George Hurrell. Costume by
Howard Greer.

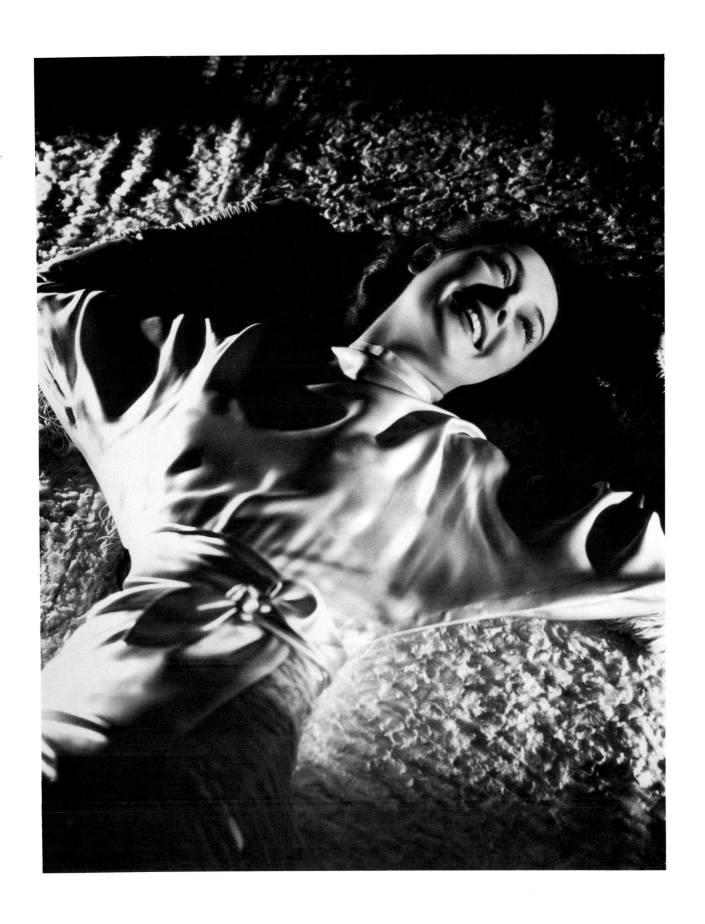

Rosalind Russell, 1935. Photo: George Hurrell, for MGM.

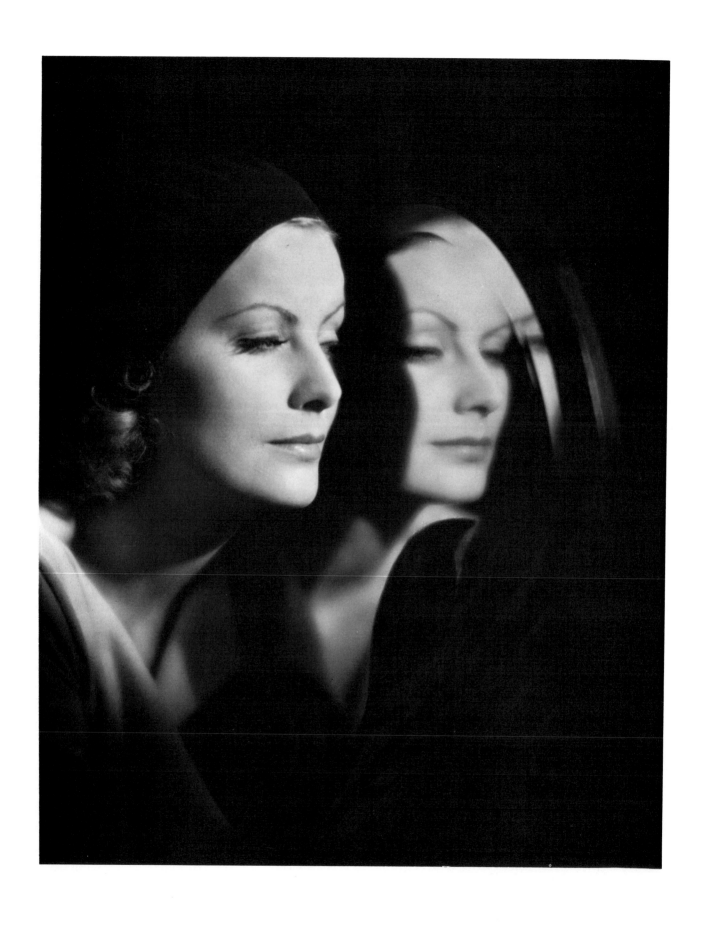

Greta Garbo, 1930. Photo: Clarence Sinclair Bull, for MGM.

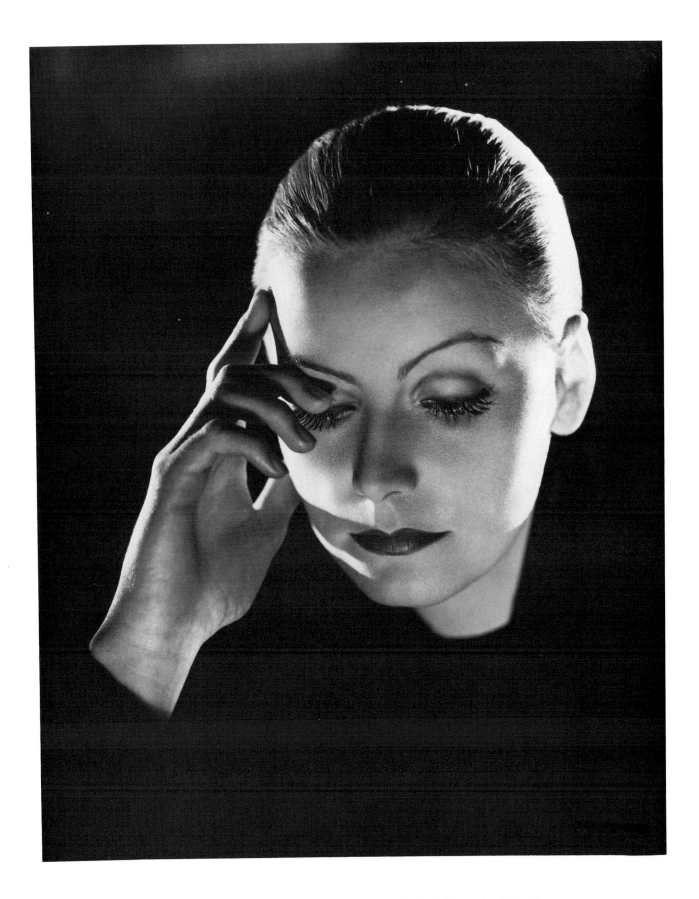

Greta Garbo, 1931. Photo: Clarence Sinclair Bull, for MGM.
Publicity shot for *Mata Hari*.

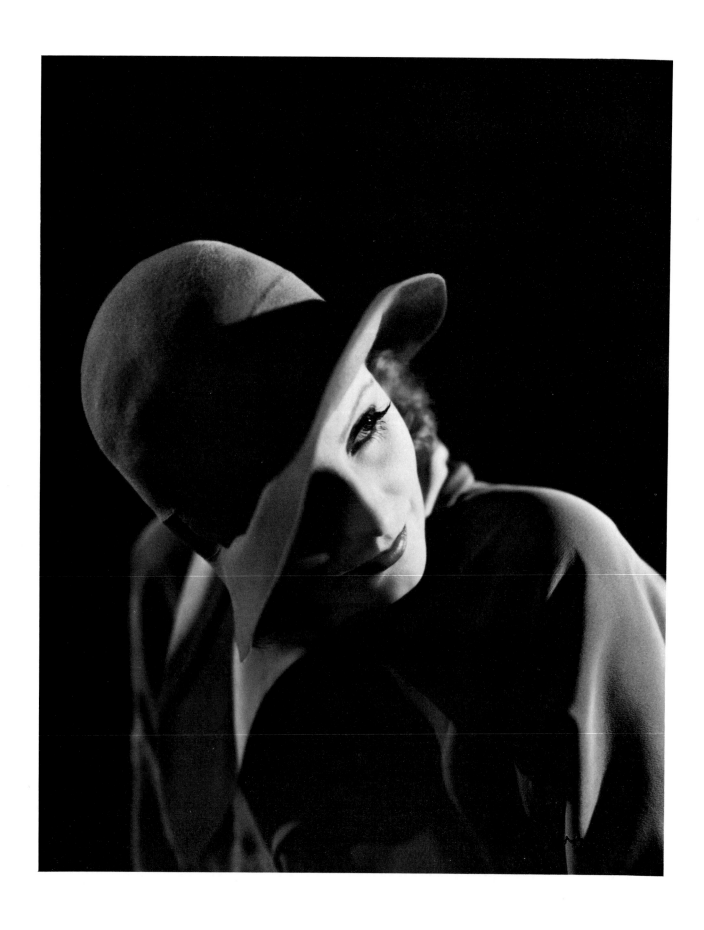

Greta Garbo, 1930. Photo: Clarence Sinclair Bull, for MGM.

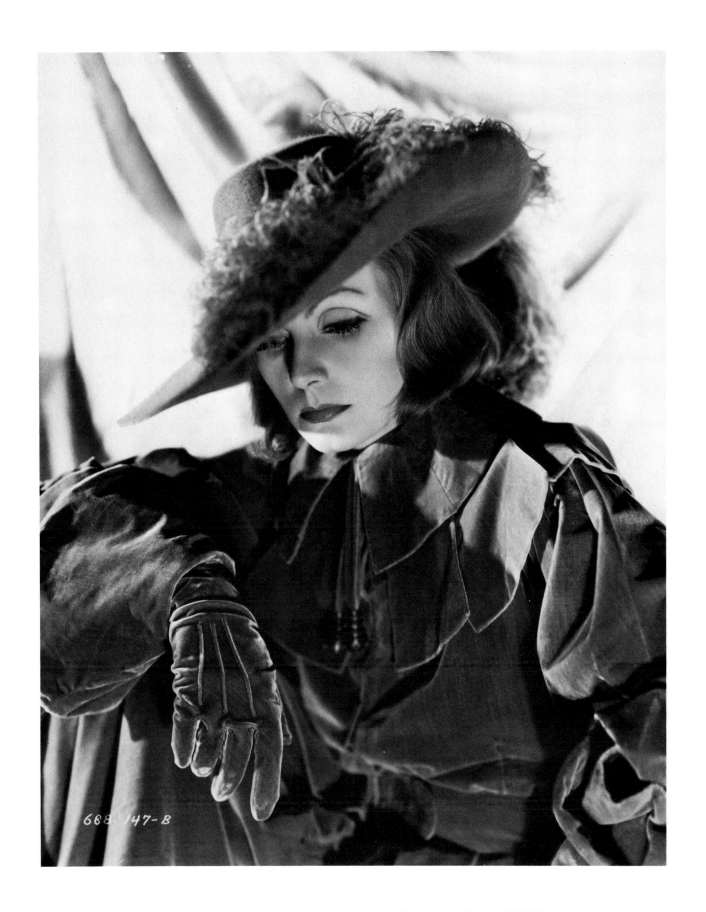

Greta Garbo, 1933. Photo: Clarence Sinclair Bull, for MGM.
Publicity shot for *Queen Christina*. Costume by Adrian.

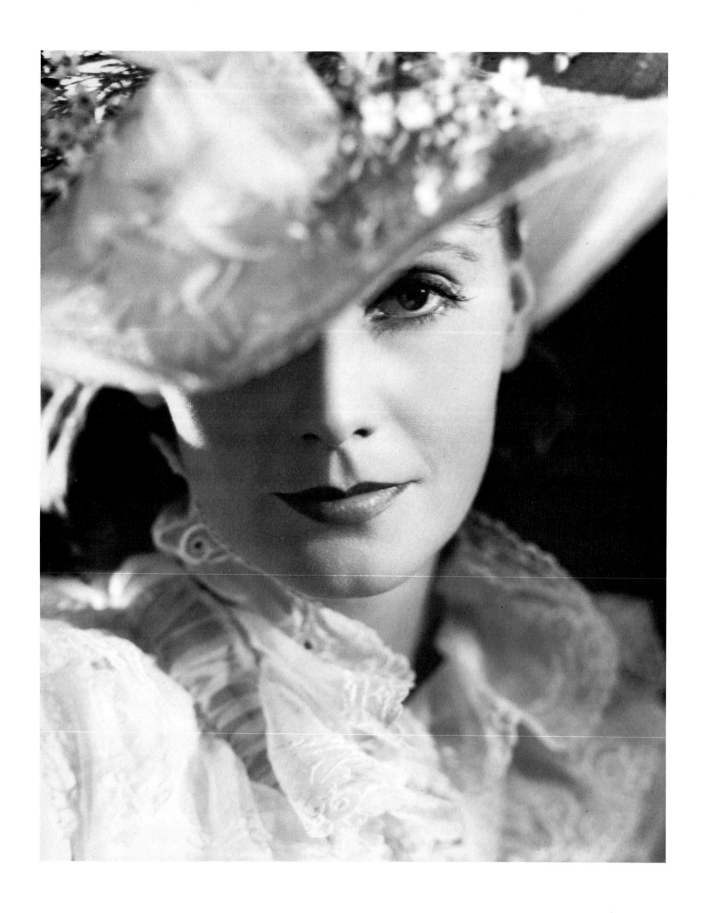

Greta Garbo, 1935. Photo: Clarence Sinclair Bull, for MGM.
Costume by Adrian. Publicity shot for *Anna Karenina*.

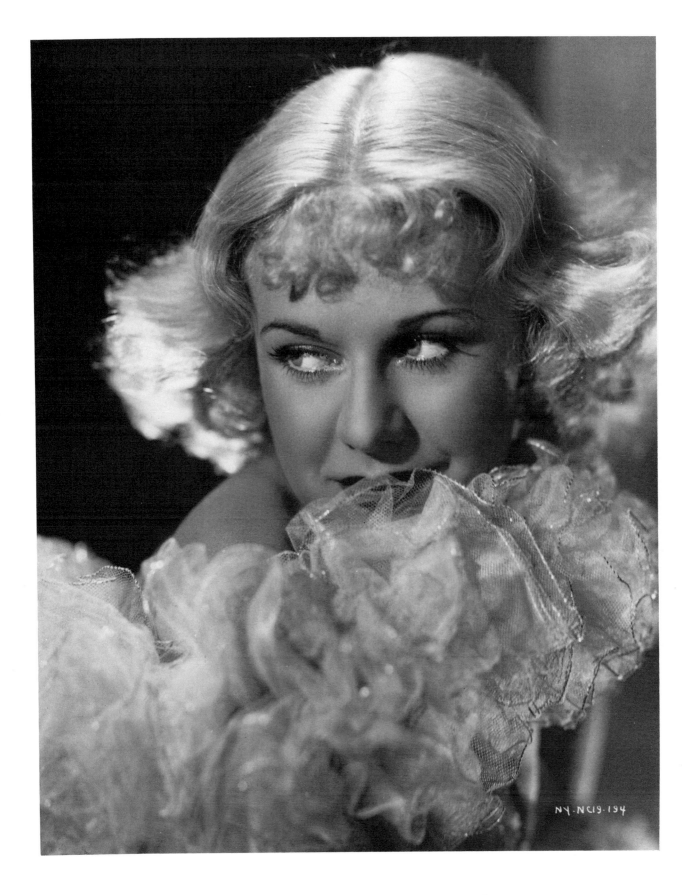

Ginger Rogers, 1934. Photo: Ernest A. Bachrach, for
RKO-Radio. Costume by Bernard Newman.

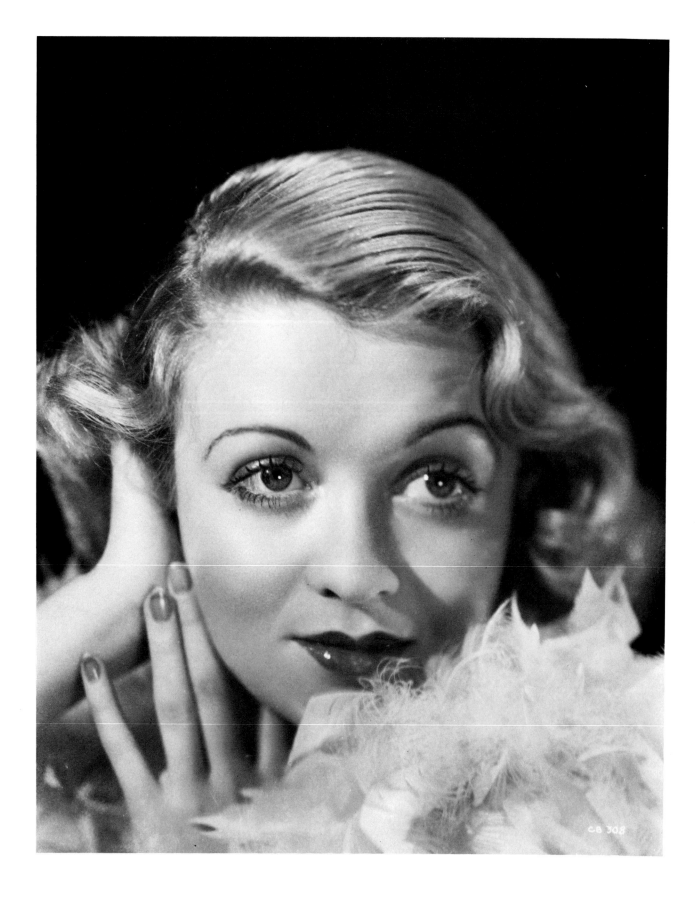

Constance Bennett, 1933. Photo: Ernest A. Bachrach, for
RKO-Radio.

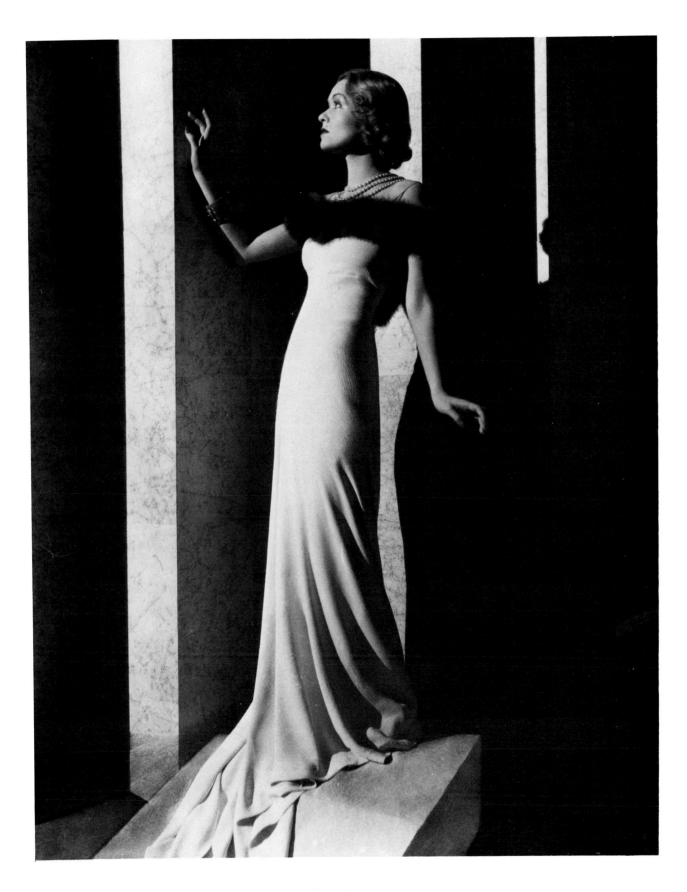

Constance Bennett, 1932. Photo: Ernest A. Bachrach, for
RKO-Radio. Publicity shot for *Our Betters*.

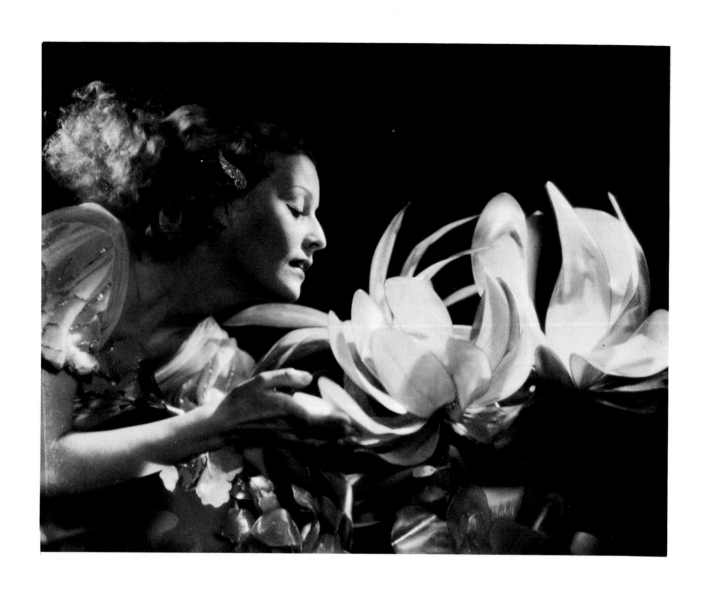

Lilian Harvey, 1935. Photo: Ray Jones, for Columbia.

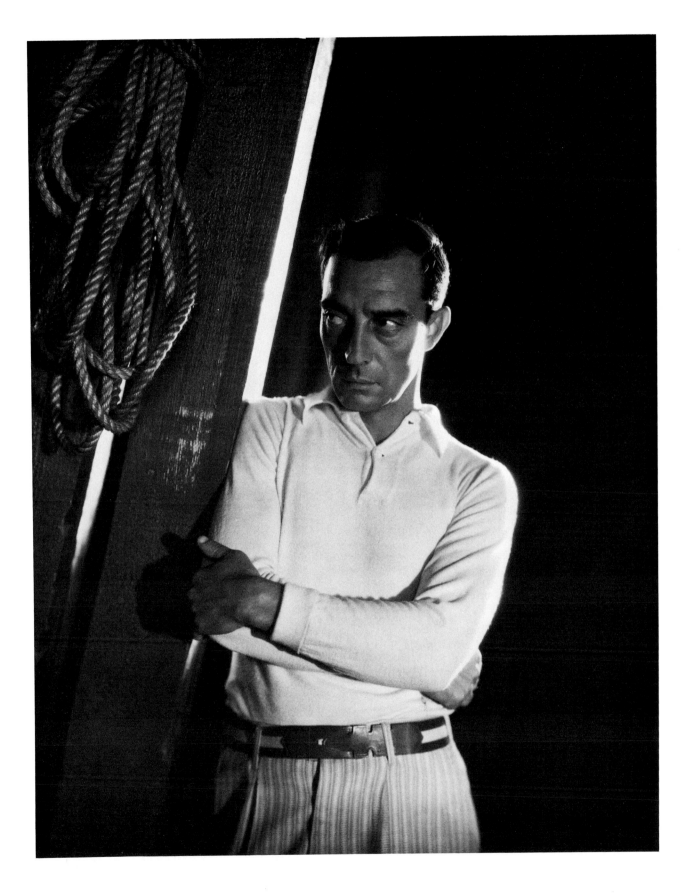

Buster Keaton, 1932. Photo: Clarence Sinclair Bull, for
MGM.

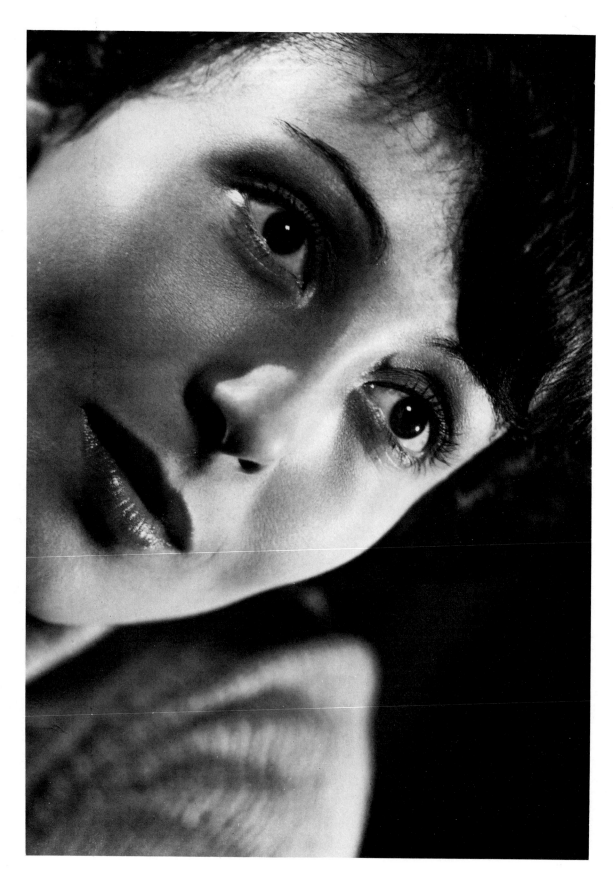

Luise Rainer, 1935. Photo: Clarence Sinclair Bull, for
MGM.

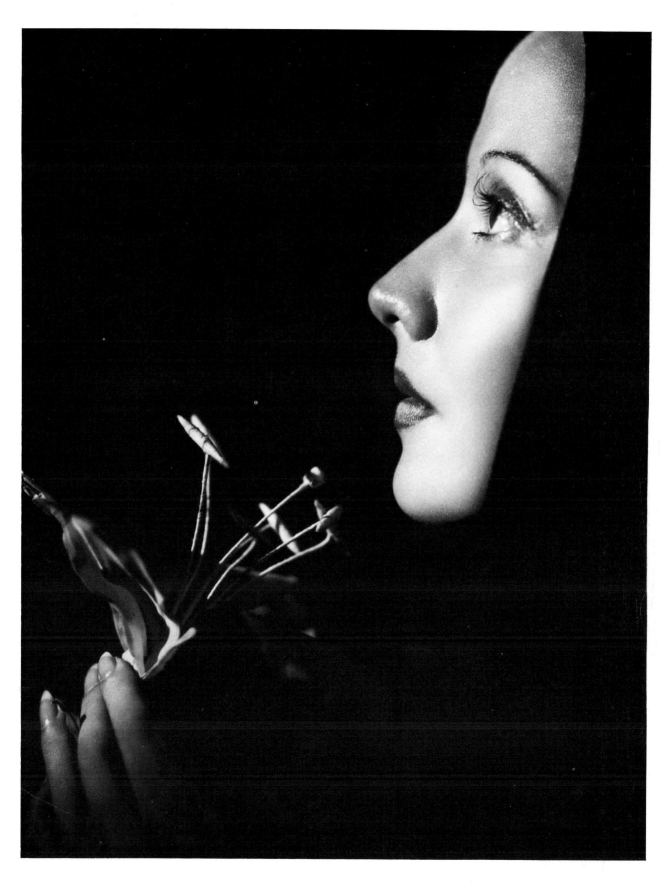

Merle Oberon, 1938. Photo: Robert Coburn, for United
Artists (Goldwyn).

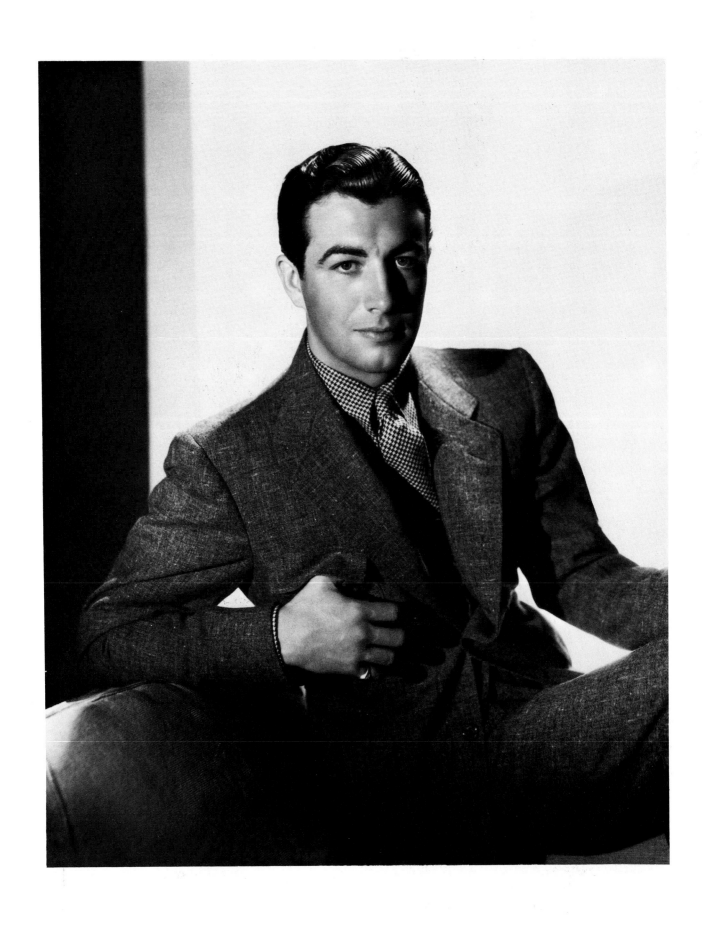

Robert Taylor, 1936. Photo: George Hurrell, for MGM.

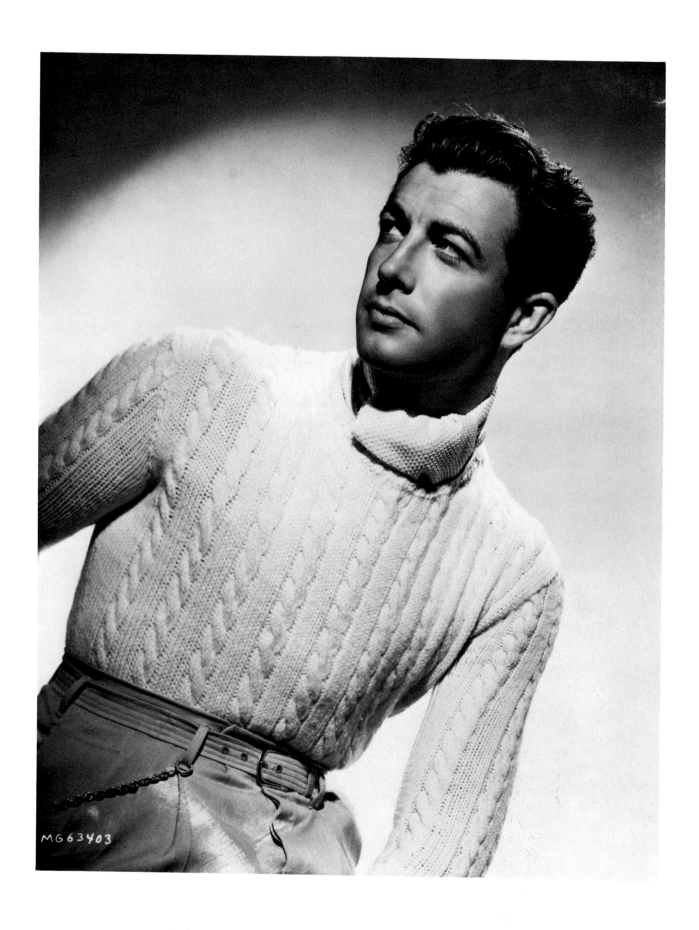

Robert Taylor, 1937. Photo: Laszlo Willinger, for MGM.

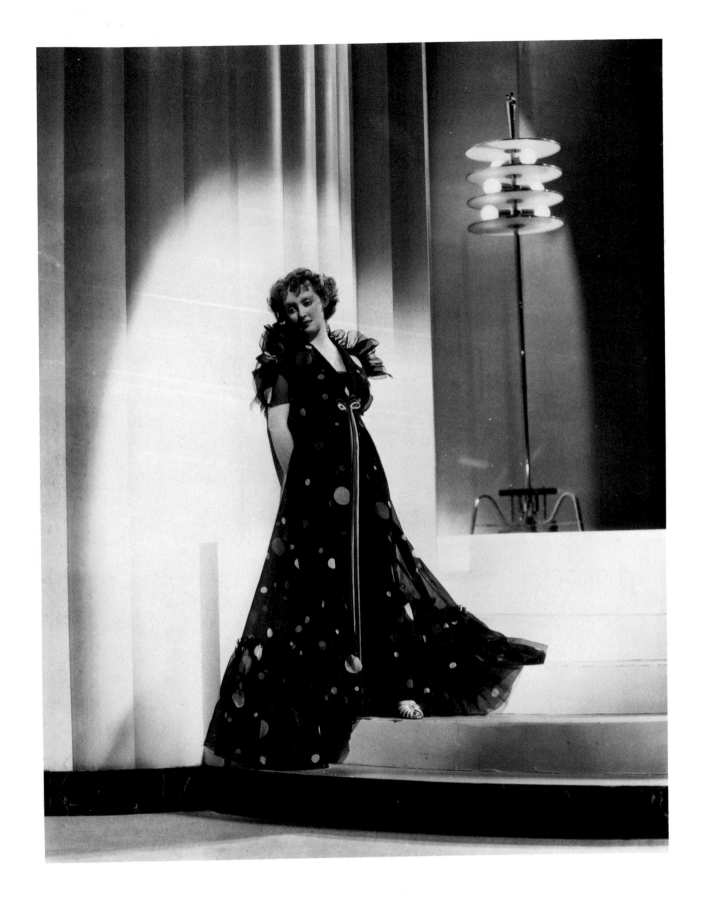

Bette Davis, 1937. Photo: Bert Six, for Warner Bros.
Costume by Orry-Kelly.

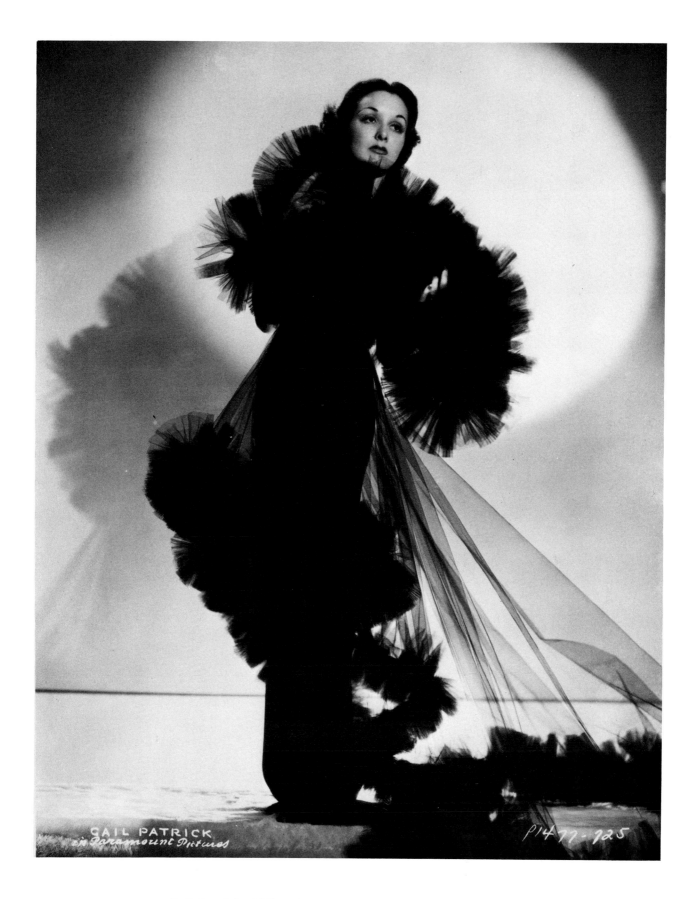

Gail Patrick, 1937. Photo: Eugene Robert Richee, for
Paramount. Costume by Travis Banton.

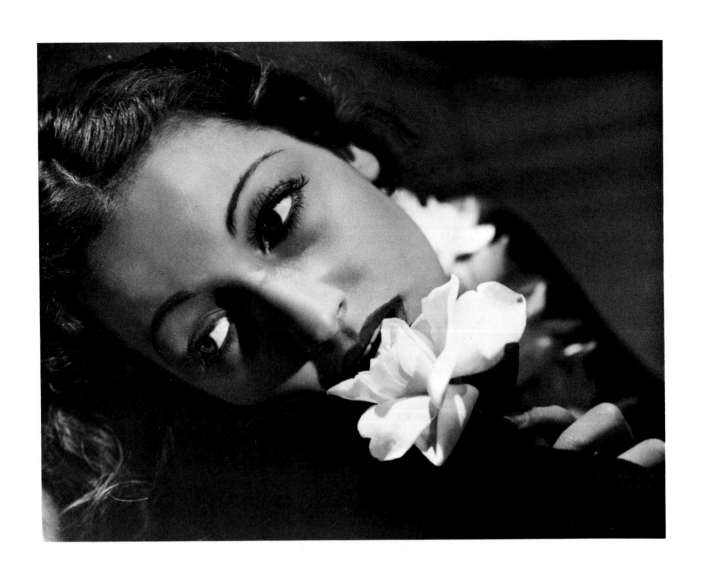

Dorothy Lamour, 1937. Photo: Robert Coburn, for
United Artists (Goldwyn). Publicity shot for *The Hurricane*.

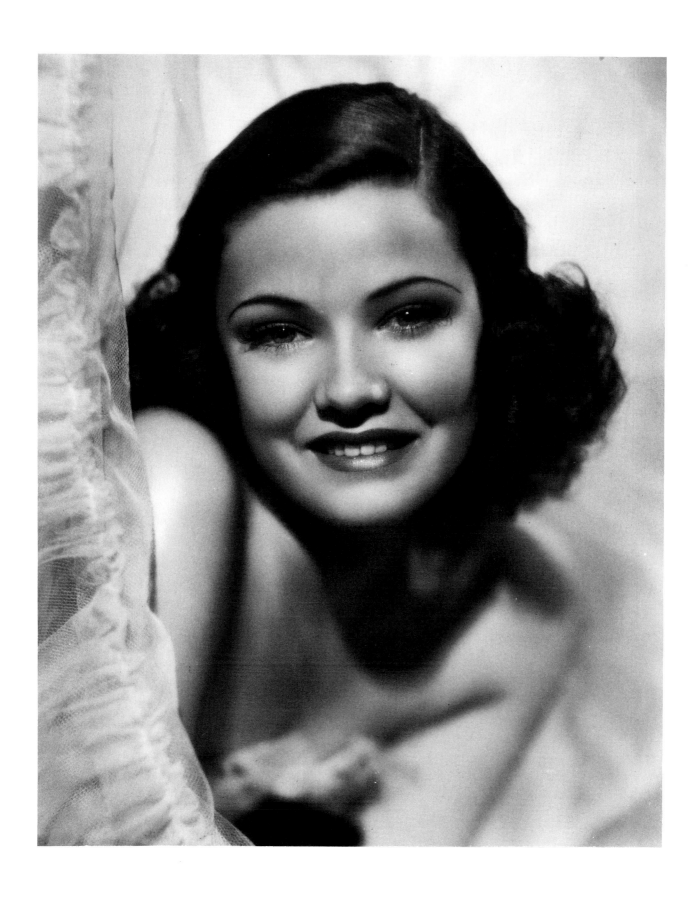

Gene (then spelled Jean) Tierney, 1939. Photo:
A. L. ("Whitey") Schafer, for Columbia.

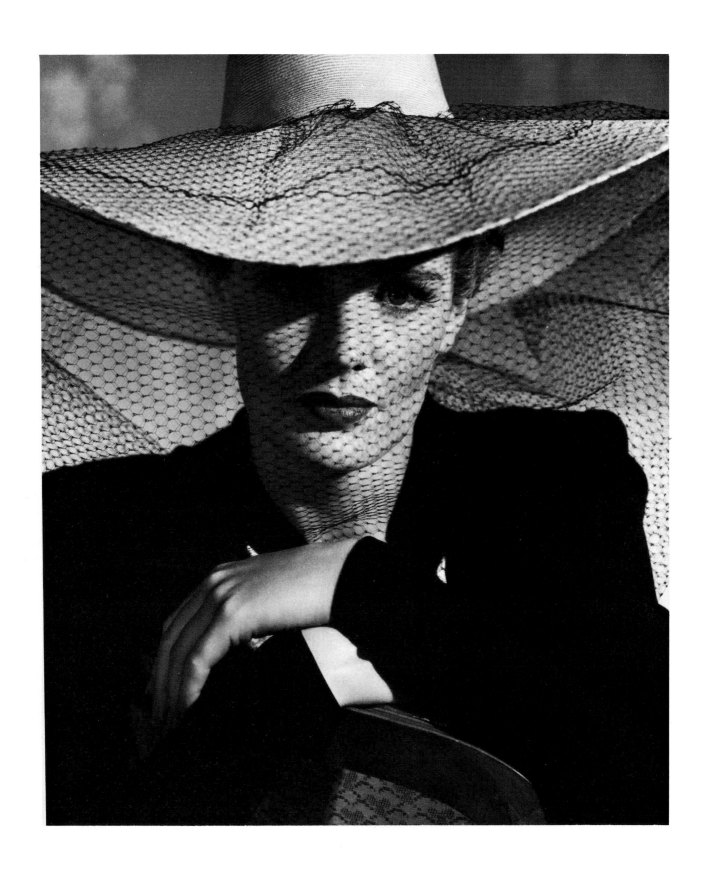

Frances Farmer, 1938. Photo: William Walling, for
Paramount.

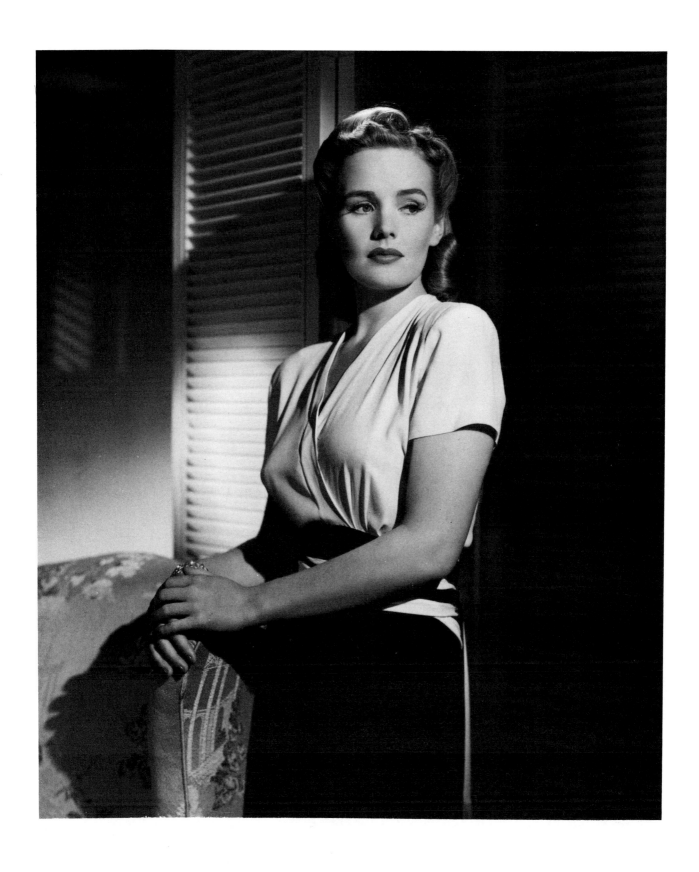

Frances Farmer, 1937. Photo: Eugene Robert Richee, for
Paramount.

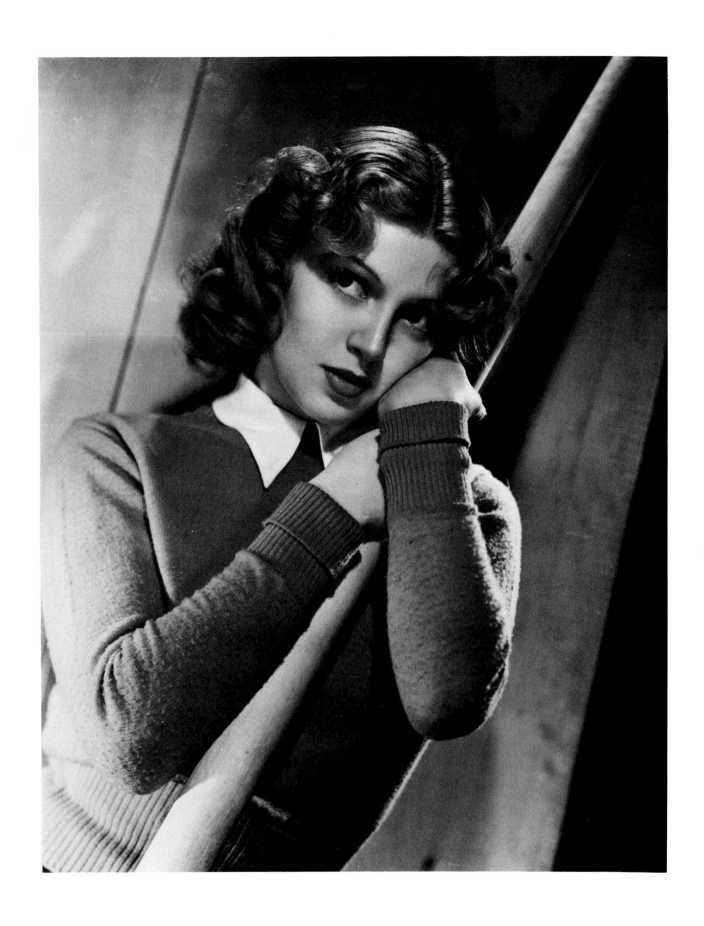

Lana Turner, 1939. Photo: Eric Carpenter, for MGM.

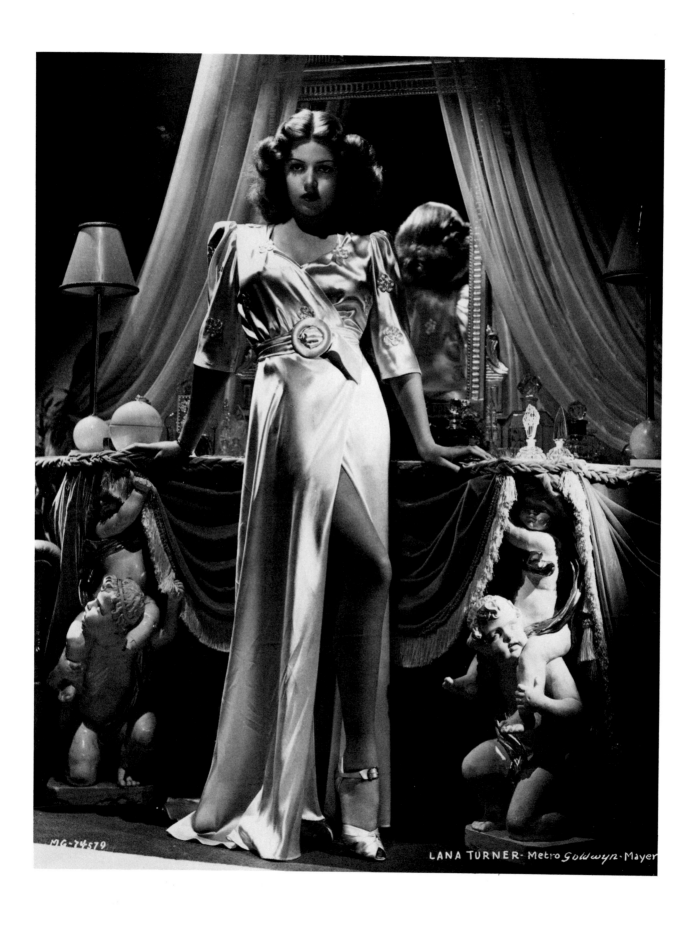

Lana Turner, 1939. Photo: Eric Carpenter, for MGM.

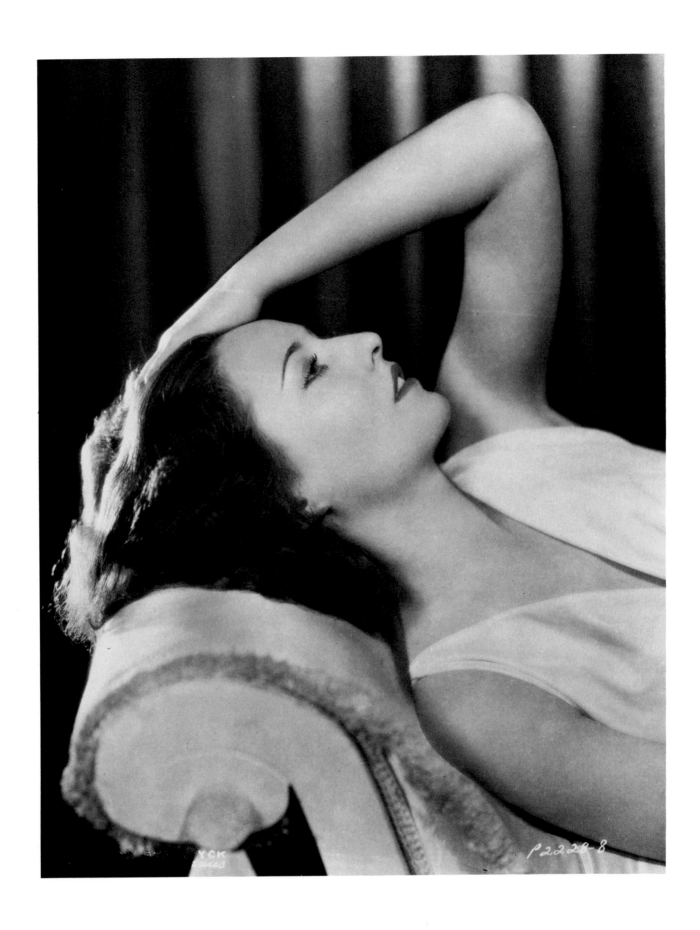

Barbara Stanwyck, 1937. Paramount.

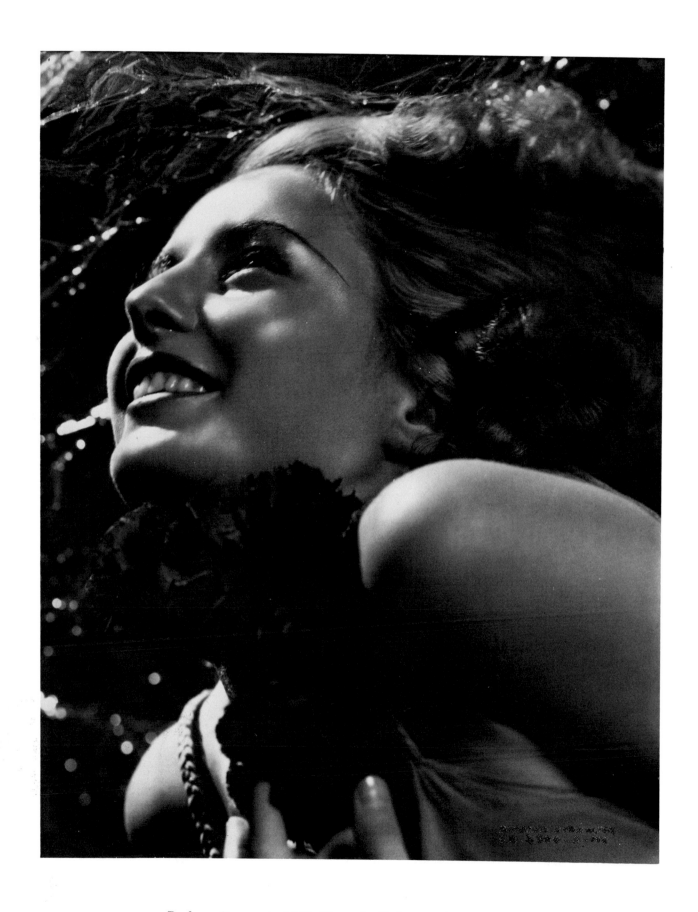

Barbara Stanwyck, 1937. Photo by Robert Coburn, for
United Artists (Goldwyn). Publicity shot for *Stella Dallas*.

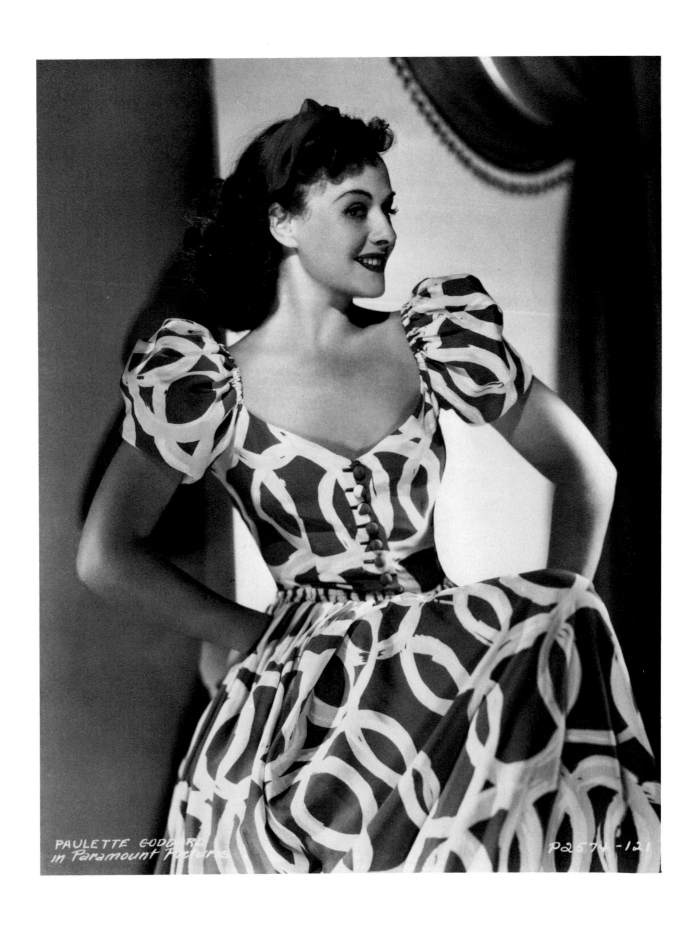

Paulette Goddard, 1939. Paramount.

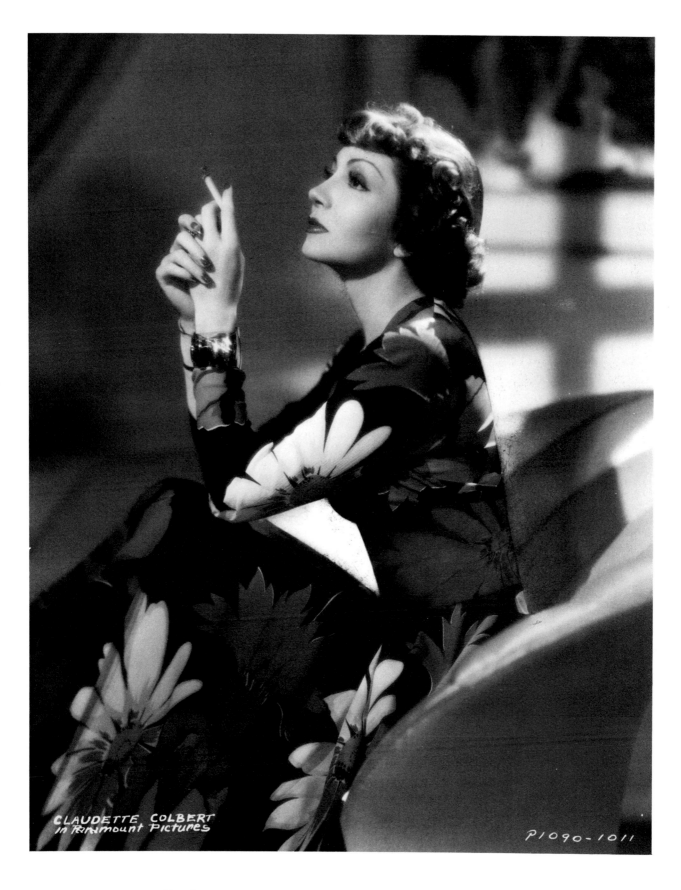

Claudette Colbert, 1938. Photo: Eugene Robert Richee, for
Paramount. Costume by Travis Banton.

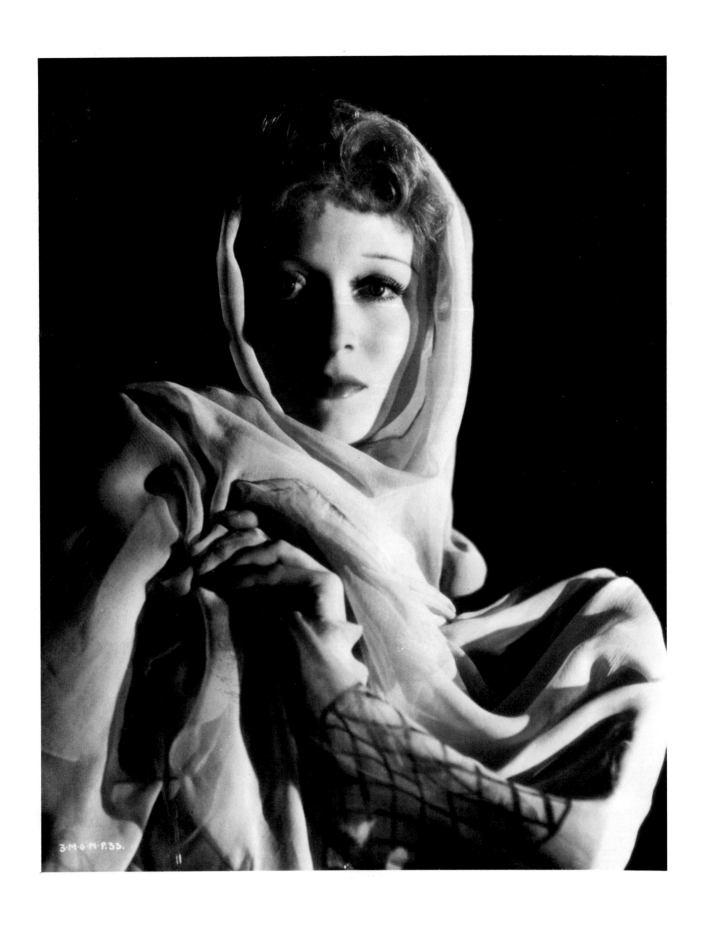

Greer Garson, 1938. Photo: Laszlo Willinger, for MGM.

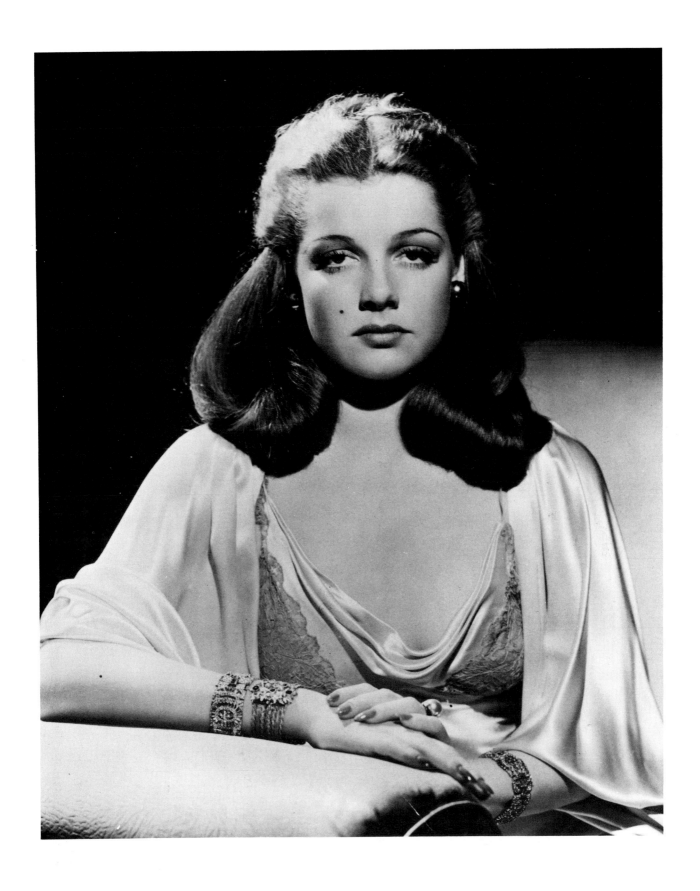

Ann Sheridan, 1939. Photo: George Hurrell, for Warner
Bros.

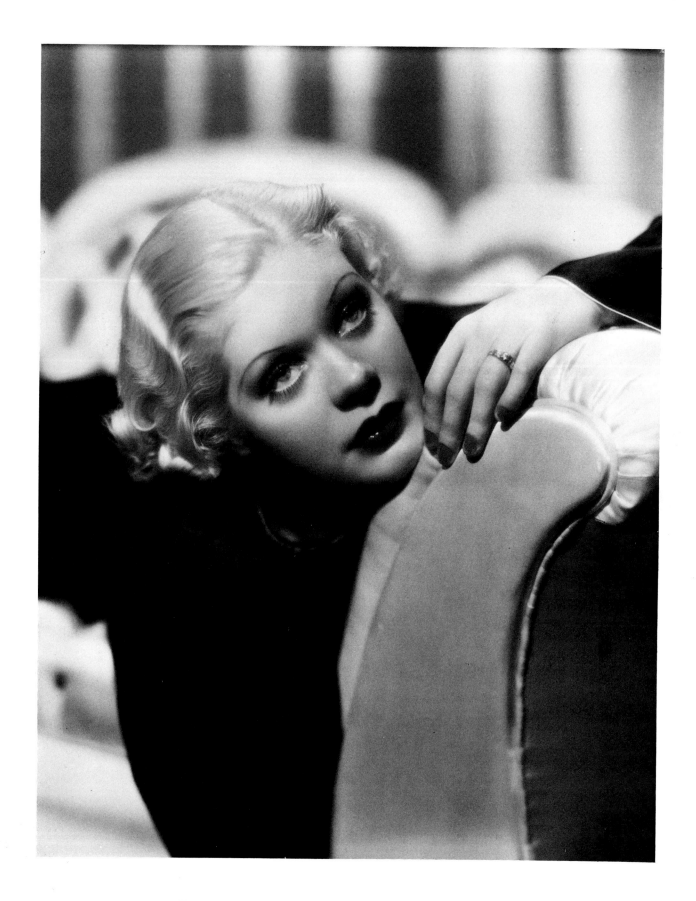

Alice Faye, 1936. Photo: Gene Kornman, for 20th Century-Fox.

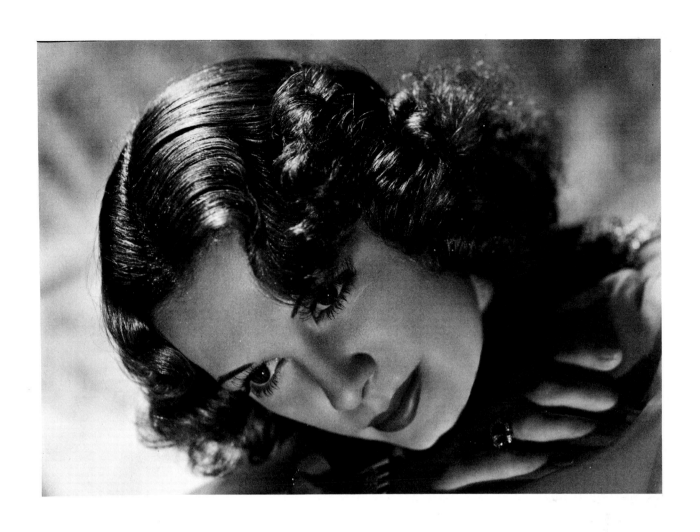

Eleanor Powell, 1937. Photo: Laszlo Willinger, for MGM.

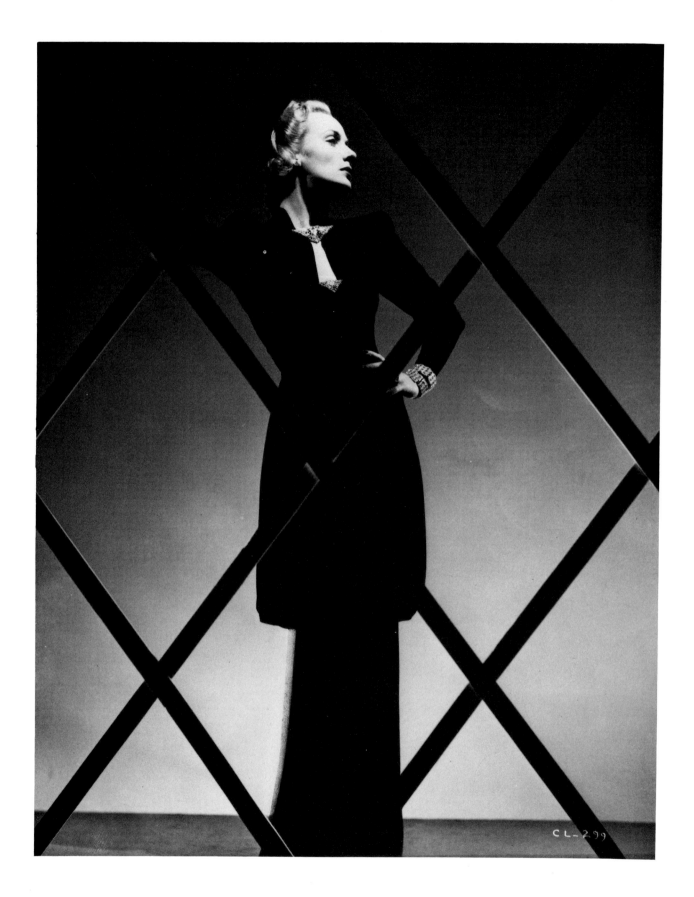

Carole Lombard, 1939. Photo: John Engstead, for RKO-
Radio. Costume by Travis Banton.

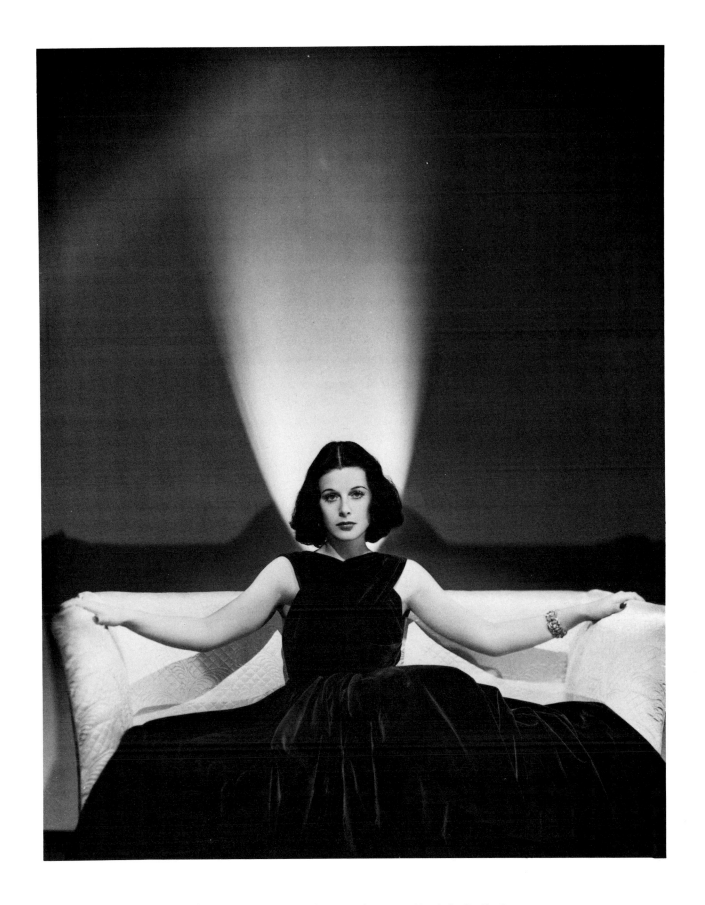

Hedy Lamarr, 1938. Photo: Clarence Sinclair Bull, for
MGM.

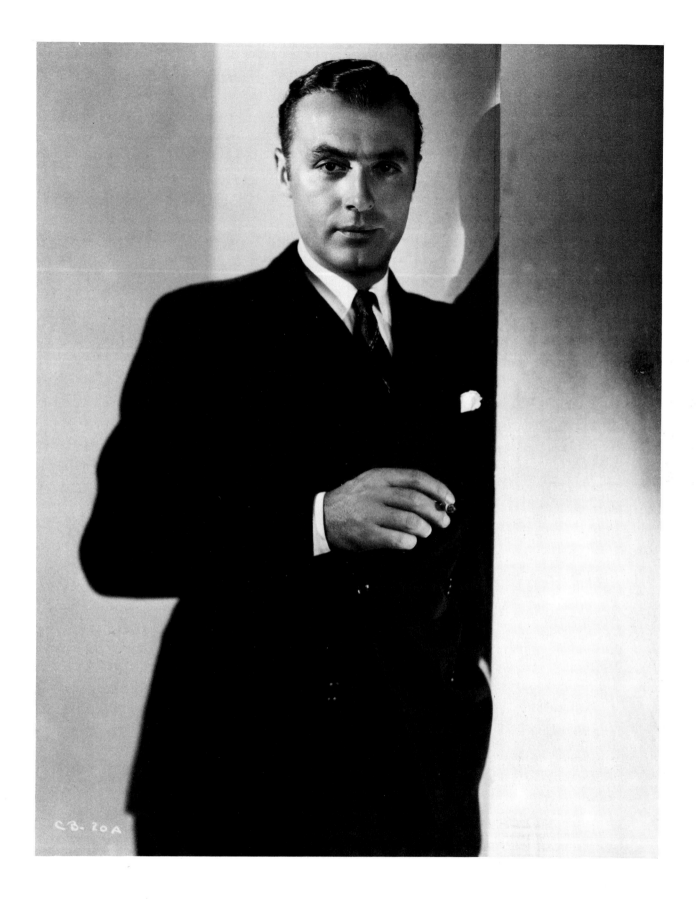

Charles Boyer, 1939. Photo: Ernest A. Bachrach, for
RKO-Radio.

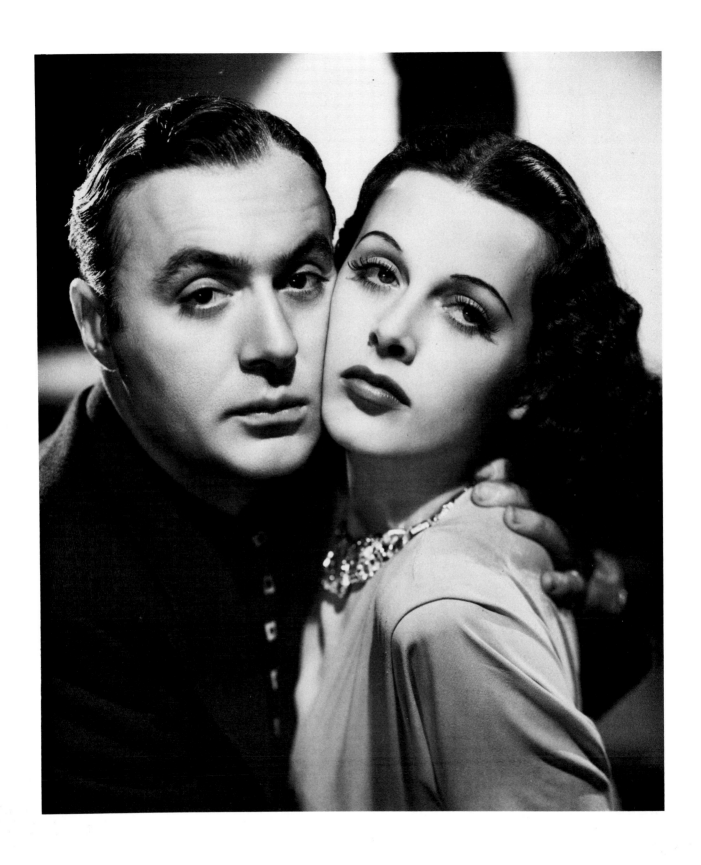

Charles Boyer and Hedy Lamarr, 1938. Photo: Robert
Coburn, for United Artists (Walter Wanger). Publicity shot
for *Algiers*.

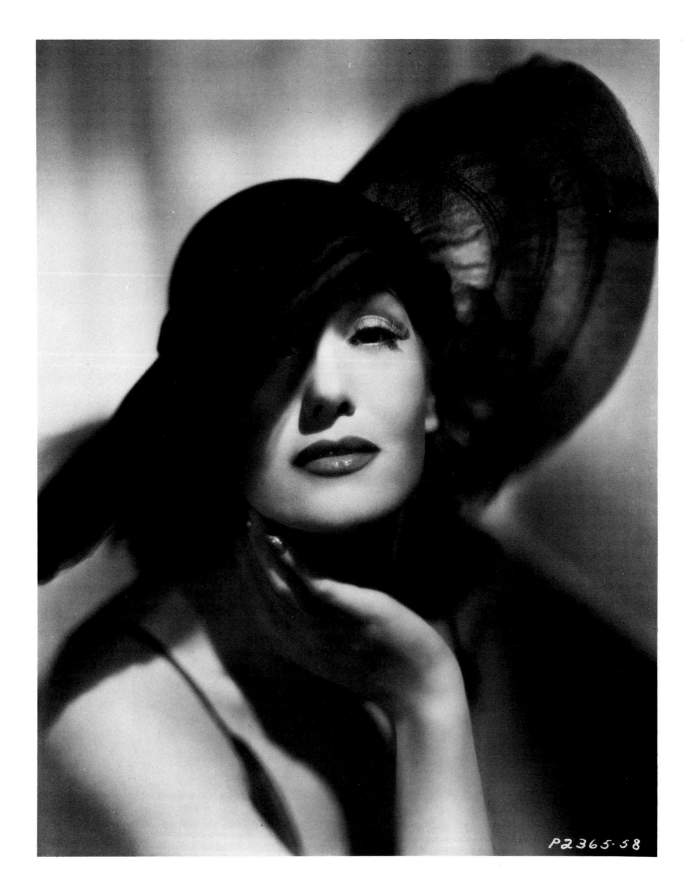

Isa Miranda, 1938. Photo: Eugene Robert Richee, for
Paramount.

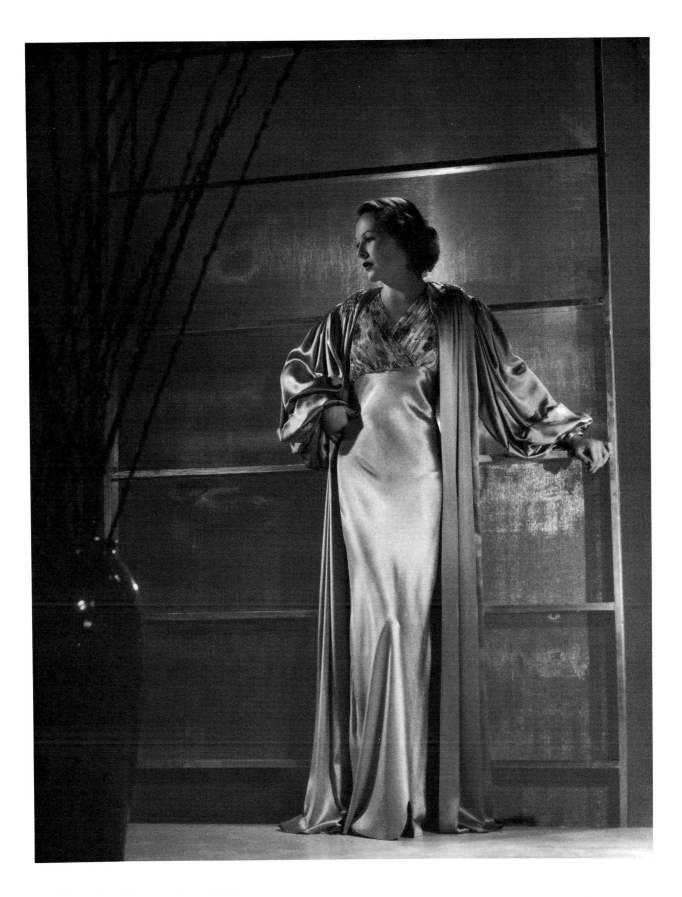

Wendy Barrie, 1937. Photo: Ray Jones, for Universal. Gown
by Howard Greer.

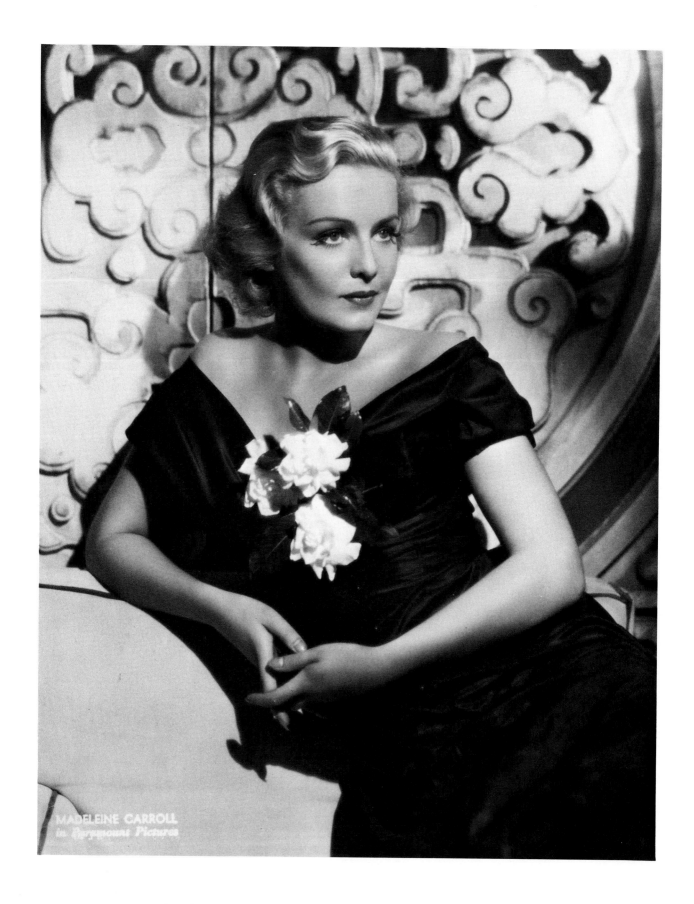

Madeleine Carroll, 1936. Photo: Eugene Robert Richee, for
Paramount.

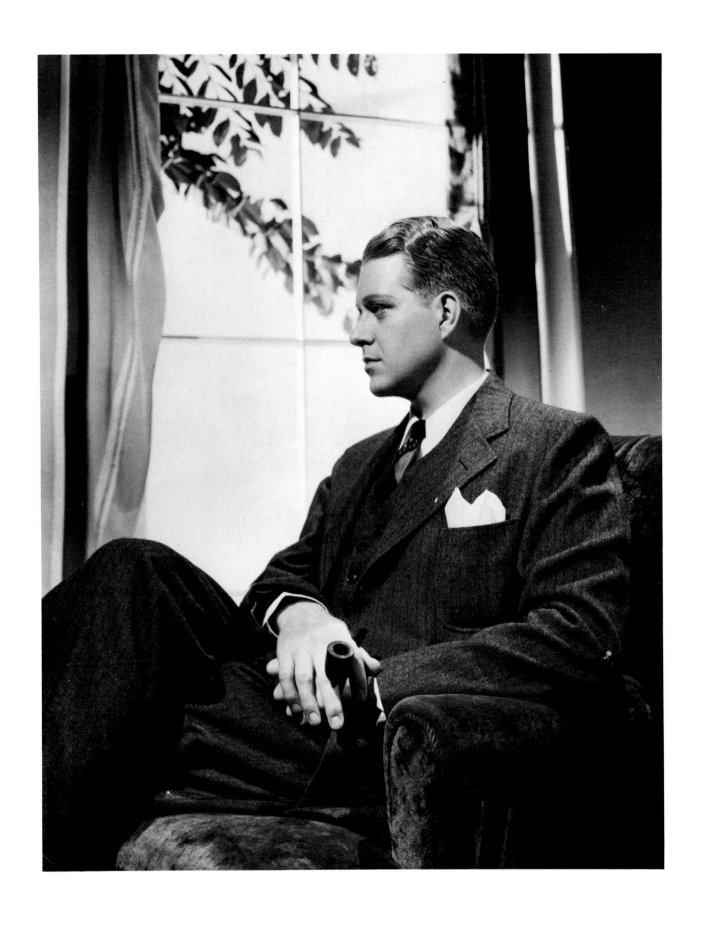

Nelson Eddy, 1937. Photo: Laszlo Willinger, for MGM.

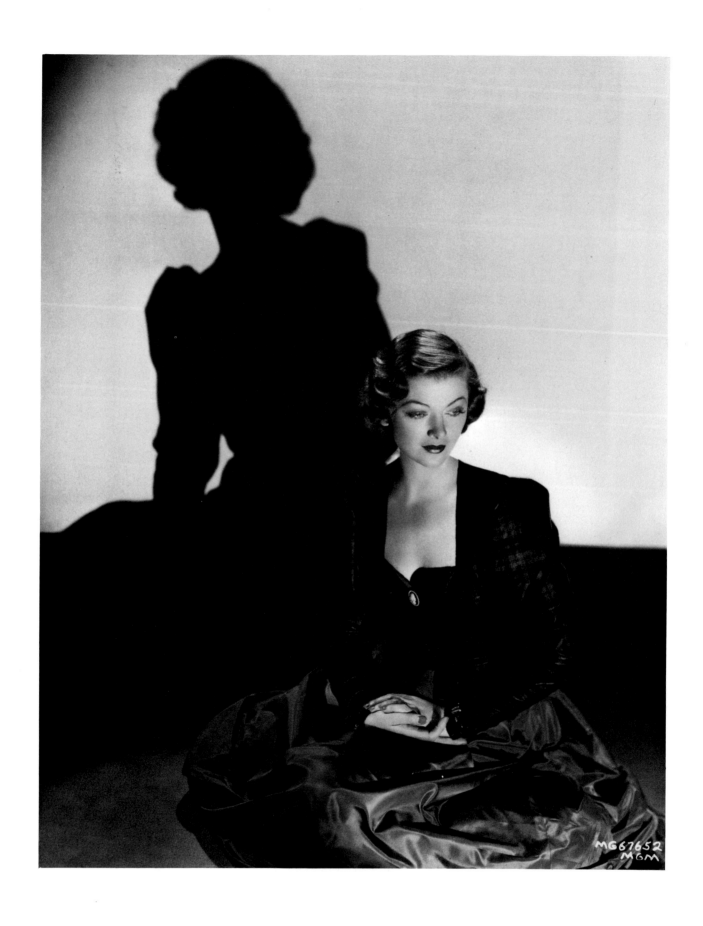

Myrna Loy, 1938. Photo: Laszlo Willinger, for MGM.

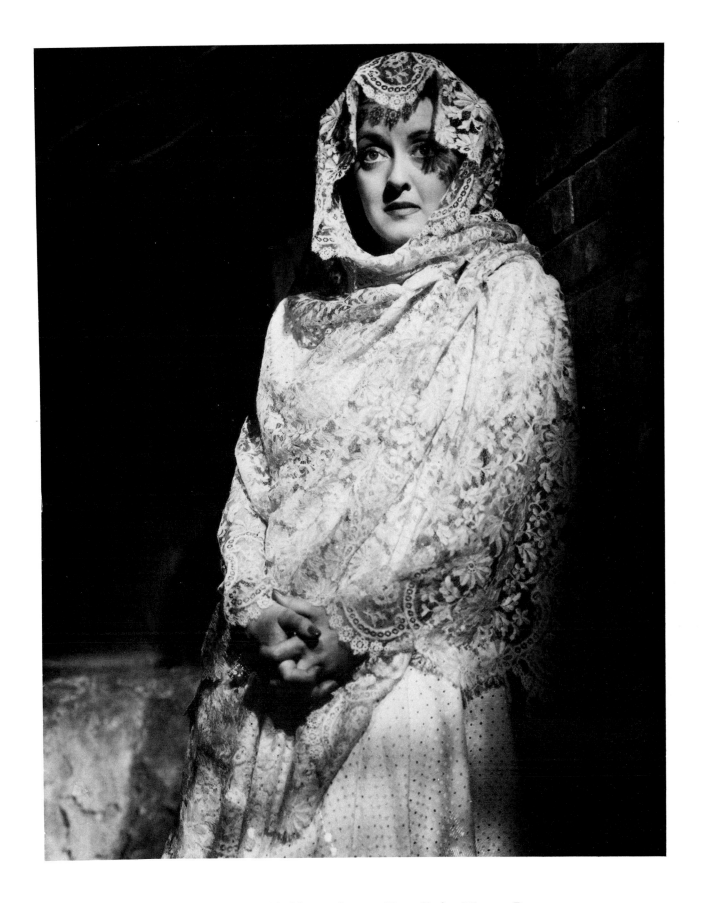

Bette Davis, 1940. Photo: George Hurrell, for Warner Bros.
Costume by Orry-Kelly. Publicity shot for *The Letter*.

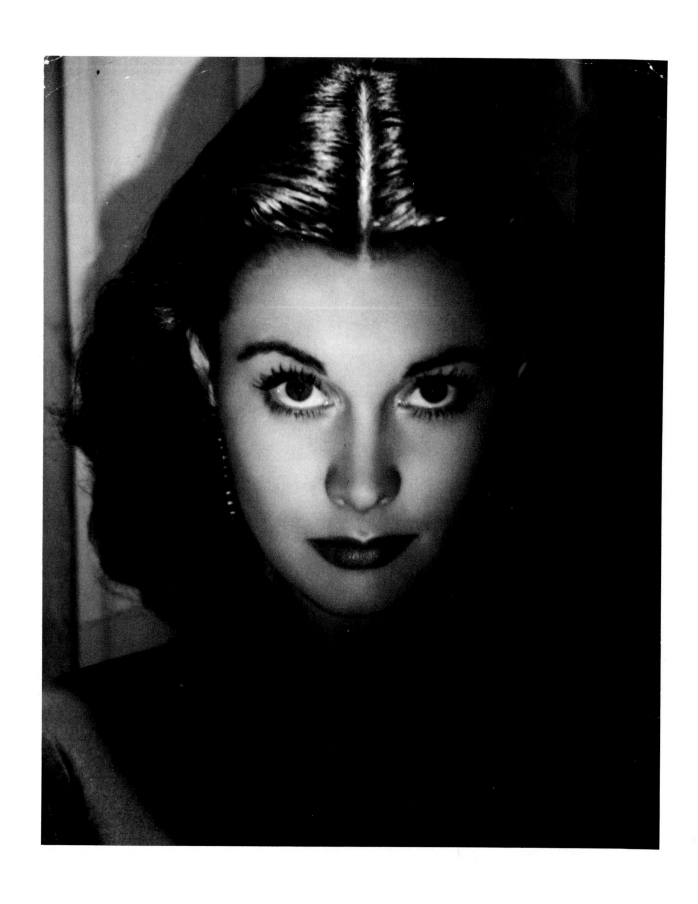

Vivien Leigh, 1940. Photo: Laszlo Willinger, for MGM.

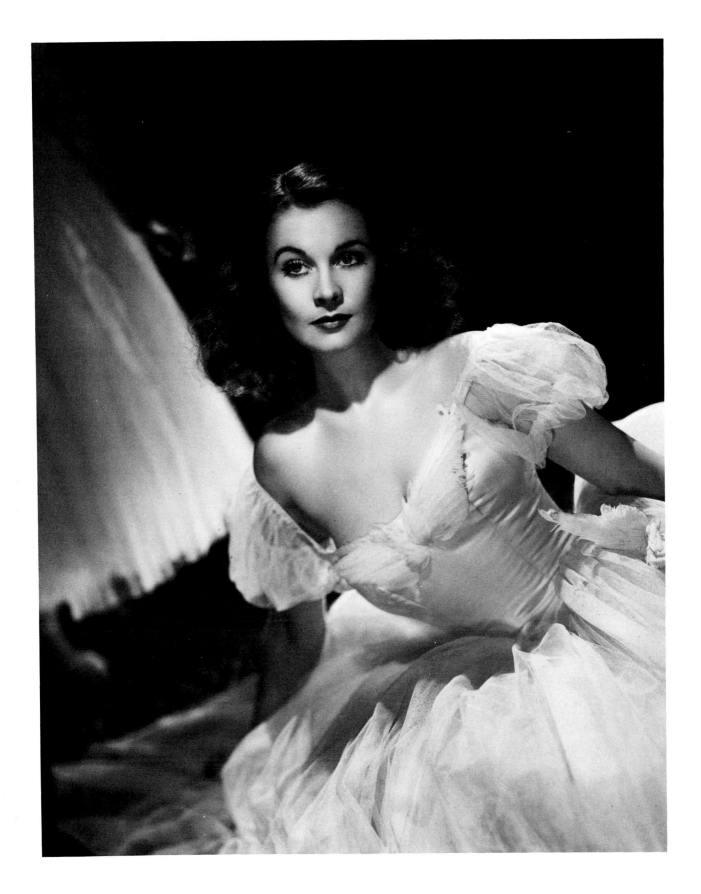

Vivien Leigh, 1940. Photo: Laszlo Willinger, for MGM.
Publicity shot for *Waterloo Bridge*.

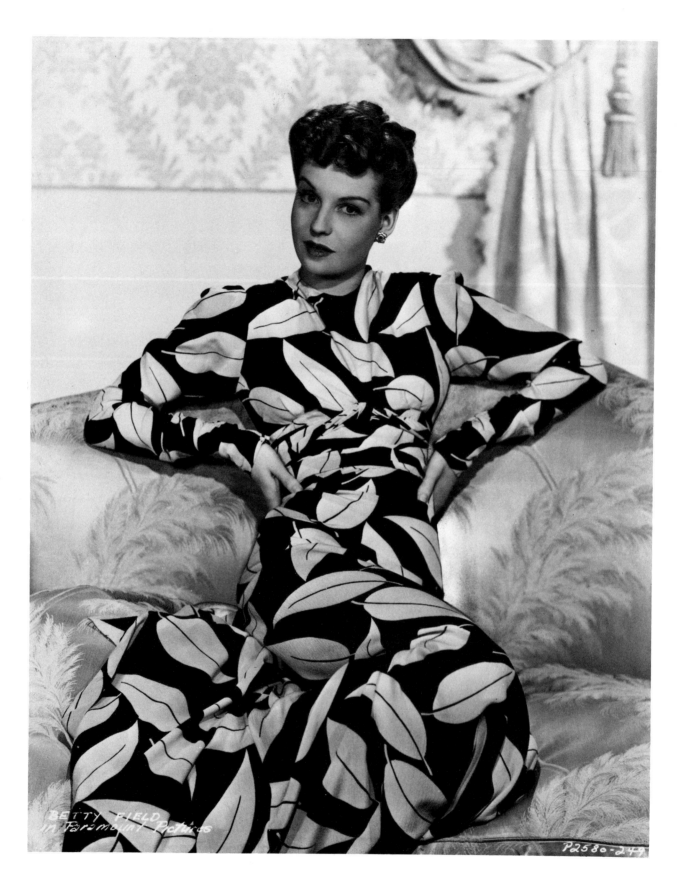

Betty Field, 1941. Photo: Eugene Robert Richee, for
Paramount. Costume by Edith Head.

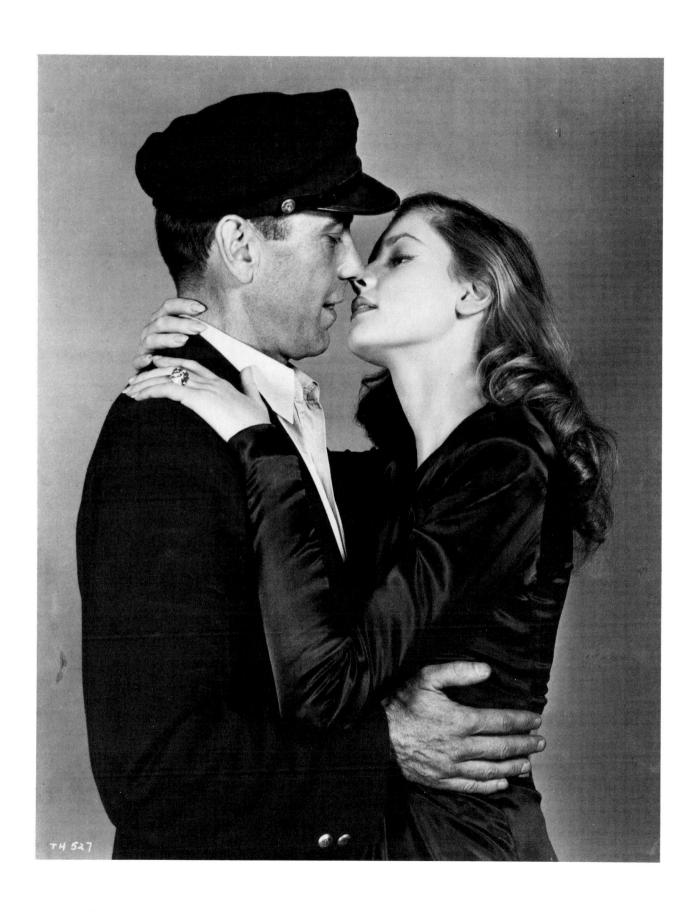

Humphrey Bogart and Lauren Bacall, 1945. Publicity shot
for *To Have and Have Not* (Warner Bros.).

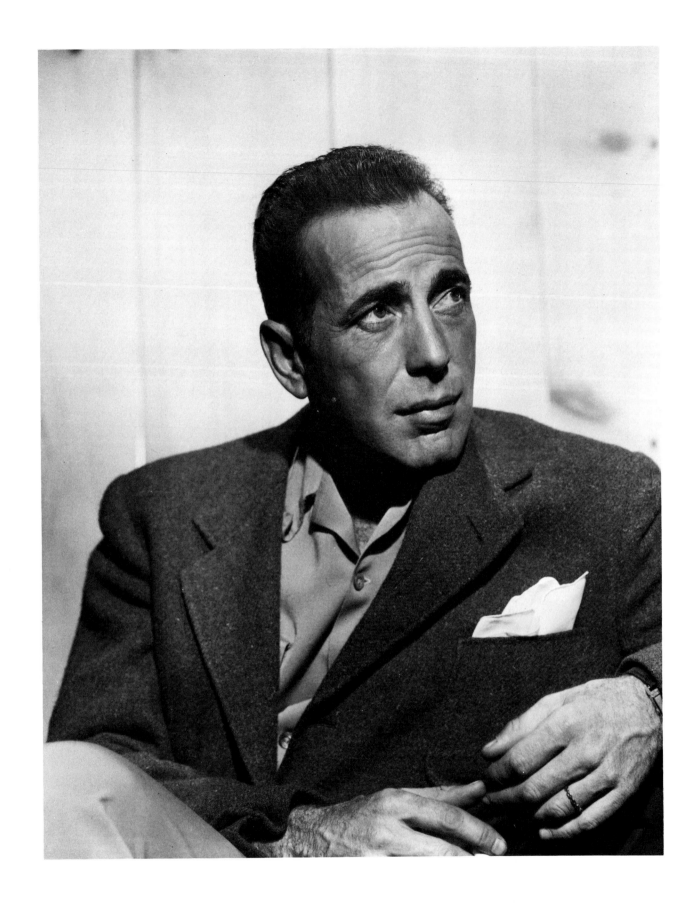

Humphrey Bogart, 1941. Photo: Scotty Welbourne, for
Warner Bros.

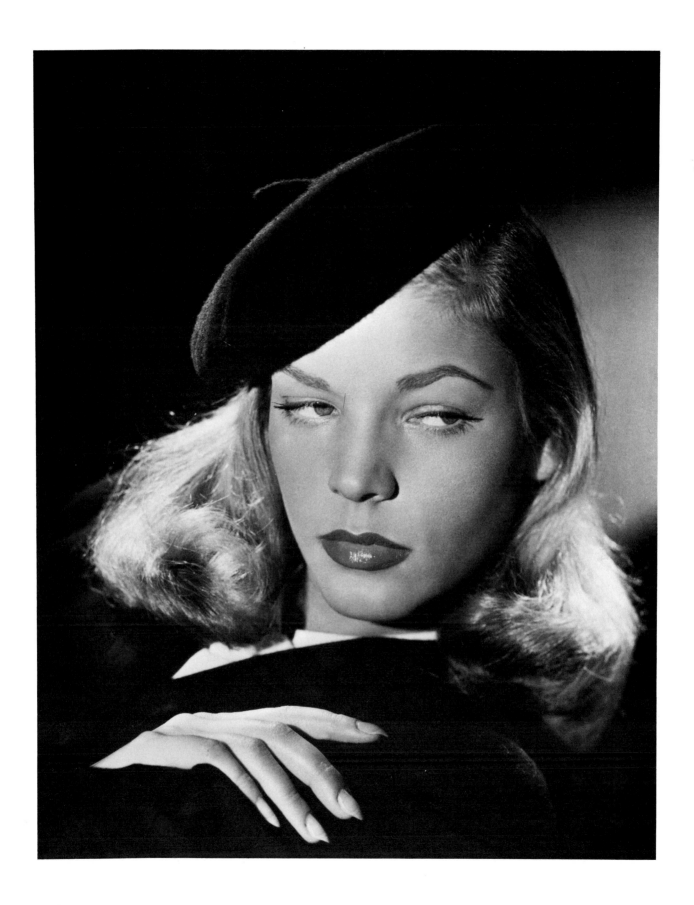

Lauren Bacall, 1946. Photo: Scotty Welbourne, for Warner
Bros. Publicity shot for *The Big Sleep*.

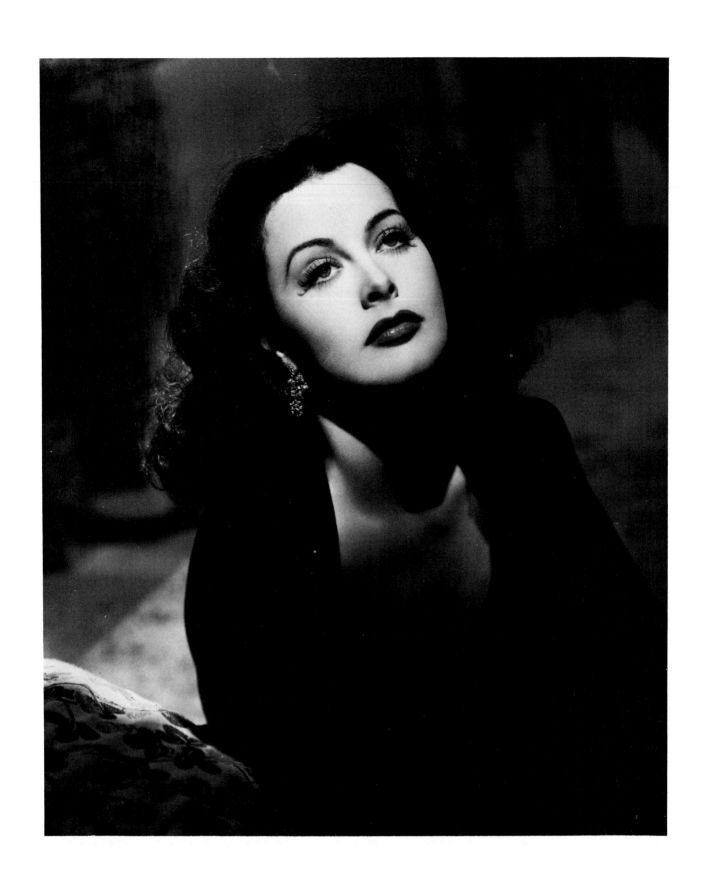

Hedy Lamarr, 1942. Photo: Eric Carpenter, for MGM.

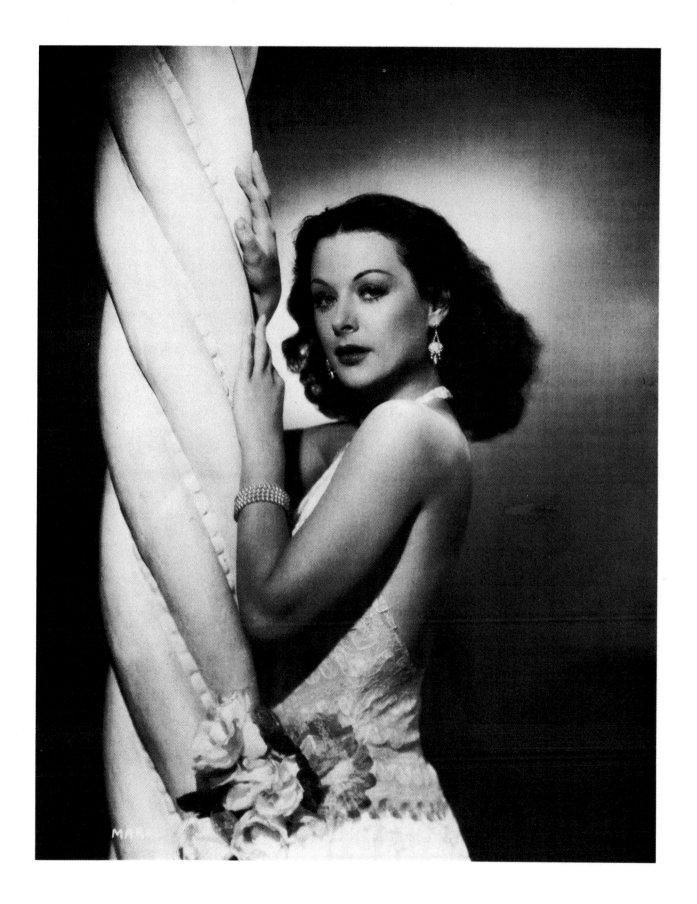

Hedy Lamarr, 1949. Photo: A. L. ("Whitey") Schafer, for
Paramount. Costume by Edith Head.

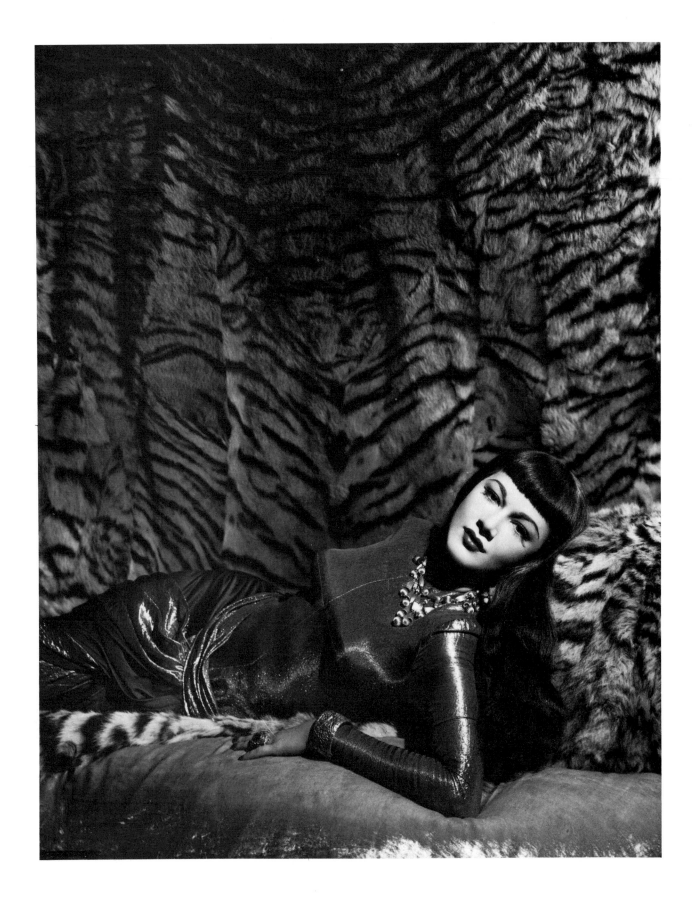

Maria Montez, 1947. Photo: George Hommel, for United
Artists. Publicity shot for *Siren of Atlantis.*

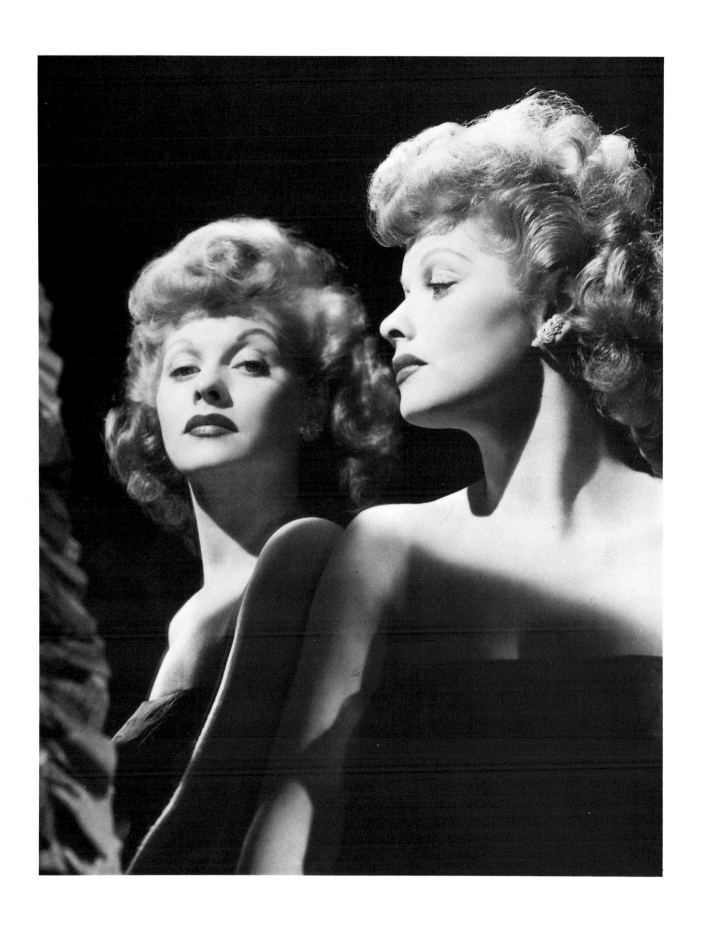

Lucille Ball, 1943. Photo: Laszlo Willinger, for MGM.

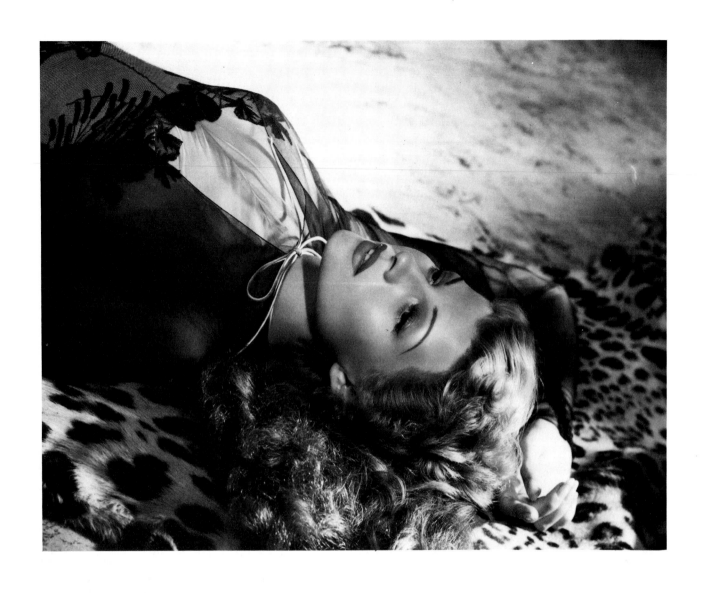

Rita Hayworth, 1942. Photo: George Hurrell, for Columbia.
Costume by Irene.

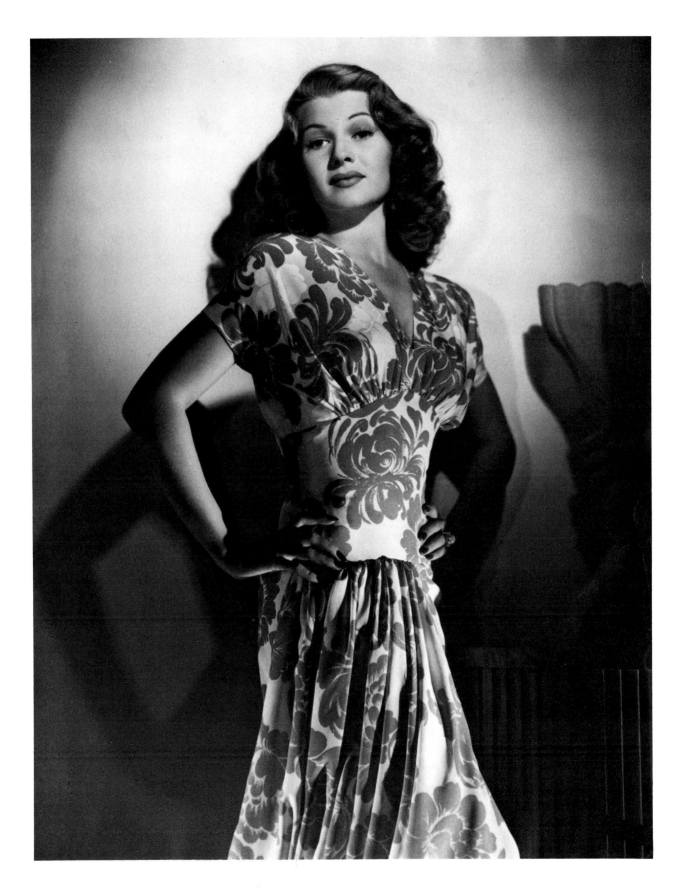

Rita Hayworth, 1941. Photo: George Hurrell, by Columbia.
Costume by Howard Greer.

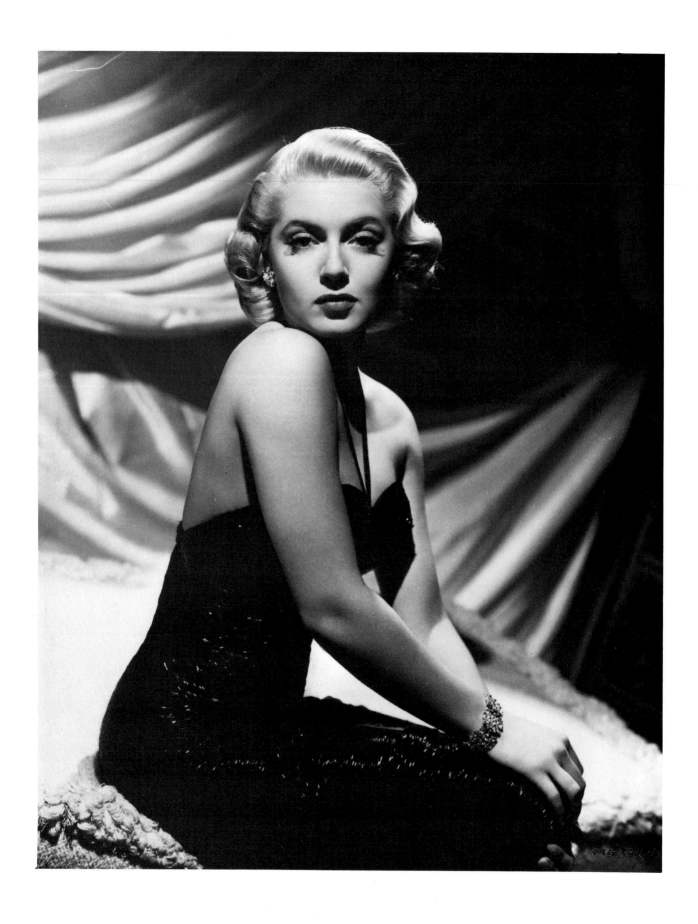

Lana Turner, 1942. Photo: Eric Carpenter, for MGM.

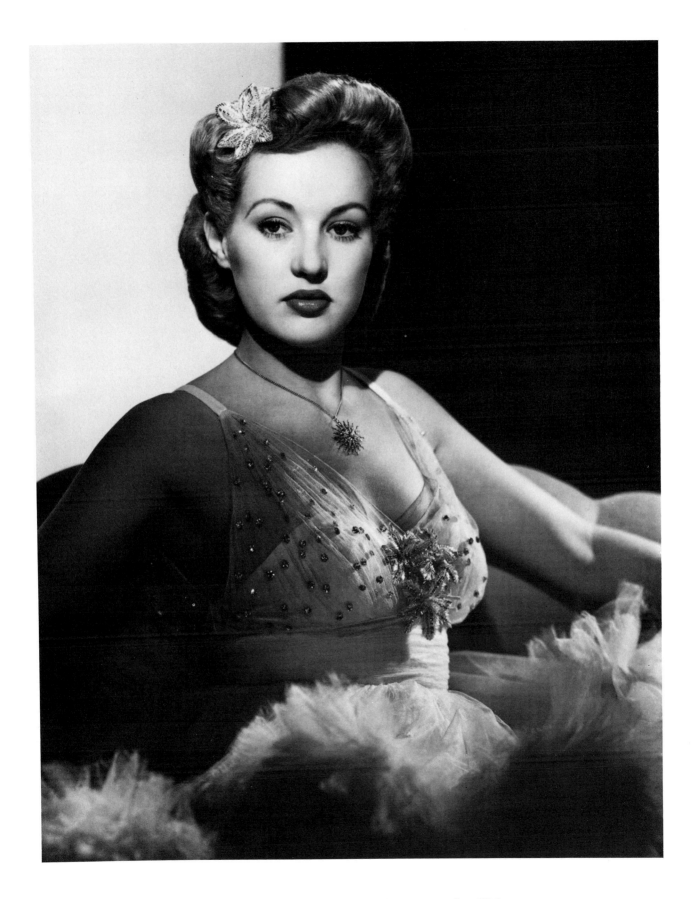

Betty Grable, 1941. Photo: Gene Kornman, for 20th
Century-Fox.

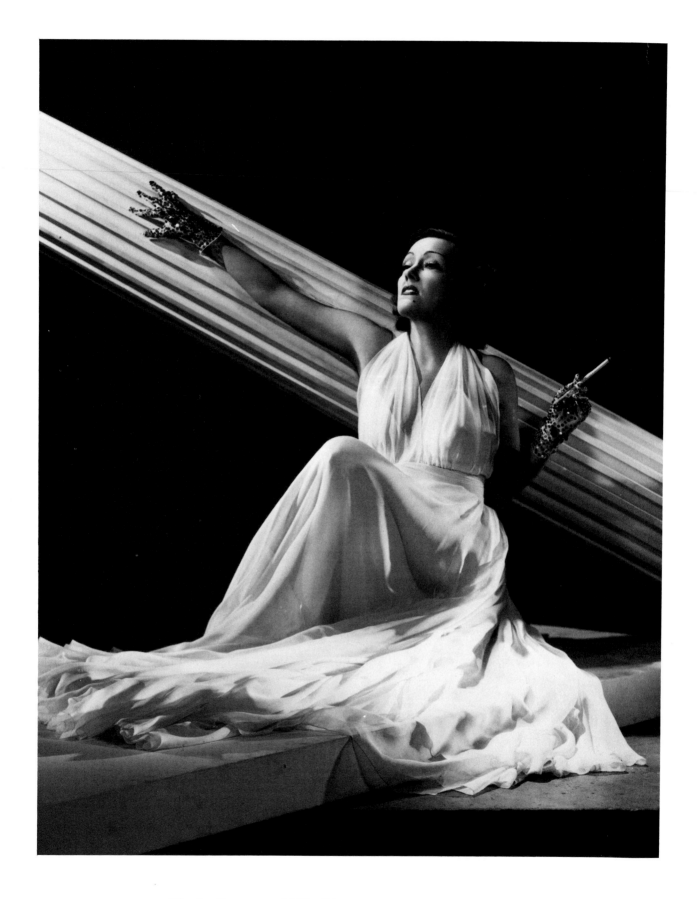

Gloria Swanson, 1940. Photo: Ernest A. Bachrach, for
RKO-Radio.

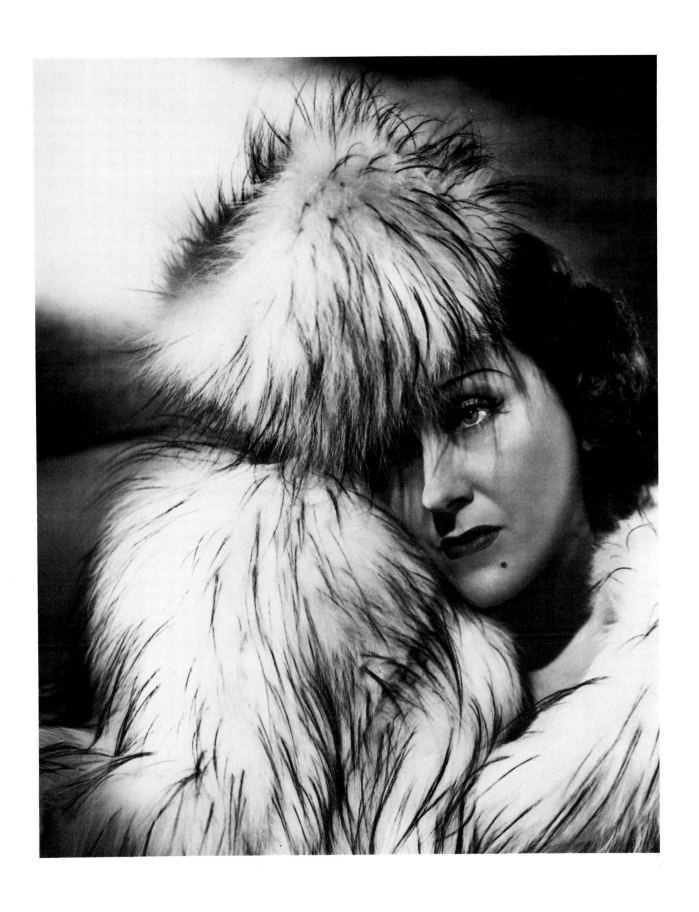

Gloria Swanson, 1940. Photo: Ernest A. Bachrach, for
RKO-Radio.

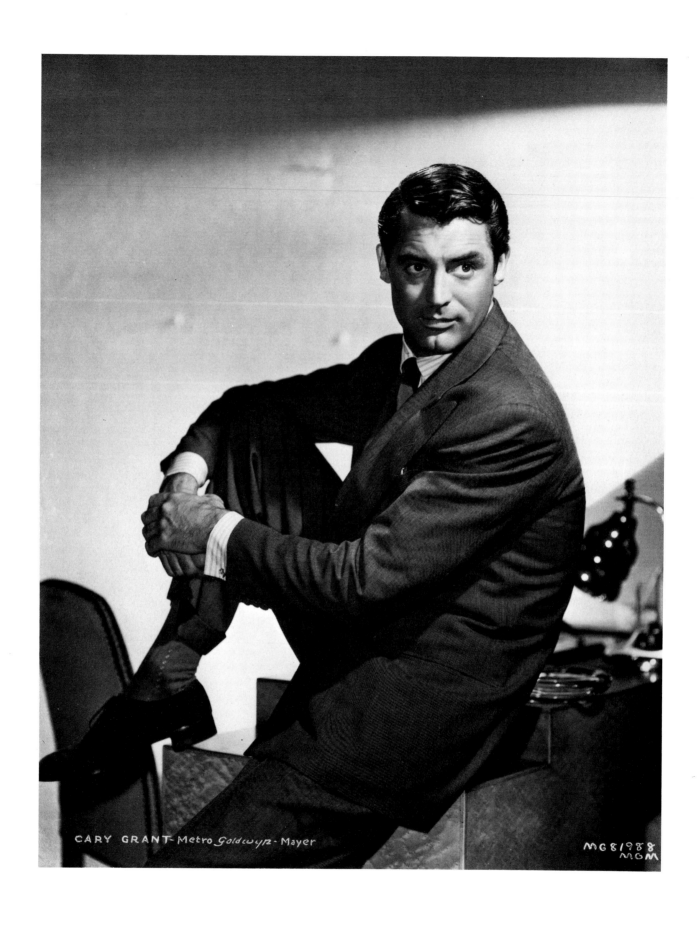

Cary Grant, 1940. Photo: Clarence Sinclair Bull, for MGM.

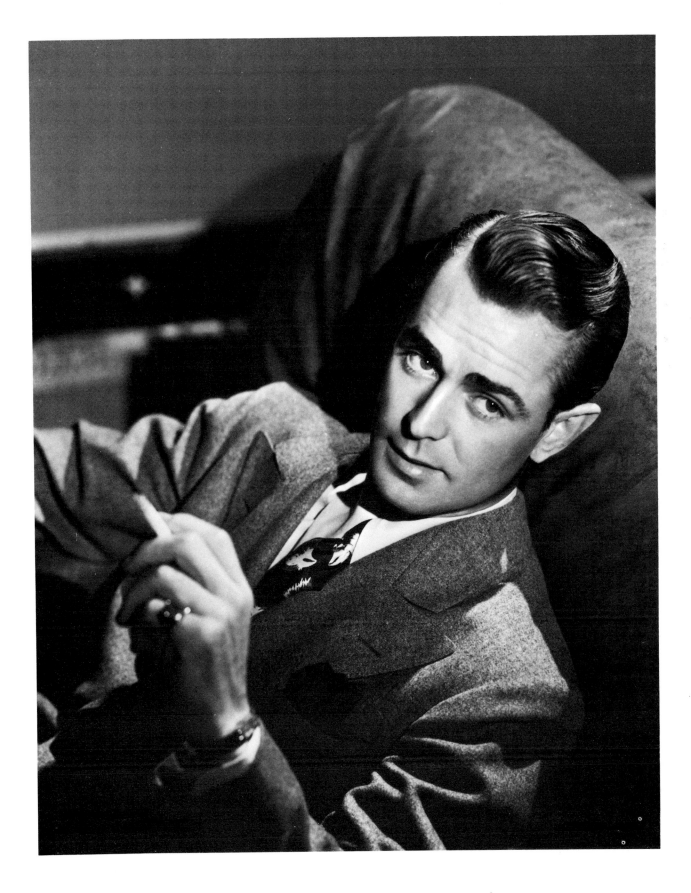

Alan Ladd, 1941. Photo: Eugene Robert Richee, for
Paramount.

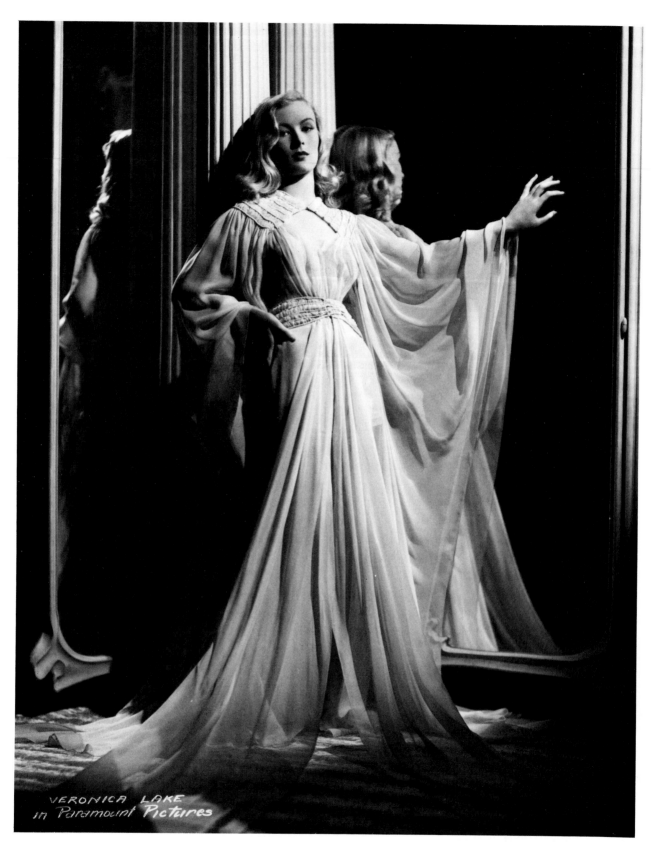

Veronica Lake, 1940. Photo: Eugene Robert Richee, for
Paramount. Costume by Edith Head. Publicity shot for
I Wanted Wings.

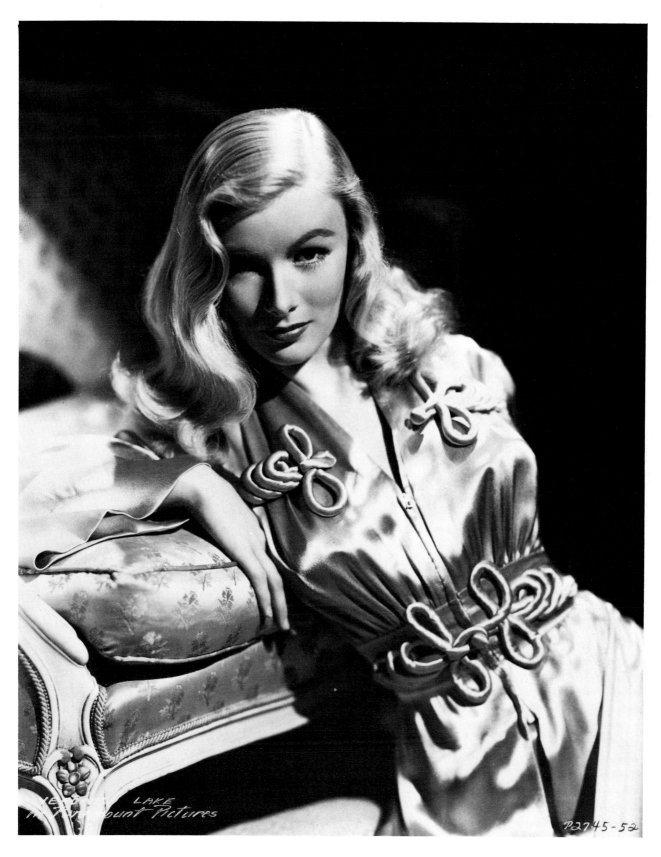

Veronica Lake, 1940. Photo: Eugene Robert Richee, for
Paramount. Costume·by Edith Head. Publicity shot for
I Wanted Wings.

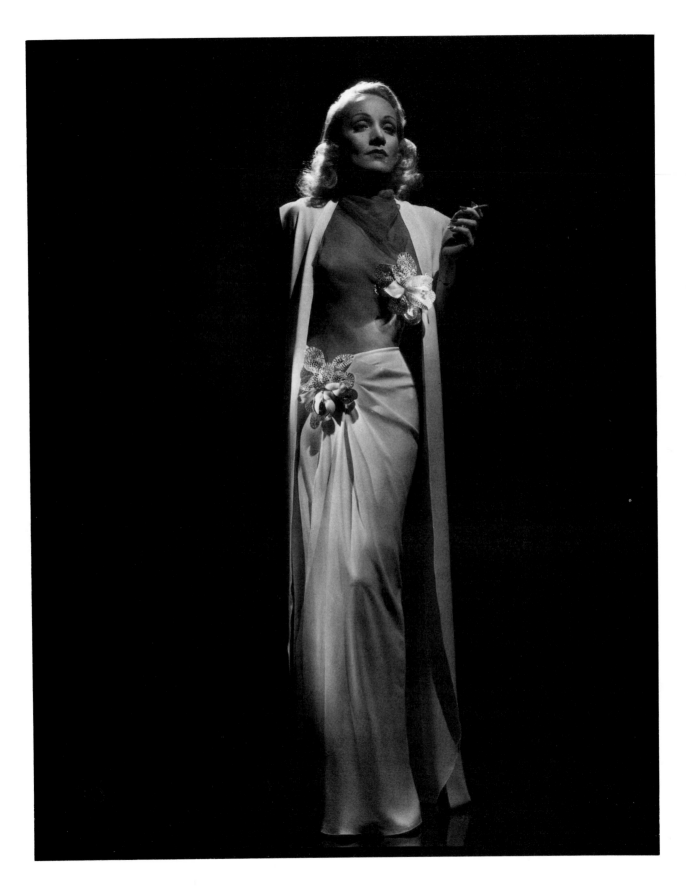

Marlene Dietrich, 1940. Photo: Madison Lacy, for Warner
Bros. Publicity shot for *Manpower*.

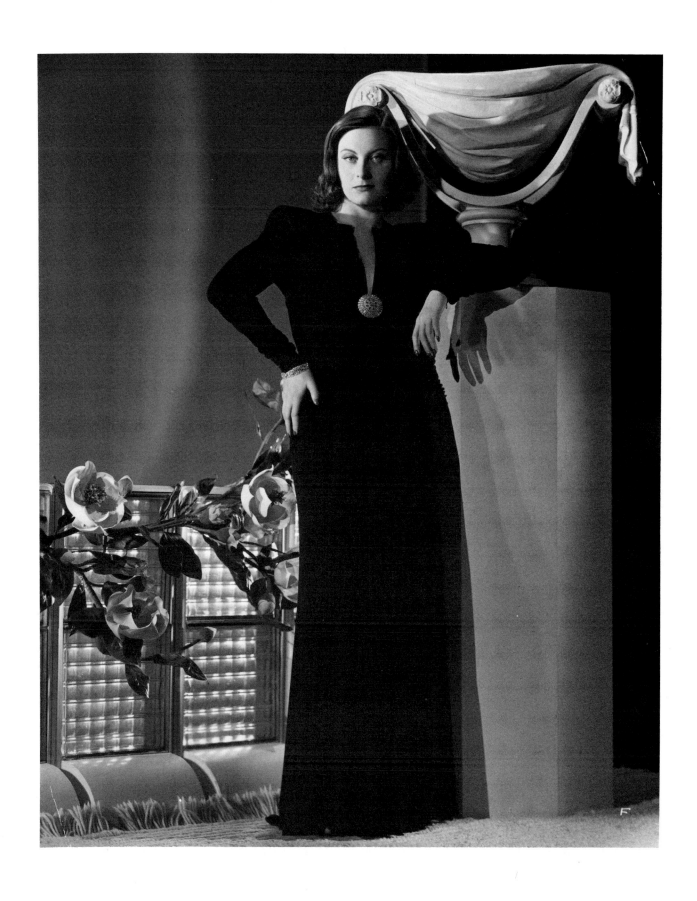

Michele Morgan, 1940. Photo: Ernest A. Bachrach, for
RKO-Radio.

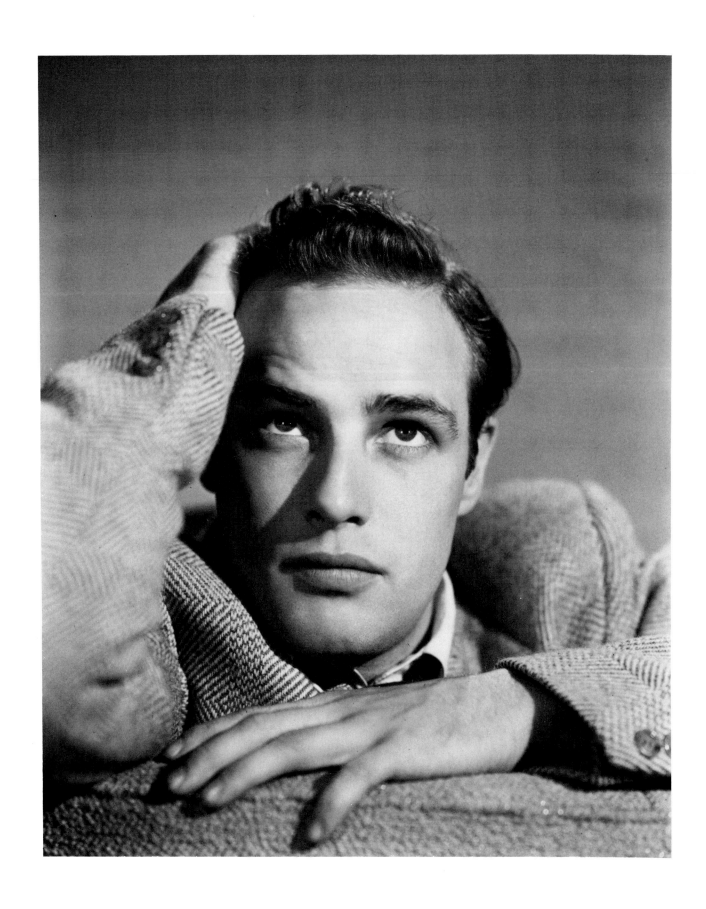

Marlon Brando, 1949. Publicity shot for *The Men*
(United Artists).

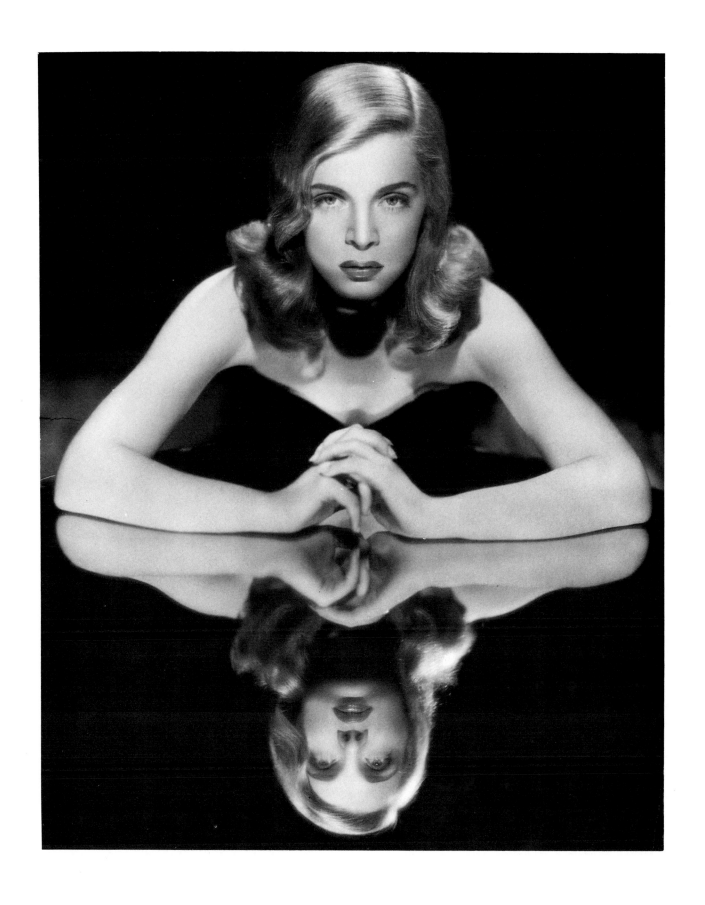

Lizabeth Scott, 1946. Paramount.

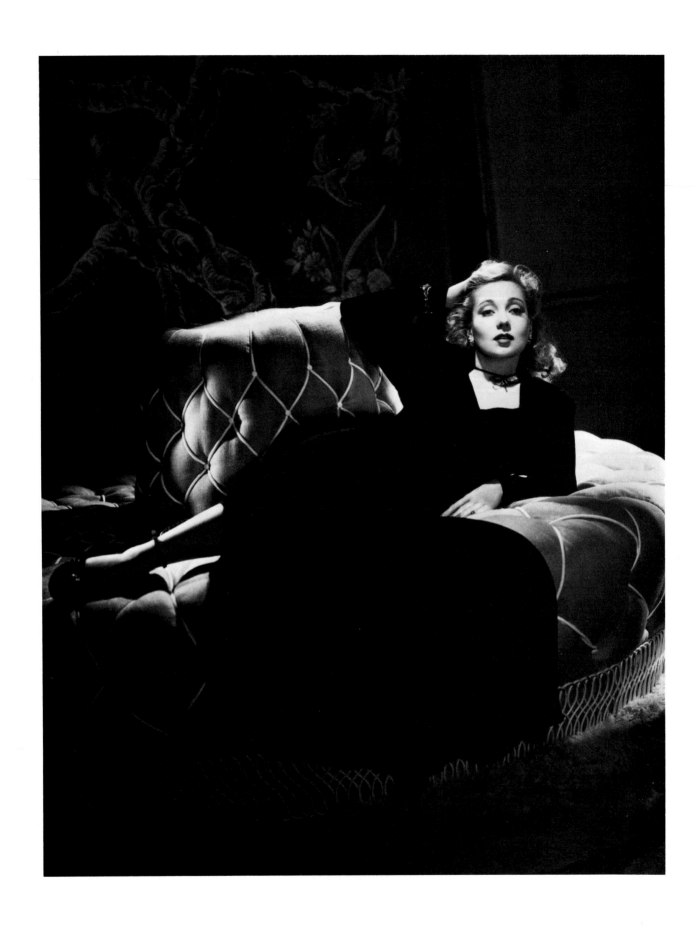

Ann Sothern, 1941. Photo: Cronenwerth, for MGM.

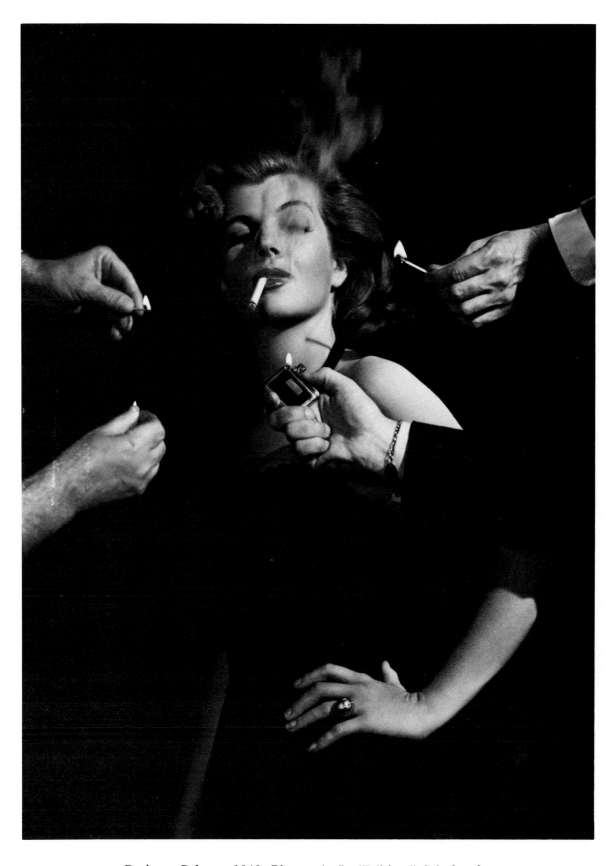

Corinne Calvert, 1948. Photo: A. L. "Whitey" Schafer, for
Paramount. Costume by Edith Head. Publicity shot for
Rope of Sand.

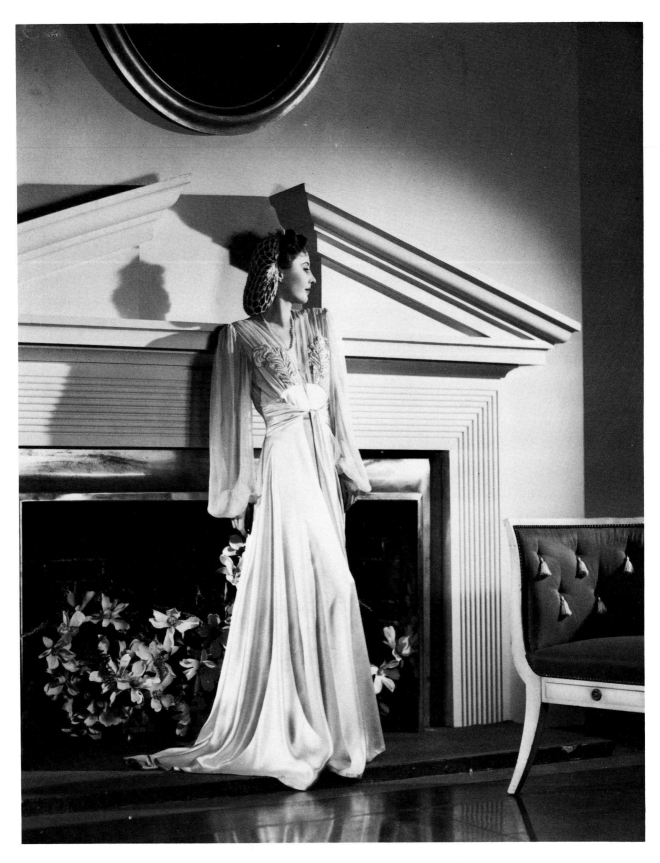

Barbara Stanwyck, 1941. Photo: A. L. ("Whitey") Schafer, for Paramount. Costume by Edith Head. Publicity shot for *The Lady Eve*.

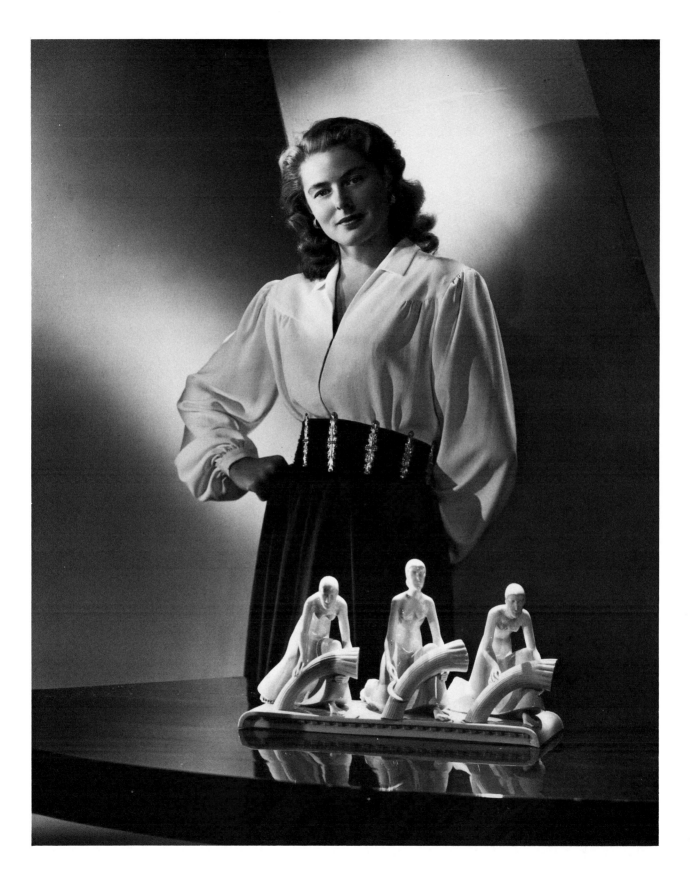

Ingrid Bergman, 1946. Photo by Ernest A. Bachrach, for
RKO-Radio. Costume by Edith Head. Publicity shot for
Notorious.

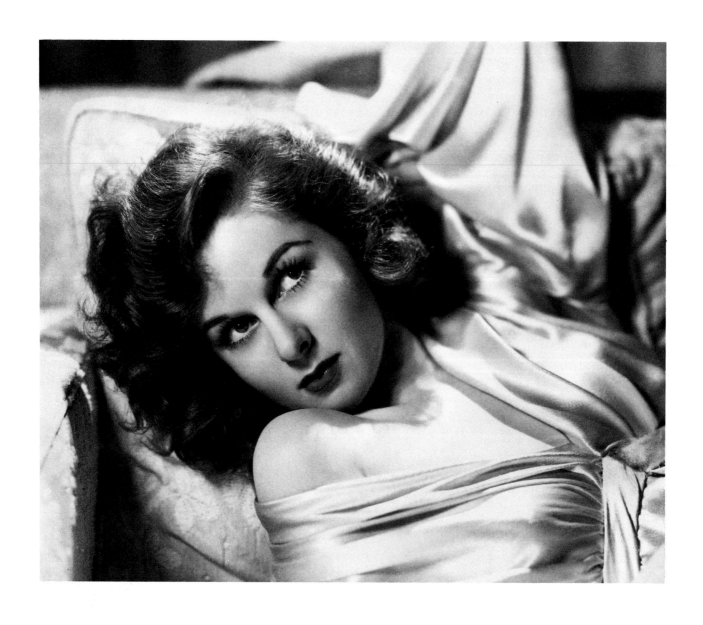

Susan Hayward, 1941. Photo: A. L. ("Whitey") Schafer, for
Paramount.

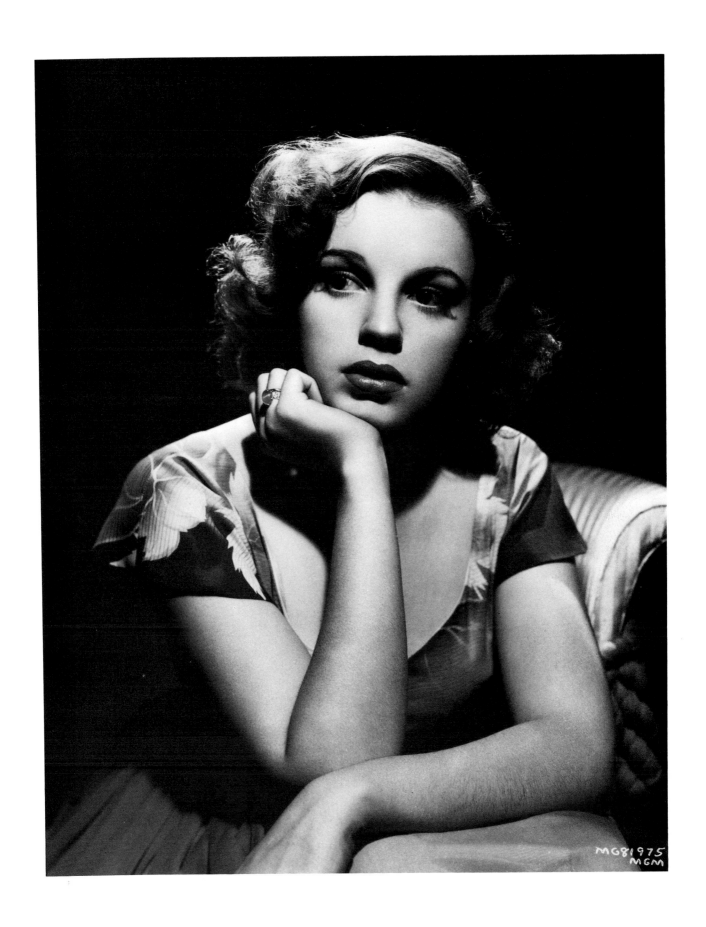

Judy Garland, 1940. Photo: Eric Carpenter, for MGM.

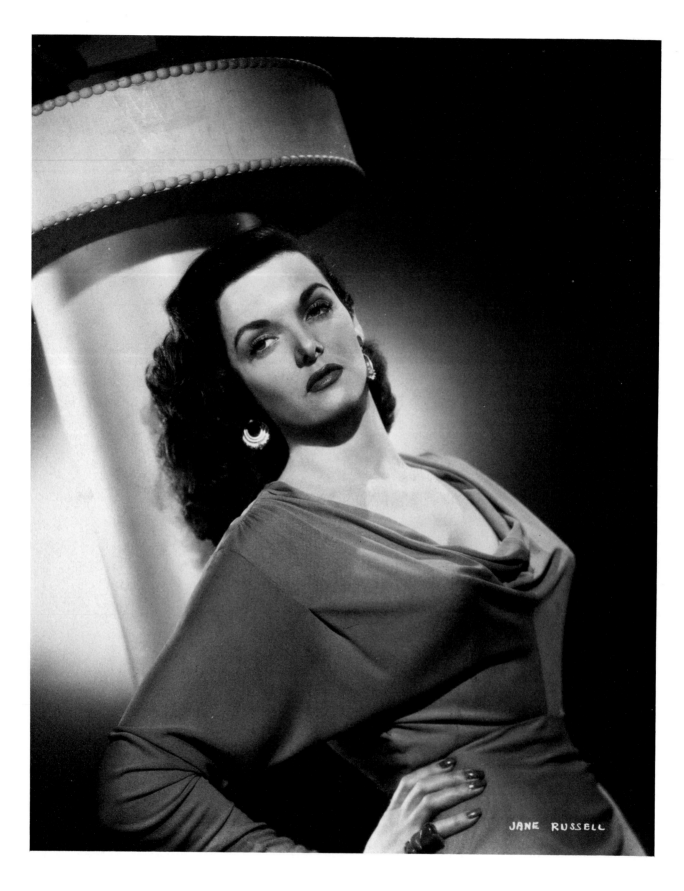

Jane Russell, 1948. Photo: A. L. ("Whitey") Schafer, for
Paramount.

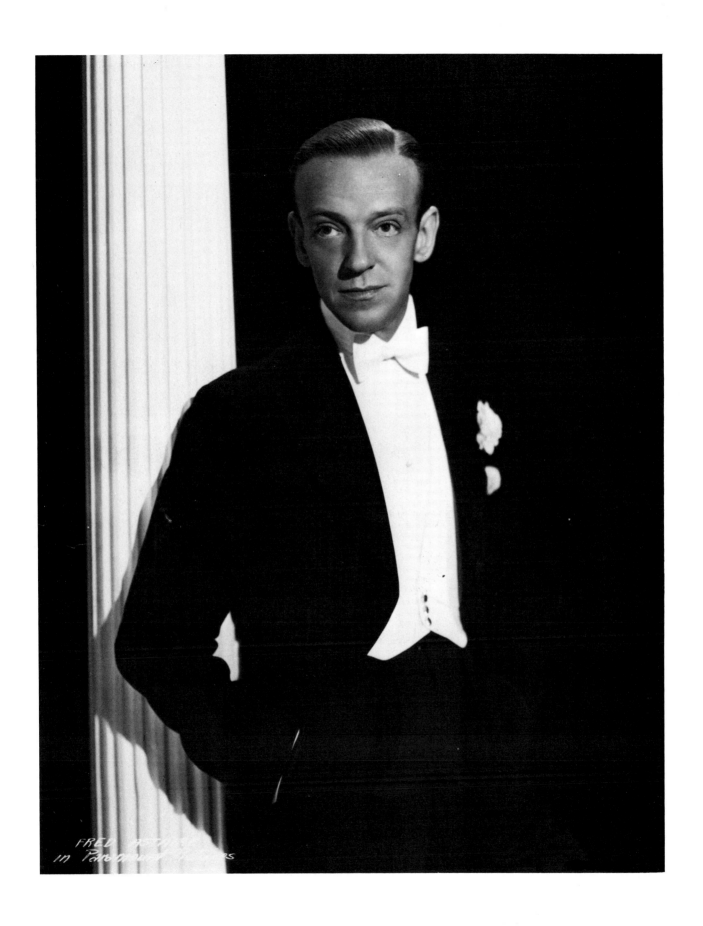

Fred Astaire, 1941. Photo: Bud Fraker, for Paramount.

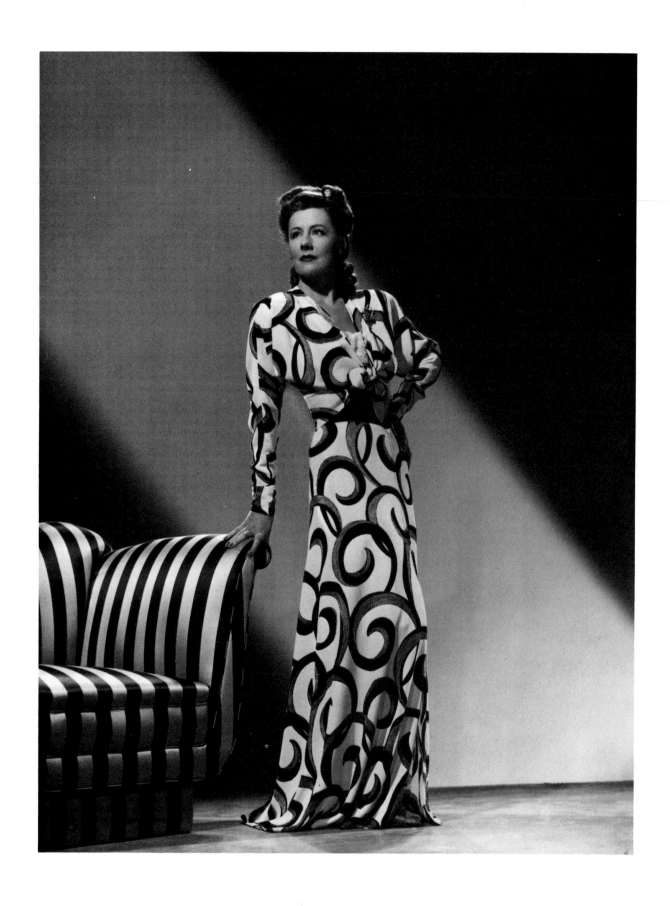

Irene Dunne, 1941. Photo: Ray Jones, for Universal.
Costume by Howard Greer.